Adapting Performance Between
Stage and Screen

Adapting Performance Between Stage and Screen

Victoria Lowe

intellect

Bristol, UK / Chicago, USA

First published in the UK in 2020 by
Intellect, The Mill, Parnall Road, Fishponds, Bristol, BS16 3JG, UK

First published in the USA in 2020 by
Intellect, The University of Chicago Press, 1427 E. 60th Street,
Chicago, IL 60637, USA

A catalogue record for this book is available from
the British Library.

Cover designer: Holly Rose
Copy-editing: MPS Technologies
Production manager: Emma Berrill
Typesetting: Newgen Knowledgeworks

Hardback ISBN 978-1-78938-233-4
Paperback ISBN 978-1-78938-750-6
ePDF ISBN 978-1-78938-235-8
ePub ISBN 978-1-78938-234-1

To find out about all our publications, please visit
www.intellectbooks.com
There you can subscribe to our e-newsletter,
browse or download our current catalogue,
and buy any titles that are in print.

This is a peer-reviewed publication.

Contents

Acknowledgements

It seems strange to be writing about past acts that contributed to the making of this book when, due to COVID-19, we are locked into an eternal present and the shape of the future seems very uncertain. Still, there are numerous people to thank.

Work on this book has been supported by research leave from the School of Arts, Histories and Cultures at the University of Manchester. Particular thanks should go to Professor Alessandro Schiesaro for granting supplementary research leave in 2019 to enable me to finish this monograph.

I would also like to thank staff at various libraries and archives from whose expertise I have undoubtedly benefited. This includes the John Rylands Special Collections, The Reuben Library at the British Film Institute and the British Library.

Special thanks to real-world Superman, Professor John Wyver and his team for granting me unlimited access to pre-production and live broadcast of the RSC's *Romeo and Juliet* in July/August 2018.

I am indebted to my wonderful colleagues in the Department of Drama, above all to simply the best Head of Department on record, Dr Jenny Hughes. Special mention should also go to Dr Kate Dorney, Professor Maggie Gale and Dr Felicia Chan for reading and commenting on parts of this text and particular gratitude to Dr Darren Waldron who gamely read a whole draft and whose thoughtful and thorough feedback really helped this project to turn a corner. I was also greatly aided by the calming presence of Dr Rachel Clements (and in the final months the wondrous Elijah!) and quite a lot of cake during writing sessions in various South Manchester cafes. Thanks also to Professor Emerita Viv Gardner for feedback and support and the anonymous reviewers of this book for their really helpful comments. Thanks to Intellect for being just brilliant to work with, to Tim for his patience in seeing this project through and to Emma for being a fantastic production editor.

My friends and family both near and far have been a constant support during the long gestation of this project. Miriam and Paolo Ba' provided me with wonderful hospitality in Italy during the summer months. My heart goes out to all my Italian relatives and friends at this unimaginably difficult time. Various friends

offered writing retreats and Rioja; Annette and Berni thank you! Shout out too to the Mums in York who have cheered me on, my brother Matthew and family in Norway and above all my amazing and inspirational sister Professor Jane Collins, whose expertise in theatre and performance was just invaluable. Thanks to her and Nick and the boys for support and lovely food. Our amazing Mum and Dad, Gwen and Don, sadly passed away whilst this book was being thought up and written out. I would like to think they provided inspiration for it. Mum was definitely all theatre and my Dad passed on his lifelong love of the cinema to me. Finally, my wonderful daughters Francesca and Giulia who made me cups of tea and my husband Stefano for expert 'cappucin'ohs'!: *Tutto è per voi.*

Introduction

We need a new idea. It will probably be a very simple one. Will we be able to recognise it?

(Sontag [1966] 1994: 37)

After systematically dismantling a critical history that saw theatre and film as artistic forms diametrically opposed to each other, Susan Sontag's article ended with the above challenge to readers. Turn the clock forward 50 plus years and a brief survey of the listings for local cinemas and theatres in Manchester, UK, shows how much adaptations between stage and screen have become intertwined. There is a projected adaptation of the Swedish film *Let the Right One In* (2008) at the Royal Exchange, in itself an adaptation of the book by John Ajvide Lindquist (2004). Meanwhile HOME, Manchester's centre for contemporary art, theatre and film, is showing both a live broadcast of the latest Royal National Theatre production, direct from London, and a stage adaptation by Imitating the Dog of George A. Romero's classic 1968 horror movie *Night of the Living Dead*. [1] Yet since Sontag's article there has been little work on adaptation between stage and screen that reflects this changed media landscape and takes on board fundamental changes in how theatre and cinema are produced, exhibited and consumed.[2] This book provides an introduction to adaptations between stage and screen that incorporates consideration of both art forms not just as texts but as performances and events. It argues that we need to see adaptations between stage and screen as distinct from literary adaptation, the 'word' to 'image' paradigm that has dominated the field of adaptation studies. My contention is that scholars working in adaptation studies have often failed to attend to the differences between novels and plays as factors in the adaptive process and that adaptation studies hasn't addressed in any significant and sustained way aspects of performance that are connected with the move from stage to film or, as I argue in this book, from theatres to cinemas or film to stage.

1

One only has to look at the remarkable growth of the live broadcast of theatre plays to cinemas in the last ten years in the United Kingdom alone, to understand why a book that looks anew at adaptations between stage and screen is necessary now. Whilst cinema and theatre have always existed in relationship to each other and influenced each other's development, we stand now at a point in history when challenges to both theatre and cinema's ontological and institutional status are evident. What is 'theatre' and what is 'cinema' in terms of the 'crisis' bought about by the emergence of digital media are questions which have concerned scholars in both disciplines. In the latter field Gaudreault and Marion have pertinently asked, '[w]hat remains of cinema in what cinema is in the process of becoming? Or rather: what remains of *what we thought*, just yesterday, *cinema was* in what cinema is in the process of becoming?' (2015: 2, original emphasis).[3] Set against this background, cultural acts such as the adaptation of films to the stage can therefore use the form to memorialize cinema, to summon up its ghostly presence through a collective theatrical encounter and thus reflect on its current status *as* a medium. This suggests a sense that during moments of technological change, media are self-reflexive, using their forms to think through their place in a changed cultural landscape. Many of the works looked at in the screen-to-stage adaptation chapters share the trait of reflecting self-consciously upon a medium's potentialities or limitations sometimes provoking, as Sandra Annett described it, 'a kind of media melancholia' (2014: 271). Modes of communication offered by stage and screen as performance media have also come together in an age marked by what has been termed 'convergence culture' (Jenkins 2006) as evidenced by a theatre director such as Ivo van Hove consistently using a screen within the stage space to transmit close ups of his actors. Adaptation between theatre and cinema therefore involves not just the textual but the spatial and temporal reconfiguration of a previously given work, articulating it using the dramaturgical systems of the new form and in this process potentially creating a hybrid aesthetic. Bolter and Grusin's notion of 'remediation' (2000) is relevant here and this is particularly the case when examining contemporary phenomena such as live casting – the live broadcast of theatre plays to the cinema, where I will argue not only the performance, but the performance event itself is adapted for the cinema audience, resulting in a blurring of the boundaries between cinematic and theatrical viewing conventions.

Yet we must be wary of reducing the analysis to a simple technological determinism or of seeing convergence culture as only marking the present moment. Adaptation as a cultural practice has always been sensitive to contextual changes and developments in stage–screen relations. It is the intention of this book to demonstrate how a 'hybrid aesthetic' might also be applied to, for instance, the adaptation of plays to the screen in Britain's early sound period, where the original spoken dialogue and/or preservation of the actor's performance were integral to

the final film. Therefore, what adaptation (re-)produces is always in the context of new conditions whether as a result of technological changes or as demanded by ever-changing socio-cultural and historical circumstances.

The book is arranged in two halves to embrace a range of perspectives on the stage–screen adaptation as a discrete area. Part One concentrates on 'Practices', taking a synchronic approach in reframing current and historical practice in stage–screen adaptation, whilst the second part, 'Histories', takes a diachronic approach, examining case studies from 1930 to the present with a focus on British films (as adapted to *and* from the stage) so as to engage with the performances and events of these adaptations within their temporal, geographical and cultural contexts.

The first chapter starts with the most commonly analysed of adaptations between stage and screen, that of the adaptation of play to film, but offers a reframing of analysis through aspects of performance to open up new avenues of exploration that include non-literary issues such as the treatment of space and place, design, sound and music, acting styles and star personas. For instance, Bola Agbaje's Royal Court play *Gone Too Far* (2007) was adapted by the author for the screen in 2013. Whilst the film adaptation demonstrates classic elements of the transfer between these forms, such as setting the film in the actual South London location alluded to by the characters in the play, an examination of how costume is used in the Court production draws attention to how this element of the performance is translated on screen. On the other hand, an examination of two film adaptations of Samuel Beckett's *Play* is used to explore what might be termed the 'unfilmable' play, because conditions of its live performance, such as a particular lighting effect, are integral to the meaning of the play.

The second chapter reverses this more conventional way of looking at adaptation between stage and screen by concentrating on the adaptation of films to the stage, arguing that they relate to each other in a post-literary way, by drawing on the images of the film rather than the spoken text. I will examine a range of works derived from art house to Hollywood films and consider how the performances reconfigure the fragmented space of the film to the continuous stage space of the theatre. Ivo van Hove's theatre adaptations of American independent director John Cassavetes' films will be used to demonstrate how stage adaptations of films raise questions of authorship in terms of the translation of an auteur's film work into director's theatre. I will also discuss how some stage adaptations can translate the haptic 'affect' of film effectively because of the physical encounter between performer and audience that live theatre promises.

Because I argue that developments in technology have led to the growth of live filmed theatre performances as an area distinct from plays adapted to film, but still understandable within the rubric of adaptation, this will be explored in Chapter 3. This means engaging with the 'events' of theatre and cinema and I see

cultural products such as NT Live as very much implicated in the processes of adaptation because of how the 'eventness' of the theatre production is adapted to the cinema, particularly in the different ways that they inscribe the perceived 'liveness' of the theatrical encounter within the cinema 'event'. This chapter also takes on board how digital technologies affect how audiences perform as audiences at these events through examining an RSC Live broadcast of *Romeo and Juliet* (2018) and looking at the way social media is used by producers to interact with actual and implied spectators.

The second half of the book takes a different approach to the subject, by looking at adaptations between stage and screen within a broader historical framework. This then positions the adaptation, as Hutcheon has described it, not just as a 'product' but as a cultural 'process' that can articulate issues specific to a particular place or idea of the nation (2006). With this understanding we can see how adaptations operate within a particular culture and are differentiated by historical specificity, so that issues of, for example, fidelity to the source material are seen as a function of a particular set of industrial and institutional circumstances. Such an approach has led to an enriched understanding of stage-to-screen adaptations in the United Kingdom in the period prior to sound film (see Burrows 2003; Gledhill 2003) but has had limited sustained application to thinking through how adaptations between stage and screen functioned after.[4] As a full history of the period is not possible within the parameters of this book, these three chapters examine adaptation between stage and screen during three catalytic periods in British film and theatre history: 1929–33 and the introduction of synchronized sound to film; post 1956 with the British New Wave on stage and screen; and finally the growth of stage adaptations of specifically British films post 2000. These particular periods were chosen to illustrate the principle that adaptations have to be understood within the particular historical and cultural moment in which they are produced. Therefore, Chapter 4 looks at the work of Basil Dean, early British Hitchcock and the Aldwych farces as differently inflected responses in film adaptation to the coming of sound to cinema in Britain. These examples give insight into the cultural context because of the way that they foreground (or diminish) theatrical elements in the adaptation to the screen. In a similar way to the first half, I am particularly interested in actors' performances in these adaptations because of the way that their presumed 'theatricality' has often been misunderstood by critics as 'holding back' British cinema, rendering it a second-order experience of a more culturally legitimated mode of dramatic expression. The work of actors can often be overlooked in adaptations and I contend that examining how acting is presented in the films can lead to a more nuanced understanding of its function.

In a different way, the British New Wave can be thought of as a movement that crossed between the performance media of theatre and cinema, with both plays

and films challenging established norms not only in writing but also in acting and design. These were articulated within medium-specific frameworks such as translating theatrical naturalism into cinematic realism, but also by other strategies that moved towards a more poetic anti-naturalistic expression across both stage and screen. In Chapter 5, I will examine two well-known film adaptations of stage plays, *The Entertainer* (1959) and *A Taste of Honey* (1961), but also a lesser-known work, *The Kitchen* (1961) by Arnold Wesker to understand how these aesthetic experiments were played out.

The final chapter in the section reverses the process again to look at the adaptation of specifically British films for the stage. My argument here is that the accelerated changes in technology since 2000 have created a climate where not just the content of the film but the medium in which it is articulated are addressed as subject matter, and so in a different way these adaptations recycle questions about the relationship between theatre and cinema for British culture raised by the early sound films. Following on from Ellis who argued that 'adaptation into another medium becomes a means of prolonging the pleasure of the original representation, and repeating the production of memory' (1982: 4), I will investigate how the cultural memory of these films is woven through the adaptation, inviting the audience to repeat acts of consumption. However, in a political context dominated by discussions of national borders and ensuing identities, the staging of these films also offers the opportunity to interrogate these issues through a theatrical engagement with the products of British cinema.

My arguments will be explored in the first half by looking predominantly at examples from a range of English language plays and American and European films and in the second half through what has been described as 'British' cinema and productions within the English theatre.[5] Particularly within British cultural history, there have, of course, been many links between popular cultural forms that cross between stage and screen such as music hall and variety, not to mention the links between theatre and television, but I feel that this is beyond the scope of my central argument so mention of this will be limited. Another further qualification is the absence of sustained discussion about Shakespeare on screen. This is because I feel that it has for a long time dominated discussion of screen adaptations of stage plays (and is beginning to dominate discussion of live theatre broadcasts too) to the exclusion of other plays and practices. Therefore, because it has been dealt with exhaustively elsewhere (e.g. Hatchuel 2004; Buchanan 2005; Jackson 2014), my discussion of this subject is restricted to discussion of the RSC's live cinema broadcasts in Chapter 3. It should maybe go without saying that the case studies (with a few exceptions where the name has been translated) all share the same name so that whether the audience has seen the referred-to work or not, the fact that they are known by the same title, but in a different medium, usually

implies a self-conscious desire to draw attention to their status *as* an adaptation. Adaptation studies has spent some time contemplating what is and what is not an adaptation and I feel it is unnecessary to replicate these points of view here, but rather to draw attention to Julie Sanders' succinct and useful definition of adaptations as 'reinterpretations of established texts in new generic contexts or [...] with relocations of [...] a source text's cultural and/or temporal setting, which may or may not involve a generic shift' (2015: 19).

Because of the fairly broad scope of the book in spanning the historical and the contemporary, it is difficult to identify one overarching critical theory or framework that can be used to analyse the play that gets adapted for the screen (recorded or live) or the film that is staged in the theatre. That is not to say that there hasn't been an awful lot written over the twentieth century about film's difference from the theatre as a dramatic medium. Susan Sontag's 1966 article, 'Film and theatre' from whence the quotation that started this chapter was drawn, was a definitive intervention into an ongoing critical debate about this issue. Sontag argued that many of the positions articulated in the debate depended on an essentialist view of each art form or were determined by a critic's need to assert cinema's individual identity by distinguishing it from theatre. She concluded that this meant that 'the history of cinema is often treated as the history of its emancipation from theatrical models' ([1966] 1994: 24). Again it is not my intention here to rehash these different viewpoints, as they have been ably dealt with in several edited collections, namely Cardullo's *Stage and Screen: Adaptation Theory from 1916 to 2000* (2012) and Knopf's *Theater and Cinema: A Comparative Anthology* (2005), and the reader is directed to these works to find relevant key works on the relationship between theatre and film. In particular, Cardullo's introduction offers a useful summary of the differences between them in terms of object, creator and audience, and lays some of the ground work for this book in calling for attention to be paid to how their relationship is affected by elements that are situated in a particular culture and/or time (2012: 1–17). Roger Manvell's 1979 *Theater and Film* also takes on board the difference in film adaptation of novels and plays and has a useful section on acting on stage on screen. However, it should be noted that both Manvell and the edited collections centre around the adaptation of plays to the screen, rather than adapting films to the stage or broadcasting live theatre to cinemas, and do little to move the discussion forward in terms of addressing a reconfigured media landscape or taking on board the increasing attention paid today in both film and theatre studies towards current processes of media convergence. A more recent work, Ingham's *Stage-Play and Screen-Play: The Intermediality of Theatre and Cinema* (2016) is more inclusive of these practices. Its stated aim is to provide 'a systematic attempt to map this stage drama–screen drama relationship across a spectrum of dramatic possibilities' (2016: 9). Ingham proposes a broad

continuum that takes on a range of intermedial exchanges between theatre and film and includes screen-to-stage adaptations and live casting as part of its remit. However, his adoption of intermediality as a critical framework to make sense of these stage–screen interactions means that his continuum goes beyond the practices of adaptation to encompass a whole spectrum of intermedial practice such as the representation of theatres on film and the use of screens on stage. Whilst intermediality is obviously a useful term in any investigation of stage–screen relations, because it refocuses attention on the operations of the media themselves, I contend that the specificity of adaptation between theatre and cinema is subsumed into this broader approach.

Centralizing performance and event

Consideration of performance is often elided in discussion of adaptation between stage and screen, with the stage treated as an adjunct of the page. This may seem surprising, with adaptation studies often claiming to move beyond the literary paradigms that have dominated the field (e.g. Leitch 2003; Cartmell and Whelehan 2010). One of the few critics to have looked more inclusively at adaptation is Linda Hutcheon who has asserted that 'theatre shares much with film as both are "showing" mediums that can use visual and sonic means to construct stories, which then can be performed by actors' (2006: 159). Hutcheon also provided the introduction for a collection of interviews and essays that consider the implications of live performance for adaptation (MacArthur et al. 2009), though this did not focus exclusively on film. Christine Geraghty has provided the most useful scholarship in this area so far with her monograph *Now a Major Motion Picture: Film Adaptations of Literature and Drama* (2007) and her chapter contribution to *Modern British Drama on Screen* (2013). The former makes a clear distinction between literature and drama as sources in adaptation and applies this understanding to a revelatory discussion of film adaptations of Tennessee Williams plays in terms of the reconfiguration of dramatic space and actors' performance styles. In the latter she applies the same principles to the screen adaptation of Ann Jellicoe's stage play *The Knack*, analysing how the 'theatrical origins of the film shaped some of its aesthetics' (2013: 121). Indeed, the entirety of Palmer and Bray's collection of essays, alongside their companion collection *Modern American Drama on Screen* (2016), provides useful models for examining screen adaptations of stage plays in terms of their shared identity as 'performance media' (2013: 8).

This book's emphasis on performance and participation in an event also owes a debt to Raymond Williams, who argued that a film drama and a stage drama can be conceived as a total performance based on the elements of speech, movement

and design they both share. Williams' argument depended on his willingness to investigate as he put it 'literary text and theatrical representation, not as separate entities, but as the unity which they are intended to become' (1991: 10). This deceptively simple assertion of the unity of written text and performance belies a long critical debate that can be traced as far back as Aristotle, who famously asserted that 'the Spectacle [...] is the least artistic of all the parts' (Aristotle and Cooper 1913: 27–28).

It is perhaps this inclination in favour of a text centred, anti-visual tradition in western culture, downplaying the significance of performance, that has contributed to a reluctance to discuss how it might function in relation to adaptation and leads to both novel and play as being understood as 'literature'. As Margaret Kidnie summarizes:

> If the identity of drama is not constructed as bridging two distinct media and what is essential to the work is limited to its text(s), then distinctions between drama and forms of literature such as the novel disappear.
>
> (2009: 21)

Therefore including aspects of the play as performance (from actors and acting to design, lighting to props and costume) in the scope of adaptation studies expands the framework of analysis. This then acknowledges that

> The performance has its own aesthetic identity, separate from the play. Plays can be the focus of a theater event, with every conscious choice corresponding exactly to, and informed by, a well thought-out interpretation of the play, but they can also be used merely to facilitate theatre events.
>
> (Osipovich 2006: 462–63)

The relationship between text and performance in the theatre is also paralleled by film's relationship with the screenplay, although the latter is rarely treated as 'literature' in the same way as a play. Indeed, Boozer (2008) and Sherry (2016) have both called for a re-consideration of the screenplay as a 'source' in its own right and a key determining factor in the adaptation process. The privileging of the artefact in adaptation studies can be detected in Brian McFarlane's explanation for *not* looking at theatrical adaptation in his 1996 *Introduction to the Theory of Adaptation*: 'That novel and film both exist as texts, as documents, in the way that a stage performance does not, means that both are amenable to close sustained study' (1996: 202). McFarlane's formulation here is revealing, because of what he assumes analysis of adaptations necessarily involves, i.e. a tangible 'thing' in

which textual authority is invested and that allows an empirical comparison. As Dicecco persuasively argues, this

> draws attention to the pitfalls of treating the logic of the archive as the interpretative default. The notion of one idealised text [...] reveals a bias in favour of the written document [and thus] drama presents a distinct challenge to formal/ ontological models of adaptation because the test of authenticity appears to operate according to different rules from those best suited to the novel/ film paradigm.
>
> (2017: 617)

Rather than shy away from performance then because it doesn't easily fit into established adaptation frameworks, this study understands this as an opportunity to question those paradigms. For instance, a concern with 'sources' and their relationship to the adapted work have characterized the field since its inception as a scholarly practice. Approaches to the adaptation that centralize consideration of fidelity have long been challenged, with Leitch, in particular, calling for an upheaval to this type of criticism not least because 'adaptations will always reveal their sources' superiority because whatever their faults, the source texts will always be better at being themselves' (2003: 161). However, theatrical performance complicates Leitch's argument here because the 'selves' of performance are determined by ever-shifting parameters. Indeed performance has in itself been described as an adaptation by Hutcheon (2006), MacArthur et al. (2009) and Babbage (2017) to name a few, because of the way that it transfers the drama from one medium (written expression) to another (theatrical expression). Kidnie refutes this approach as she argues it removes all meaning from the term 'adaptation'. She argues for a definition of adaptation that doesn't distinguish between text as source and second-order performance but uses the term 'work' to understand the relationship of text and performance (2009: 28).

This is a useful conceptual approach in terms of my study, in that it understands the work in terms of both a textual and performance identity and it is these material aspects of the latter (that can be detected in the play text but can be variably inflected in the performance) that I propose have been overlooked by only thinking of, for instance, how a text might be adapted for the screen. This is particularly true when it comes to accounting for the work of actors and how they make meaning on stage and on film. The differences between acting on stage and acting on screen have been discussed by Braudy (2005) and Baron and Carnicke (2008), but they haven't been triangulated into an examination of how the actor mediates performance in the adapted work, something that would simply not be possible to identify by just reading the play or the screenplay.[6]

Discussions of actors' contributions highlight how consideration of perform-ance offers not just an (re)-examination of contemporary practices but can reframe historicized analyses of adaptations between stage and screen, within a specific national culture. Christine Geraghty has called for a re-evaluation of British cinema and literary adaptation, arguing that

> accepting adaptation as normal, particularly in a screen culture marked by con-vergence and intertextuality, helps us to stop using the fact of adaptation as a means of evaluation whereby a film (and a national cinema) are automatically dismissed as derivative or welcomed as classic.
>
> (2019: 155)

Whilst calling for adaptation in British cinema to be seen more in terms of 'exchanges between media' (2019: 152), Geraghty still includes plays under the category of literary adaptation. The advantage of my approach is that by uncoup-ling stage sources from literary sources, issues around performance can be brought into view and discussion can be reframed in terms of a dynamic exchange of prac-tice across stage and screen within what might be termed British performance cul-tures. Furthermore, if we see the exchange as being orientated towards practice, we can also think how it operates not just from stage to screen but also from screen to stage. Geraghty is right to call out the prejudice which is often embedded in value-driven judgements about the 'dependence' of British cinema on adaptation and she also challenges the assumptions about the verbal vs. visual communicative properties of film that these dismissals often rely on (2019: 151). But it must not be forgotten that words and dialogue in film are often inextricably bound up in performance: how words are spoken by the actor, how they combine not just with *mise en scène* but with the bodies and gestures of performers. So as we shall see in Chapter 4, a reliance on dialogue often means a reliance on how actors deliver that dialogue; the nuances that are conveyed in performance.

Discussions of actors' agency here points to the clearly challenging methodo-logical issues in approaching stage–screen adaptations through the prism of per-formance. Merely inverting the object of study into performance instead of text runs the risk of a theoretical cul-de-sac which either 'shatter[s] that object into an infinite number of performances, or make[s] it self-identical with an individual performance' (Kidnie 2009: 104). Investigating questions that involve live per-formance will always involve difficult issues of access and epistemology for the researcher. In terms of the former, more often than not, the material as performance will simply not be available for the researcher to view when needed. In terms of the latter, every performance as Peggy Phelan argued is unique: different audiences will respond to different things and actors will react in kind (1993: 146).[7] There

may be different kinds of mediated and non-mediated records of a production more generally – the script, reviews, director's notes – but this all relates differentially to the actual performance. Of course, a performance can also be filmed but when the object of study is thinking about transitions between stage and screen, to understand one of the elements as being presented through the medium it is hypothetically contrasted with somewhat defeats the object of study. On the other hand, advances in technology have in some cases actually collapsed the boundaries between performance and documentation so that in the case of NT Live, for instance, as Claire Read has argued, the performance *is* the documentation and vice versa (2014).

In terms of my approach then, as far as possible, I limited myself to working with case studies where I had actually seen a production and could think through how it related to the written text. However as, particularly in the second half, I wanted a historical reach to the stage–screen adaptations examined, I extended that condition to where I could access material that gave me an idea of what the play was like in performance. This led to prioritizing practitioners' accounts of their work and embedding their own ideas about adapting between stage and screen into the interpretative framework wherever possible. Practitioner accounts can be valuable, in that they often transcend disciplinary boundaries, which can be restrictive when approaching performance elements across stage and screen.

My overall aim with this book then is to critically examine adaptation between stage and screen as a cultural practice in a way that in the end validates Sontag's argument that the two media have always and will always share a dynamic and aesthetically beneficial relationship rather than being mutually exclusive. This critical examination takes on board a contemporary media landscape but also takes a longer view by reflecting on stage–screen adaptation as a practice informed by particular cultural and historical circumstances. It restates the importance of performance elements, the 'labor of theatrical agents of production' (Kidnie 2005: 5) in the move between stage to screen, screen to stage and theatre to cinema, and hopefully will inspire new generations of scholars and critics to re-examine this fascinating field of study.

NOTES

1. This book was in production as the COVID-19 crisis emerged, altering arts events in unprecedented ways. It is currently uncertain whether these productions will go ahead as planned.
2. The journal *Adaptation* (August 2014, 7:2) had a special issue entitled 'From Theatre to Screen – and Back Again!' (eds D. Cartmell and E. Parsons). The *Journal of Adaptation in Film and Performance* (July 2014, 7:2) had a dossier, 'Film Adaptation in the Post Cinematic

Era' (eds. Russell J. A. Kilbourn and P. Faubert), although this didn't look specifically at stage–screen adaptations. Scholarship in the developing area of transmedia studies is also relevant, particularly in thinking through definitions of media and the effects of specific media on narratives (Ryan 2014) with Zipfel discussing fictionality in film and theatre specifically (2014).

3. The uncoupling of film and cinema in the age of digital production and exhibition has led to debates amongst scholars, with Bruce Issacs in *The Orientation of Future Cinema: Technology, Aesthetics, Spectacle* going so far as to ask, '[i]s the image created out of digital code cinematic?' (2014: 24).

4. *Modern British Drama on Screen* (2013), edited by Palmer and Bray, is the exception here.

5. I am using the term 'British cinema', although this is clearly a problematic term when describing both contemporary and historical films. See Higson (2010: 5–11) for discussion of this.

6. Theatre studies and latterly film studies have demonstrated a sustained engagement with how the actor makes meaning in performance. Works across both fields such as Klevan's *Film Performance* (2005), Zarrilli's *Acting (Re)Considered* (2002) and Naremore's *Acting in the Cinema* (1988) are notable here, with Richard Dyer's influential work on stardom offering a cine-centred analysis of the actor as star (1997). However, because of the downplaying of performance in the adaptation matrix, I would argue that this work hasn't been drawn upon in any sustained way in adaptation studies.

7. Although this has since been rebutted by scholars such as Rebecca Schneider, who in her influential essay 'Performance remains' (2001) challenges Phelan's assertions of the ontology of performance and considers its place within archival culture.

PART ONE

PRACTICES

1

Stage-to-Screen Adaptation and Performance: Space, Design, Acting, Sound

Most novels are irreversibly damaged by being dramatized as they were written without any kind of performance in mind at all, whereas for plays visible performance is a constitutive part of their identity and translation from stage to screen changes their identity without actually destroying it.

(Jonathan Miller cited in Hutcheon 2006: 36)

This chapter offers a different approach to adaptations between stage and screen, one that accounts for the performance elements of the 'work' in its adaptation to the screen, such as the results of creative agency in acting and design. This is because an exclusive emphasis on in what way a written text is transferred to the screen would elide the question of, for instance, how a particular actor's star persona might affect the character as performed. Discussing performance brings into play what exactly is being discussed in the comparative frame as 'performance' can be defined as both

> a one-off experience (an experience for which one, usually, pays money), and 'performance' as a term able to frame any number of such unique experiences as generically related in terms of the physical activity and audience-actor dynamic to which they give rise.
>
> (Kidnie 2005: 105)

As we have seen Kidnie's work is applicable here because it seeks to uncover the antitheatrical bias in adaptation studies or what she terms 'the ideology of print' that seeks to cordon off plays from their performances, or at least attribute to the latter a second-order status. This then leads to 'acculturated reading strategies founded on

the text as literary object', which can obscure aspects of performance that the stage and screen have in common (Kidnie 2009: 104). This is not to say that the text only exists in performance, as Levin has identified because then 'there would be no independent "reality" apart from the performance that could be understood' (1986: 548). What does exist of the performance, and can to a certain extent be referred to in terms of a material object, is a 'production'. As Osipovich argues, 'a production is a series of acting, blocking and design choices that are rehearsed until the run of the show is set' (2006: 464). Whilst each performance will have a unique quality that will be difficult to quantify, detailing these features 'will still be vital for putting into context the unique character of every performance' (2006: 464). The three features that Osipovich identifies will be the focus of this chapter although I will extend the analysis to include sound and music as both theatre and film often use aural elements to complement their visual means of communication. I do not deny the presence of the written text as this is one aspect of the 'work' as Kidnie would describe it, but neither do I allow the slipperiness of identifying the performance to preclude analysis of those qualities that are bound up with the written text but exist outside of it as well.

The first section of this chapter will examine the opening of stage and screen versions of Bola Agbaje's British comedy *Gone Too Far* (2008/2013), firstly according to comparisons of space, time and structure, which is traditionally how stage-to-screen adaptations have been analysed (Bazin 1967; Manvell 1979; Davies 1990), but then extending the analysis to consider one crucial aspect of performance and how it is configured in the adaptation. Turning to August Wilson's *Fences* (1987), I will examine how the stage design in various productions has been referenced in the film and look at how its function in the play is taken up by the *mise en scène* of a key sequence. This will be contrasted by looking at adaptations of Samuel Beckett's *Play* (1966), which, because of the abstract nature of the space as conceived for the stage, raises certain challenges in its transfer to the screen. The next section will consider issues of acting and performance and the implications of the contribution of star discourses for fundamentally altering adaptations in their transition to the screen. Bill Naughton's stage play *Alfie* (1963) will be examined for how the central character has been played across stage and screen. Finally, I will argue that sound has traditionally been overlooked in adaptation studies but that it often marks a key element of the negotiation of affect in the transition from stage to screen production. This will be discussed in reference to films where scores/sound effects are added in the film adaptation to convey character or theme. I will examine theatre and film versions of *Amadeus* (1979) and look at the integration of visual and aural elements in stage and screen versions of Tennessee Williams' *A Streetcar Named Desire* (1947).

Cardullo contends that analysis of stage-to-screen adaptations needs to consider how the film translates the theatre play's structure and its utilization of time and space (2012). As Bazin argued, 'there can be no theatre without architecture'

indicating that space for performance is organized in terms of the area/s for the actors, for the audience and optionally a setting for the dramatic action. He maintained that the consequences of this organization of theatrical space render the stage a 'privileged spot removed from everyday experience which renders significant any object or action that appears on it' (1967: 44). Davies argues that these elements of engagement with the space fundamentally change with the film and its audience calling it 'a collusion with the cinematic medium – not with the director, designers and actors who present the dramatic work' (1990: 6). With film the action is not bounded within a demarcated space but rather parts of it are captured; the audience must believe that reality goes on beyond what can be seen because, 'the screen is not a frame like a picture but a mask which allows only part of the action to be seen' (Bazin 1971: 105). The spectator of film can be put into a different relationship with the action depending on how that action is framed by the camera, and the variety of viewing positions available to the audience of the play in the theatre is denied by the fixed perspective of the camera.

Closely related to different organizations of space are theatre and film's treatment of time. Just as film can offer different perspectives on the action from close up to long shot and is not bound to one continuous use of space, it is also not restricted to the continuous and sequential time marked by the duration of a play. As Cardullo identifies, the realization that whilst 'on the stage, an actor crossing a room has to cross it step by step; on the screen, he can come in at the door and immediately be at the other side of the room' was a key moment in the development of cinematic technique (2012: 25). Editing, both visually and sonically, can link two different times together, such as the move across two decades in *Citizen Kane* (1941) between Thatcher's words 'Merry Christmas' and 'a Happy New Year', which enables Kane to move sequentially in the drama from a child to a young man. Structurally, the play and film are also different with the shot being the key component of cinematic structure, against the scene, or more precisely as Cardullo contends, the 'theatrical "beat" within the scene that introduces or resolves conflict' (2012: 27).

Anthony Davies argues therefore that for adapters working on translating material from stage to screen, there are two strategies available to them. They can either

> decide to treat dramatic action with the object of preserving its theatrical essence as far as possible by simply photographing the staged performance on the stage space [or] effect an entire visual transformation by moving the action from the confines of the theatrical enclosure and [create] new relationships between the actor and décor, between space and time and between the dramatic presentation and the audience.
>
> (1990: 9)

Although Davies is rather binary in his arguments here (plays adapted for the screen might contain both a proscenium arch framing and a more mobile use of camera and that does not make them any less 'cinematic') his formulation offers a framework for thinking through how time, space and structure are adapted between theatre and film.

This can be demonstrated by an analysis of the opening of Bola Agbaje's *Gone Too Far*, originally performed at the Royal Court Upstairs in 2007 and then adapted for the screen in 2013 by Agbaje and directed by Destiny Ekaragha. The play is about the conflict between two brothers, one British born and one who has just returned from living in Nigeria. It entertainingly dismantles the idea of a homogenous black 'community' showing characters whose sense of identity is contingent on how they relate to ideas of indigeneity and the diaspora. The Court's production of the play had a simple set consisting of black drapes and props to help delineate particular places, such as the newsagents where the characters go to try and buy some milk. The Court production also interspersed the scenes with dance sequences where performers moved around the stage to a grime soundtrack to give a more abstract sense of youthful energy beyond the action of the play. The film on the other hand takes great pains to set the action on the streets and estates where the play was ostensibly set. The writer of both the play and screenplay emphasized how the South London setting was a key factor in the transfer of the play to the screen:

> When I transferred it into a film all I needed to do was transfer it back into the setting that it originally came from [...]. It was important to put that world on the screen – to make that world interesting because we wanted to put Peckham on the screen but in a really good light.
>
> (Into Film Clubs 2015: n.pag.)

This 'opening out' is a common strategy of many stage-to-screen adaptations, as they connect with a world that is implied or referred to by the play but can be realized more effectively by using a photographic medium. In other words, as Palmer and Bray note, 'the film medium possesses the ability to deepen the sense in which dramatic presentation depends on the interaction of characters with a world we can recognize fully as our own' (2013: 10). The play's first scene is set in Yemi's bedroom, where the two brothers are unhappily sharing an obviously limited space. They are there to do squats administered as punishment by their mum, who is heard offstage admonishing them when their arguing gets too loud. Through the dialogue the differences between the two brothers, one born in Brixton and one born in Nigeria, one speaking English and the other Yoruba, starts to emerge.

The film on the other hand starts with a pan round a typical south London street scene and then follows a young man on a bike as he weaves his way through the connecting roads (including one showing a recognizably London red bus with the destination 'Peckham' on it). The film's credits are written across the images in a jaunty, coloured font and there is an upbeat extra-diegetic soundtrack. The music then becomes diegetic and the audience move through exterior doors into a local radio station booth with a DJ speaking over the music, before cutting to Yemi's bedroom as he listens to the broadcast whilst practising his chat-up lines directly to camera. There follows a short scene where Yemi's mum buys okra from a street market and tells the trader how excited she is that she is going to see her son from Nigeria. The scene then moves to the football field, where Yemi plays with his friends and chats to Armani, the object of his affections, before being interrupted by his mum who hauls him away to meet his brother just off the plane. Therefore the whole sequence cuts together a number of different locales to give a spatially coherent sense of the inner city in which the characters exist. Yemi is shown interacting with the places that make up his daily life, which makes him more clearly the protagonist in the narrative, whereas in the play both brothers have equal weight in terms of their story as the play begins with them sharing the same space. In contrast to the clearly delineated time frame of the opening of the play, the film is much less specific and flexible, juxtaposing different events (the mum shopping and the football game) and moving between concurrent presents (the DJ's patter and Yemi listening to the broadcast in his bedroom). Structurally the beginning of the play is organized around the dialogue between the two brothers with interventions from the mum offstage, which begin to hint at the themes of identity, culture and belonging, whereas the beginning of the film is taken up with action establishing the main protagonist visually and sonically in his social environment before the disequilibrium represented by the arrival of Ikudayisi.

However, I would like to look now at a crucial bit of information that is communicated through costume in the play and then is adapted to the film, using *mise en scène*, editing and sound. In the Royal Court production of the first scene there is a bare stage with a few suitcases strewn about the floor, containing a mixture of African and Western clothes visible to the audience, alongside the PlayStation that marks the typical British teenager's bedroom (and to which Yemi keeps returning in defiance of his mum's punishment). Ikudayisi in the scene is dressed in clothes that are a bit dated in contrast to Yemi who is dressed in more up-to-date fashionable sportswear. This gives the audience a subtle visual signifier of the culture clash that is significant thematically for the rest of the play. This metaphorical use of costume is emphasized in the final scene when we return to Yemi's bedroom. Ikudayisi has discarded the pseudo western clothes made fun of by Yemi and is dressed in traditional African clothing whilst Yemi is trying to put on an agbada

(West African shirt), visually signalling that through the events of the narrative both brothers are coming to terms with what bonds them together; namely family and their shared Nigerian heritage.

However, in the film, where costume does not always carry such metaphoric significance, the introduction of Ikudayisi is constructed audio-visually in such a way as to draw attention to his clothes. Yemi and his mum are walking down the street when they realize that Ikudayisi has arrived. We see a pavement-level shot of a car door opening in slow motion and then cut to Yemi's expectant face, before cutting to a close up of a foot encased in an unfashionable sock and sandal emerging from behind the car door. We then see Yemi looking worried at what's coming next before cutting back to the whole figure of Ikudayisi emerging in slow motion from the car. He is dressed in jeans and a cheap looking fake leather brown jacket, with a gold ring on his finger and a chunky looking watch on his wrist, made noticeable to the audience through the deployment of a cut away from the main action. We cut back to Yemi looking even more alarmed and the Afrobeat music accompanying Ikudayisi's exit from the car is abruptly brought to a halt as if a needle had been swiftly taken off a vinyl record and the action is brought back to normal speed. In a similar way to the play, the signifying power of clothes is used to mark the brothers' fundamental cultural difference but in the film the sequence is constructed in such a way to highlight Ikudayisi's clothing as significant and make the sequence more amusing, aligning the spectator with Yemi's appalled viewpoint at his brother's unfashionable clothing and marking Ikudayisi more clearly as the 'outsider'.

A comparable use of *mise en scène* to find a way to communicate a key aspect of production design is evidenced by the film adaptation of August Wilson's play *Fences* (2016). In a similar strategy to *Gone Too Far*, the action begins outside of the place where the action in the play starts. The protagonist Troy (Denzel Washington) and his friend Bono (Stephen McKinley Henderson) are shown riding on the back of a garbage truck that trundles its way through the streets of the suburbs of an American town in the 1950s. This brings some movement into the frame (like the bicycle in the previous example) and allows the characters to plausibly move through their social environment, to set their conversations in context. The film then moves to the front-yard of Troy's house, as per the stage play, as the after-work chat and drinking begins. The film switches between inside and outside the house, as well as the street in front of the house, but most of the significant scenes take place, as in the play, in the yard. This was noted by the critics who generally berated the film for failing to disguise its theatrical origins, with *The Guardian* noting 'the aesthetic is still inescapably stagy. Vestiges of greasepaint are everywhere, from the carefully assembled period props to the entrances and exits' (Shoard 2016: n. pag.). As the reviewer implies, too much careful 'selection' in the look of a film

can appear to undermine its claims to be set in a 'real' environment. In the theatre, 'effective theatre design is essentially the architectural manifestation of the psychological dynamics which operate in the total experience of theatre' (Davies 1990: 7) whereas in most realist films, design shouldn't be too 'noticeable' (Ede 2010: 23).

The necessity of the set design to communicate the 'psychological dynamics' of the play is fundamental to Wilson's play *Fences*. The play was first produced in 1985 at the Yale Repertory Theater, directed by Lloyd Richards and then opened on Broadway at the 46th Street Theater on 26 March 1987. It won the Pulitzer Prize for Drama in 1988 and has been frequently revived since then, most notably in the United Kingdom in 2012, in a production with Lenny Henry in the central role of Troy Maxson. Set at the end of the 1950s, the play explores how Troy's life experience is shaped implicitly and explicitly by his conflicted Afro American identity in a pre-Civil Rights movement America. The play is set in the suburbs of Pittsburgh in 1957, in the ramshackle house Troy shares with his wife Rose and son Corey. Events happen off stage that affect the fate of the characters in the drama but are all played out in the same location, the porch and yard of the house. Key in the design, as the title suggests, is the fence that gets slowly built around the house as the action progresses. As the character of Bono says in the play, 'Some people build fences to keep people out and other people build fences to keep people in', and the poignancy of the last scene, after Troy has died, is that the fence that Troy never quite gets round to building throughout the play has been finished. Whilst all designs have to include the fence, most have shown a typical American porch and garden in various states of dilapidation, alluding to the Maxson family's impoverished status. A designer for a production at the Pacific Conservatory Theatre in 2017 mentions trying to incorporate both 'the gritty truth and poetic blues-scape of the Maxson family household which consists of an ancient two-story brick house in a dirt yard in the hill district of Pittsburgh in 1957' (PCPA n.d.: n.pag.). The design for the original Washington/Davies stage production in New York in 2010 added a tree at the centre of the backyard because it 'signified and concretized crucial themes of forgiveness, redemption and renewal that Wilson investigates throughout *Fences*' (Wooden 2011: 124). These design ideas emphasize both the pragmatic and the poetic functions of the setting in the theatre: to enable audiences to understand the specifics of place in which the play is set but also the more universal questions about human experience that the play investigates.

The film adaptation was initiated in 1989 with Wilson appointed to write the screenplay for Paramount but the playwright refused to let his screenplay go into production without a black director, writing in 1990 that in cinema, 'whites have set themselves up as custodians of our experience' (Shoard 2016: n.pag.). It was stalled for some time until after Wilson's death when Denzel Washington took on the project as director and lead actor, having previously played the part on Broadway

in 2010. Many of the same cast, including Viola Davis as Troy's wife Rose, made the transition from this production to the film. The design for the film follows the play faithfully in recreating the yard, although it's a back yard rather than a front porch and yard, and has a tree in the centre that Troy uses to hang his baseball bat on. However, the wooden fence exists with a number of other wire fences, which surround the property and are seen in the background as the main characters talk. This means, as one critic identified, that the building of the fence loses its central symbolic significance. 'There's a literal fence at the center of *Fences,* but it doesn't resonate onscreen the way it does onstage. It's not a living metaphor' (Edelstein 2016: n.pag.). If design then cannot function in the same way as metaphor, how else does Washington invoke the metaphysical significance of Troy's situation? One scene towards the end of the film is notable in this respect because unlike most of the rest of the film that almost replaces the proscenium arch with the frame of the screen, it breaks this 'fourth wall'. After settling a fight with his son Corey, Troy grabs the baseball bat and looks wildly around him, shouting, 'come and get me', directly to the camera. This has the effect of boxing Troy in, whilst his gaze is directed out beyond the frame, which operates as

> not only a gesture towards what is outside the film fiction (we, the viewer, the material act of filming and so on) but also as a potentially rich metaphor for the problems of vision (insight, foresight, other kinds of perceptiveness) that are often the internal currency of movie narratives.
>
> (Brown 2012: xii)

The particular construction of this shot operates as a filmic equivalence to the metaphorical aspects of design and directs our attention towards the broader significance of Troy's situation. He is physically constricted by the frame and looks beyond it into the unknown which he addresses as the Devil. As his wife Rose says earlier in both the play and the film, 'Anything you don't understand, you call the Devil'. The lack of 'seeing' implicit in breaking the fourth wall thus communicates the 'problems of vision' that characterizes Troy's actions in the narrative and ultimately leads to his demise. The camera's perspective is emphasized as it then sweeps up into a god's eye view, as Troy follows the camera by looking upwards, making him ever more smaller and insignificant compared to his surroundings. It is also of course a perspective that could never be achieved in the theatre by placing the spectator above the action, and giving them an omnipotent perspective on the scene. Again, this change in the relationship between spectator and space effects a more contemplative attitude to what is being viewed, seeing Troy as not just an individual, but representative of a broader social environment, where a person's fate is clearly shaped by subtle but all pervasive prejudice and racism.

Whilst the models described above reflect the fact that both stage and screen versions aim to point to recognizable places albeit through different representational means, what happens when the space referred to is more abstract and this abstractness is integral to the dramaturgical workings of performance? Two film adaptations of Beckett's 1963 *Play* can be compared to identify how the performance space, resistant to representation, has been adapted to the essentially representative world of the screen.

> Beckett's theatre is thus not about something, not a simulation of a known world; the image or images of the artistic creation are not images of something outside the work; they are 'that something itself', as he famously quipped in 1929 in reference to James Joyce's then titled 'Work in Progress'.
>
> (Gontarski 2015: 130)

Play was written in English in late 1962 and first performed in German as *Spiel* in June 1963. Its first British performance was by the National Theatre Company at the Old Vic Theatre, London, on 7 April 1964, produced by George Devine. The play has three figures, one man, two women, trapped in urns, speaking rapidly about a love triangle they are all involved in. A significant aspect of the play in performance is the spotlight that shines on each of them as they talk and switches rapidly between the figures as they speak. Beckett's own notes on staging indicate the importance of this spotlight and specific instructions for how it should function, noting that there should only be one spotlight and it needs to occupy the same stage space as its 'victims', preferably placing it in the centre of the footlights so the faces are lit from below. In the rare moments that all three faces need to be illuminated it should 'be as a single spot branching into three'. Otherwise Beckett directs that, 'a single mobile spot should be used, swivelling at maximum speed from one face to another as required' (Beckett 2009).

The light then is used to bring the voices into being and frame the rather banal story being played out. It works as a meta-theatrical device by seeming to compel the bodies on stage to speak when their figure is illuminated by it. The actors behave mechanically as the spotlight falls on them; they regurgitate their monologues in an endlessly repetitive cycle. The use of the spotlight directs attention onto the medium itself rather than the plot, parodying the conventions of theatrical performance.

> Whatever sympathy the audience feels for the characters comes not from the story they tell, which is undercut with humour, but from their existential predicament, which is the condition of the actor forced to repeat a lame story over and over for an audience whose benevolence is questionable at best.
>
> (Gatten 2009: 97)

The function of this spotlight is central to the dramaturgical workings of *Play* and so obviously offers both semiotic and technical challenges when adapting this piece to film. As director Anthony Minghella pointed out, when engaged in this task for the *Beckett on Film* series in 2001, the challenge is to find a 'cinematic correlative' for the light 'otherwise the only alternative is to lock off the camera and record a live performance. You can't have a light moving and a camera moving – one has to be still' (quoted in Herren 2009: 19). Minghella's answer was to let the camera do the work of the light and communicate the materiality of the medium through making the camera an active, visible and audible participant in the drama. The opening image shows the play's title in white against a grey background whilst scratchy, static noises can be heard on the soundtrack. This then cuts to a section of film leader, with the numbers counting down, usually hidden when a film is projected as it's a guide for the speed the projector should run the film. We then hear the mumble of voices, before fading up on what looks like the surface of the moon, clearly meant to be a sort of no man's land. This then shears into an empty frame with 'hairs' in the gate, again denoting the materiality of the medium on which the drama is recorded, and the cinematic equivalent of an empty space, before jump cutting back again onto the three figures in the urns in the moonscape setting. This makes the audience aware, in a similar way to its use in Godard's *Breathless* (1959), of the presence of the editing in the construction of the piece. The film strip then speeds up and cuts between three quick close ups of one of the figures in the urn (Kristin Scott Thomas) in the middle of her speech. The light is uniform throughout and it is therefore the camera, rather than the light, that acts as a predatory figure here, swivelling between the figures and focusing and refocusing on the faces, before jump cutting to another figure as they begin to speak. However dizzying the moving camera work though, the essential conceit of the play is lost because cinematic convention determines that the camera frame will cut to a figure speaking. The idea that the camera movement, and by extension the medium of film, prompts the figure to speak does not come across with the same clarity as the operation of the spotlight on stage.

There is also an earlier adaptation of *Play* in 1966 made by director Marin Karmitz in collaboration with Beckett himself. Karmitz and Beckett had a different solution to the issue of adapting light by showing all the faces lit up against a background of black screen. This maintains the abstraction of the play but stabilizes the light so the camera can move, showing the faces in long shot, close up and occasionally two shots. Herren argues that this still weakens the 'ontological principle that light=activation, that light essentially constitutes being on stage and must always be answered with a response from character' because each character can choose to remain silent under the camera's eye (2009: 21). This

therefore fundamentally undermines 'the obligation to express that the utilisation of the spotlight on stage communicates to the audience' (Beckett 2009). Does this then make this Beckett play ultimately unfilmable? Returning to Bazin here is instructive because of how he refused the split between written text and its setting and performance, arguing that 'a play [...] is unassailably protected by the text' and that the 'mode and style of production [...] are already embodied in the text' (Bazin 1967: 84). It would seem as if it would be impossible to adapt this stage play to film because the mechanics of live performance are integral to the work.

However, one aspect of the play's performance that can be inflected across stage and screen versions of the work is the actor's playing of character. The labour of the actor in embodying characters has arguably been neglected by adaptation studies. One of the few scholars to have paid it attention is Christine Geraghty, who has argued that one of the key pleasures of classic literary adaptation is the re-materialization of literary language into specific embodiments by particular actors (2002: 42). Yet in the transition from stage to screen, there are already bodily and vocal incarnations of these characters by actors. Sometimes the same actor will play the part on screen that they played on stage, such as Marlon Brando's iconic performance of Stanley Kowalski in *A Streetcar Named Desire* (1948 and 1952). Sometimes, different actors will be brought on to projects because they have a particular star appeal or they can draw on a star persona garnered from their other film appearances, to inflect the character with particular meaning. In *Streetcar* for instance, Vivien Leigh replaced Jessica Tandy as Blanche, partly because the film needed a known star in the role, but also to draw on associations with her most famous film role, that of southern belle, Scarlett O'Hara in *Gone with the Wind* (1939). Often adaptations of stage plays will only get made because of stars agreeing to appear in them, to enable a wider audience than those who might have seen the play in the theatre. The agreement is mutually beneficial as stars can make their name in films and then use their appearance in film adaptations of plays to increase their cultural capital, such as Dustin Hoffman in the film version of Arthur Miller's *Death of a Salesman* (1985).

Yet the actor or star does not figure in much thinking about adaptation either in terms of how an actor's performance might mediate a 'known' character through nuances of gesture or voice or indeed how a star persona might engage productively or antagonistically with that character. Both Linda Hutcheon and Christine Geraghty have called for adaptation scholars to think more expansively about actors as agents in the adaptive process, with Geraghty claiming that adaptations 'not only present different actors in the same role but also present acting in a different way' as they call attention to a gap between the character as originally constructed and its embodiment on screen (2007: 11). Hutcheon raises the question of 'embodied performance': unlike characters in books, characters in stage and screen plays are presented to audiences through the bodies and voices of actors who play

them and this demands analysis about the relationships between role, actor and star image (2006: 38). This section will consider these issues by looking at stage and screen versions of Bill Naughton's *Alfie* (excluding Alan Price in the sequel *Alfie Darling* in 1975, as it tells a different story). I will argue that by taking into account the character of Alfie in the first radio and stage versions and comparing it with the star personas of each actor in the film roles (Michael Caine, Jude Law), the character of Alfie is significantly changed. The original Alfie was described in 1962 as 'that dreadful little lorry driver' (Crossman 1962: 22). Caine's screen interpretation of the role in 1966 drew upon the public construction of the actor's star image in the mid-1960s as aligned with the values of the ascendant, young urban working classes and the film then helped to shape Caine's subsequent brand of 'blokeish' charisma. However, Law's screen articulation in 2004 drew upon his more ambiguously positioned, metrosexual star persona to enable the film to articulate its concerns with post-millennial masculinity in crisis.

Alfie was initially a radio play, first broadcast on the BBC's Third Programme in a production by Douglas Cleverdon on 7 January 1962 between 9.10 p.m. and 10.25 p.m. and subsequently repeated twice on 3 February at 6.30 p.m. and 11 September at 8 p.m., because it was so popular with listeners (Aldgate 1995: 106). It was written by Bill Naughton, a working-class writer from Salford. The radio play, entitled *Alfie Elkins and His Little Life*, had just two characters, a northern narrator and the Cockney sounding Alfie speaking directly to the audience. The play spanned two decades from the end of the Second World War to the late 1950s. The main character goes from one 'bird to the other' with a grim sense of determined hedonism, rejecting anything or anyone that might touch him too deeply. The part was played by Bill Owen (later known as Compo in *Last of the Summer Wine*) who was older (48) at the time of the broadcast than the character as written would suggest, but obviously being radio there was less dependence on visual appearance (Archive.org n.d.: n.pag.).

Naughton then turned his work into a stage play, first performed at the Mermaid Theatre on 19 June 1963 (it subsequently transferred to the Duchess Theatre) with John Neville in the title role. Neville was a theatre actor who had found matinee-idol success early in his career in the roles of *Hamlet* and *Richard II* in the 1950s. His performance, changing the lorry driver to a London wide-boy, was described by the critic Harold Hobson as 'the highlight of his career' (cited in Coveney 2011):

> John Neville imbues this cynical egotist with the easy meretricious charm that is Alfie's stock in trade. He handles with great skill that ticklish scene when it dawns on his mind that fatherhood is an experience at once desirable and out of his world.
>
> (Darlington 1963: 16)

The stage version expanded the radio play to actually show the women in Alfie's life but retained the direct address to the audience. Breaking the fourth wall was a distinctive feature of each adaptation and had different implications with the change in medium. The radio medium emphasized the intimacy that direct address engenders, the feeling that one person is confiding in you their individual thoughts and feelings. In the theatre, a more public space, this technique is a device by which the play is able to comment on its leading character. By taking the audience into his confidence, the gap between Alfie's self-presentation and the audience's knowledge of him through witnessing his actions on stage becomes ever wider.

The play transferred to Broadway the following year, with Terence Stamp (fresh from his breakthrough film role of Billy Budd) playing the lead. Whilst the play in London was a success, its Broadway incarnation was not. In his autobiography Stamp describes how delighted he was to play the role and as an East End native, with a glamorous model girlfriend in Jean Shrimpton, he would have seemed to have been ideal casting for the role. The play opened in New York's Morocco Theater on 17 December 1964, after playing to good audiences in provincial theatres, but the production played for only 21 performances. Stamp blamed a devout Catholic critic for a damning review that would have doomed any play that depicted abortion to failure (1989: 147). Shrimpton however claimed that the audience was just bemused:

> [T]hey didn't understand cockney rhyming slang – in fact they did not understand the play at all. Terry was dynamic enough but this near monologue from him in an East End accent was baffling the audience. It seemed to me it was not going to work and it didn't. The applause at the end was polite and the critics delivered their coup de grace the next morning.
>
> (Shrimpton and Hall 1990: 127)

Bill Naughton also wrote the screenplay for the film adaptation in 1966, following the play relatively faithfully. It was a comparatively big budget production, financed by Paramount and designed to showcase Swinging London for American audiences, where it was, according to Alexander Walker, aggressively marketed (2005: 95). In an echo of the failure of Stamp's authentic East End accent to appeal to American audiences, Geoffrey Macnab claimed that Caine had to re-loop his dialogue to make his speaking clearer for the American market (Macnab 2000: 205). Caine was brought in to play the part after it had been originally offered to Stamp, who was his former flatmate. Stamp declined it after his failure in the role on Broadway and Caine recalls in his autobiography that he spent many

hours remonstrating with Stamp to do the film role, to no avail (1993: 180). Caine himself at this point had actually failed an audition to replace John Neville in the stage version and was under contract to Harry Saltzman at the time after a minor but significant role in *Zulu* in 1964 and his starring role as the anti-Bond Harry Palmer in *The Ipcress File* in 1965. With the resources from the Bond films at his disposal, Saltzman was intent on making Caine a star and *Alfie* was the vehicle by which this was to be achieved, supported by an increase in the circulation of stories about Caine's wild off-screen life and iconic photos of Caine in sharp suits and trademark glasses. Christine Gledhill has suggested that 'stardom proper arises when the off-stage or off-screen life of the actor becomes as important as the performed role in the production of a semi-autonomous persona or image, a development which depends on mass circulation journalism or photography' (1991: 192). This is evidenced by the extratextual information circulating around Caine at the time. The film's original poster demonstrates an elision of character and star with the strapline, 'Caine IS Alfie'. In his biography, Caine claims that at this time he was fully aware of building his public image and giving newspaper editors something to write about, so he made sure that all the interviews 'were about birds' leading to a swathe of articles in the popular press with titles such as 'The bird man of Grosvenor Square' (Caine 1993: 187). Therefore the original character of Alfie, whose character deficiencies are gradually revealed to the audience, becomes invested with the qualities of Caine's star persona. This has implications for the overall drama as Alfie's intensive womanizing is reworked to seem admirable for audiences rather than misogynistic or self-destructive. For American audiences, in particular, Caine was also being sold as the living embodiment of the social changes brought about by the mid-1960s consumer and post-war baby boom and became emblematic of the apparent breakdown in class divisions exemplified by Swinging London. An article in *American Esquire* that was intended to launch Caine as a star in the United States claimed that his working-class London roots made him a new kind of British star:

> No one exemplifies this transformation better than Caine [...] he established his reputation not only as an actor but as an emblem of the new Britain and currently he is the most fashionable example of the crumbling of old class prejudice.
> (Lawrenson 1966: 32)

Alfie was a transatlantic box office success, being the second highest grossing film at the UK box office after *Thunderball* and making $10 million in the United States. However, the film didn't meet universal critical acclaim, with several reviewers noticing the difference between the original play and the screen adaptation.

Bill Naughton's funny, touching and sad little character study has suffered the ultimate metamorphosis. Drenched in garish Technicolour, stretched into Techniscope and fitted with a pop theme tune, it has made *Alfie* a modish anti-hero inside whose thick skin the original play can occasionally be heard struggling to get out.

(Anon. 1966: n.pag.)

This review points to a tension between a character whose actions the narrative demands we should question and the star who we are asked to admire for his freewheeling brazen sexual confidence. There is therefore a certain distance between the star who remains visually and sexually powerful and the character who is subjected to the effects of the narrative that demand he should pay some sort of penalty for his sexual and social transgressions. This tension is compounded by the retention of the play's direct address to the audience, so that Caine as Alfie is the on-screen narrator of his own story, inviting the audience's collusion with his view of events, whilst the other characters remain oblivious to Alfie's on-camera discourse. This direct audience address and Caine's throwaway ironic delivery of it render Alfie, as Jeffery Richards concluded, more of a 'role model than an object of condemnation' (1997: 163).

Yet whilst an examination of Caine's star persona would support this view, there are moments in the film when Caine's performance does show Alfie to be more sensitive than his brash exterior would suggest. Although events are shown without the audience gaining any access to the women's point of view, as the film progresses, it deliberately opens up a space between what Alfie says about his actions to the audience and what the film shows us of their effect. Caine's performance underpins this, particularly in the scene, when he returns to the flat, where Lily (Vivien Merchant) has had to go through a painful abortion after Alfie has got her pregnant. After entering the room he ignores Lily's tired plea not to enter into the side room, where the aborted foetus has been discarded. From his entrance into the room, Alfie's face is framed in close up and Caine shows him looking nervously around and then slowly approach the foetus. The camera stays on Alfie's face, without cutting away. Caine looks down and then up, with his face contorted by an expression of extreme anguish and tears come to his eyes as he realizes the implications of his actions. The fact that this is all shot in close up accentuates identification with the character at this moment and seems to give the audience privileged access to Alfie's inner anguish, albeit arguably more for himself than for his partner.[1] In the following scene, Alfie confides in his friend (Murray Melvin) about his attitude to the event rather than the audience, indicating that the direct address to camera presenting a

confident lothario is more of a performance and Alfie's masculinity is therefore more fragile than it appears. Therefore as Carson concludes:

> For all their representations of a male centred style centred exaltation of the classless consumerist self these films do not present the spectator with a uniform celebration of a male centred perspective.
>
> (Carson 1998: 58)

The equivalent scene in the play puts Alfie in a much more unsympathetic light. It is constructed differently as we see Alfie with Lily after the abortion before Alfie leaves her to get some air and then narrates directly to the audience how he went back to the flat and accidentally sees the aborted foetus. The fact that he tells the audience that he cried, and not for anyone else but "is bleedin self', encourages the audience to take a more critical view of him and his actions (Naughton 1963: 60). Furthermore, in both the scenes with Lily he appears incapable of realizing the full implications of what has happened. He slaps her to stop her from screaming in case the landlady hears and the illegal act is found out. At the end of the scene he thoughtlessly tosses her a toy teddy bear for her youngest son, although goes silent when he sees her holding it like a baby. The ending of the play, when he looks back over his 'little life', shows him in a more pensive mood, but this is undercut by him inadvertently bumping into Siddie, who he had unceremoniously dumped at the beginning of the play. He persuades her to go off with him and seems to have recovered his former swagger. This contrasts with the ending of the Caine film, which ends more ambiguously with Caine famously asking the audience, 'What's it all about?'

Changing the focus in adaptation to performance brings into view what the star brings to the character in terms of their persona, what the actor brings to character in terms of performance of the role and the interplay between the three elements. By looking at the actor as an agent in the adaptive process we can understand how texts can change quite fundamentally between stage and screen and in screen remakes. In the case of *Alfie*, the strong star persona constructed for Michael Caine at the beginning of his career comes into conflict with the morality of the original material. However, Caine's performance and the way it is presented by the *mise en scène* could be said to point to this moral imperative by showing us a character hiding behind a public persona that is revealed by the end to be a construction.

Other actors then can affect the character as performed and it's useful in this respect to compare Caine's Alfie with the remake in 2004 and Jude Law in the title role as an ersatz post-feminist Alfie. Law's star persona at this point was marked by a more fluid metrosexual masculinity than Caine's and publicly Law identified himself with the film's *attitude* to the main character rather than the character

itself, which again subtly altered the ideological import of the drama. The remake was positioned as an updated adaptation of the film rather than the play, with Law claiming that

> The only thing I didn't want to do was a Michael Caine. It's a rethink of *Alfie* [...] you can't remake it because it's too much of a classic but we've taken the essence of Alfie Elkins and set him in a modern age with modern women which puts a completely different slant on how he behaves and what he can get away with.
>
> (Hiscock 2004b: n.pag.)

The action was transposed from Swinging London to contemporary New York (although the film was actually shot in Manchester), with Alfie still working as a chauffeur but now zipping about the streets self-consciously on his blue vintage Vespa. The issues of class embedded in the play and still traceable in the Caine version are erased in multicultural, classless New York, as Law, the cheeky outsider, moves with ease between Marisa Tomei's humble flat to Susan Sarandon's penthouse suite. There is no abortion scene and male friendships in the film are given more prominence. Alfie's affair with his friend's girlfriend is therefore framed more in terms of the betrayal of homosocial bonds it represents. Although the film seems to draw on *Sex and the City* discourses of female empowerment, the film is still ambiguous in its portrayal of sexual relations. Arguably the introduction of Alfie's impotence as a key narrative device early on in the film positions him as more sympathetic to audiences, so that his inability to commit is ultimately more damaging to himself than to the feisty women around him. This shift of emphasis in Law's Alfie is evidenced by the reworking of the poster away from 'Caine IS Alfie' to the more plaintive (and referencing Cilla Black's original theme tune), 'What's it all about?', with Law gazing out soulfully to the audience, trapped within the I of Alfie, rather than in the 1966 poster, where Caine's disembodied head sits cheekily on top of it.

Although his role in Alfie was supposed to launch Law as a transatlantic star in a very similar way to Michael Caine, there are significant differences in their star personas that mediate the effect of Alfie as a character. Whilst Caine appeared to embrace stardom and was happy to collude with the construction of his persona as Cockney man about town, Law seemed notably more reluctant to commit himself to the construction of a consistent star persona. Up until Alfie, Law was known for his stage as well as screen acting and, despite his leading man good looks, tended to take on character parts. Anthony Minghella, who directed Law in *The Talented Mr Ripley* (1999), described Law's reluctance to take on roles beyond the dazzling character turn and embrace the fact that he could be seen as both an actor and a star.

It's true of all wonderful actors that they somehow are in a complex relationship with stardom, particularly British actors; they think they mistrust it, and they want the regard of their peers. They want to be perceived as actors.

(Wolf 2003: n.pag.)

Alfie, however, marked a turning point in Law's choice of roles, trading unashamedly on his boyish good looks and capitalizing on press interest deriving from the break-up of his marriage, so that his public image went from stable family man to freewheeling Lothario overnight. This offered the possibility (similar to Caine) of a conflation between a womanizing man about town persona and his character in *Alfie* but Law, unlike Caine, distanced himself in interviews from the character he played.

Alfie is a guy who relies on the veneer. He thinks that it's enough to buy a great cheap suit, say the right things and bed this woman and that woman and that will bring him happiness but he's so wrong.

(Hiscock 2004b: n.pag)

In terms of Law's performance, the direct address to the audience was retained and elaborated on in the 2004 *Alfie*, but operates differently to the Caine film. Whilst the former was delivered squarely to camera, in the latter Law's Alfie seeks a more ironic, self-deprecating complicity. Whilst Caine switches from talking to the audience to going back into the scene, with Law there is more ongoing communication with the audience within the scene. He winks, shrugs, scowls and smiles at the camera, whilst simultaneously engaging with the female characters. Therefore whilst Caine's performance suggested that Alfie's admissions to camera are self-deluding performances, Law's performance implies that his Alfie is much more knowing about his behaviour to women, asking the audience to understand and forgive his transgressions. Caine's verdict on Law's interpretation demonstrates this:

My Alfie didn't know what he was doing in that film – but thought that he did. Jude's Alfie clearly knew what he was up to all along [...] I played Alfie as a sort of primitive. The last line I say in that movie is, 'What's it all about?' The minute Jude walks on you know that here is a guy who knows exactly what everything is about.

(Pearce 2007: 21)

Therefore Law's metrosexual masculinity, despite being in Dyer's terms a 'perfect fit' for a reconfigured post-feminist *Alfie*, ironically emphasizes the potential misogyny of the material as his knowingness regarding his actions towards women

is signalled through his way of playing the direct address to the audience and seeking their complicity.

Both screen versions of *Alfie* added songs that emphasized their status as pop-cultural events, and in this next section, I will look at music as performance in stage–screen adaptations. The significance of music and sound for live performance has recently been explored by Roesner (2016) and Kendrick and Roesner (2012), counteracting a scholarly tendency to privilege the visual or the spectacle in analyses of theatrical productions. Roesner in particular has argued that attention paid to musicalization in the theatre 're-introduces a full range of textual potential: as rhythmical, gesticulatory, melodic, spatial and sounding phenomenon as well as a carrier of meaning' (2016: 3). This section will focus in particular on how music operates on stage in relation to the spoken and aural elements of the performance text, predominantly using the example of the original production of Tennessee Williams' *A Streetcar Named Desire*, a work that was notable for its conscious deployment of musical elements to support the development of character and themes. I will then look at the film adaptation to track how the relationships between music and visual elements were carried over or reconfigured.

Raymond Spottiswoode described film music as having the following functions: imitation – where score imitates speech or natural sounds; commentary – where the score takes the role of commentator to the images on screen; evocation – where music reveals something about character (this includes the 'leitmotif' where a tune becomes associated with a character through repetition); contrast – where music contrasts with the image to create effect; and finally dynamism – where music works together with the composition to emphasize editing or cutting (1965: 49–50). Narrative conventions such as Classical Hollywood Narrative style developed after synchronous sound was introduced meant that the relationship of image and sound was determined by certain ideological practices, which used the soundtrack to support the image and render itself invisible in the process. Music for plays rarely functions as underscore in this way, although it does sometimes echo the same practices of providing musical leitmotifs for certain characters, or using well-known songs to heighten the emotional affect. For instance, Lyn Gardner recalls the use of Otis Redding's 'Try a Little Tenderness' at the end of a production of Jim Cartwright's 1980s classic about the effect of Thatcher's policies on a community, *Road*. The use of the song implicitly demands audience empathy for the plight of the protagonists:

> Redding's anthem suddenly soars over the deafening daily roar of despair and hope-lessness of a group of young people living in a dead-end Northern town that has had the community ripped out of it by unemployment. In both cases, without the cunning use of the song, the emotional impact of each scene would be diminished.
>
> (Gardner 2008: n.pag.)

Music has become part of the toolkit with which productions can impact their audiences today, although in the past it was more typical for music to be absent from a stage production and then introduced to underpin classical narrative conventions in the screen adaptation. For instance, in Joe Orton's *Entertaining Mr Sloane* (1966) no music is indicated in the written text of the original stage production. The film adaptation, made in 1970, in a strategy typical of the period, has a pop theme tune with the same title, written and sung by Georgie Fame, placed over the opening credits and revisited throughout the film. However, the film also uses music to signal that the action is to be understood as a farce, a generic signifier that the play scrupulously avoids. Campbell has examined the use of music and sound in the marriage scene between Sloane (Peter McEnery), Kath (Beryl Reid) and Ed (Harry Andrews). As the characters promise, 'I will', the music suddenly stops and there is 'a plucked bass portamento, which produces a decidedly comic effect' (Campbell 2013: 152). Both Ed and Kath then kiss Sloane, and the soundtrack returns to Fame's theme tune and then to a church organ finish as 'Amen' is written across the final image of the threesome together. Campbell argues that the sound explicitly positions the gay marriage as farcical, a parody of Christian marriage and thus encourages the audience to not take it too seriously, unlike the play where the final *ménage à trois* between Kath, Ed and Sloane is presented without commentary (Orton 2014: 129). The music therefore dates the film in a way that the play remains timeless and because of the legalization of same-sex marriage in the United Kingdom in 2014, 'the use of audio effects to distance the audience from considering gay marriage as a potential reality now seems quaint' (Campbell 2013: 167).

There are also examples where music is used in the original production of the play but takes on a different significance in the film. Peter Shaffer's *Amadeus* was first performed at the National Theatre in 1979 and subsequently adapted into a film in 1984 by Shaffer himself and directed by Milos Forman. Both play and film depict the rivalry between court composer Antonio Salieri and Wolfgang Amadeus Mozart, with the former tortured by the realization of his own mediocrity in the presence of Mozart's feckless genius. The original play was in two acts and divided into twelve and seven scenes, with the music in the play presented as if it was heard from the perspective of Salieri's paranoid mind. For instance, rather than use sections of Mozart's actual music, the composer for the stage play, Harrison Birtwistle aurally distorted patches of Mozart's music so they were almost unrecognizable (Tibbetts 2004: 168).

The film on the other hand both exploited the prestige factor of recognizably 'classical' music in the soundtrack and arranged it in line with the conventions of the Hollywood biopic genre. Sequences of Mozart's actual music were used, recorded by the Academy of St Martin in the Fields and conducted by

Sir Neville Marriner specifically for the film. Commentators have noted how the release of the film led to a renaissance in Mozart's popularity, with the CD of the film's soundtrack becoming one of the year's bestsellers. However, specific pieces of Mozart's music were also selected to highlight the narrative's thematic concerns. Most notable in these terms was the sequence depicting Mozart's death, where Salieri notates his rival's Requiem, as the former lies on his deathbed, communicating each part as it is heard in his head until it builds into the whole of the musical score. The scene was not in the play (and couldn't have happened in real life) but was written by Shaffer specifically for the film. It is designed to take advantage of the properties of the cinematic medium, in that the audience get privileged access to what is inside Mozart's head and thus witness his genius in putting together the musical parts to make the whole. Shaffer has spoken about how a concern to present the nature of musical inspiration was paramount in his adaptive strategy.

> We were able to construct a scene that is highly effective in cinematic terms, yet wholly concerned with the least visual of all possible subjects; *music itself*. I do not believe that a stage version of this scene would have been half as effective.
> (Shaffer 1984: 57, original emphasis)

It is noteworthy then that a revival of *Amadeus* at the National Theatre in 2016, after Shaffer's death, took a very different attitude to the music and one that arguably was inspired by the integrated use of music in the film. Whereas Hall's original production used music sparingly, Michael Longhurst's production put the music centre stage by employing twenty musicians from the Southbank Sinfonia to play Mozart's music whilst being assimilated into the action. Dressed in modern black clothes they become a chorus commenting on the action, responding to Salieri with both music and movement. As the *Independent* review highlighted, this enabled Mozart's music to have a visceral impact, by being brought alive in correspondence with the action on stage, similar to that described by Shaffer above.

> There's an extraordinary sequence in which Salieri is glancing through a folder of his rival's sheet music. As he drops the pages one by one, unable to bear the beauty of what he reads, the Sinfonia's glorious performances of them get abruptly aborted but the mobile platform of steps on which they are standing continues to bear down like an implacable juggernaut on the writhing and retching Salieri.
> (Taylor 2016: n.pag.)

Finally I would like to look at an example where the relationship of music to the drama was both integral to the production and then examine how this was then adapted to the screen. The play in question is Tennessee Williams' *A Streetcar*

Named Desire, which was adapted to the screen in 1951. Both versions were directed by Elia Kazan, with Marlon Brando in the role of Stanley and Jessica Tandy/ Vivien Leigh in the role of Blanche in stage/screen versions respectively. The debut production of *Streetcar* opened at the Ethel Barrymore Theater in New York on 3 December 1947 and was a huge commercial and critical success, playing for 855 performances. As Davison has argued, the 'music created for theatrical productions is notoriously ephemeral. It is not uncommon to find that the only information about a production's music to survive is a credit for the composer and/or performers in the play's program or playbill and, occasionally, a few lines about the music in reviews of the play' (2011: 402). Because of the existence of archive material relating to both stage and screen versions of the drama, the score of *Streetcar* has been subject to an unusual level of critical investigation (e.g. Davison 2009; Butler 2002). For instance, Davison describes how because of disputes about the categorization of the play between producer Irene M. Selznick and the American Federation of Musicians, the extent and purpose of the music, and how it developed from text to production, is exceptionally well documented (2011).

From the start, Williams had included references to music in the play, including a blues piano, which 'expresses the spirit of the life which goes on here' (Williams and Miller 2009: 1), a muted trumpet and a 'polka tune' that functions as Blanche's memory music and comes in towards the end of the play to highlight Blanche's mental disintegration. In pre-production, Kazan developed this into two dissimilar types of music that played at different times in the production and Blanche's 'leitmotif' was brought in earlier in the play. As Davison suggests, 'placing these cues throughout the play suggested that Blanche's mental state was fragile prior to her arrival in New Orleans' (Davison 2009: 83). The theme was performed on the world's first polyphonic synthesizer, the Hammond Novachord and was played just slightly off-stage. The Novachord could warp acoustic sounds into defamiliarized and uncanny variations in order to leave it ambiguous whether it was there as mood music from outside the action or represented the sounds that were inside Blanche's head, as she recalled her life in Belle Reve.

The blues piano and trumpet in Williams' playscript evolved into improvised jazz music performed by a live band upstairs in a dressing room and amplified to the auditorium to give the impression of a band playing in the fictional 'Four Deuces' café over the road. Davison also relates how the jazz score was used at key moments to counterpoint the action, such as a 'slow, whimsical, sexy version of Sugar Blues' being deployed to undermine Blanche's protestations that she has 'old fashioned ideals' (Davison 2009: 84). Kazan also decided that the jazz blues was to be used to underpin the latent physical sexuality that is expressed between characters, 'whether characters are conscious of its power, expressing it in their words and actions (Stanley and Stella), or whether the music expresses its power

over them, in their denial or suppression of it (Blanche)' (Davison 2011: 440). In production then, Williams' original suggestions for music cues were often changed or removed. A particular example of this is the ending, where Kazan chose to bring the action to the close with the sound of the haunting polka music rather than the upbeat jazz indicated by Williams, which encouraged sympathy with Blanche as she is led away by the doctor and matron and implicitly linked her demise to the suicide of her husband, the loss of Belle Reve and the fragmentation of her identity that followed.

This sense of the music being used to comment on characters was fairly innovative for music accompanying a play in the theatre and this active engagement with the characters and narrative was retained in the score for the film. Alex North's score has been described as 'the first functional, dramatic jazz score for a film. Up until then, jazz had been generally used only as source music' (Lochner 2006: 3). Davison argues that the score of the film challenged the notion that music for a film should guide the audience towards a particular interpretation (sometimes called Mickey Mousing), maintaining that it retained the play's ambiguity towards its characters (2009: 84). Butler on the other hand argues that the film score operates within dominant Classical Hollywood norms, by using jazz music to aurally point to what is deemed seedy and immoral (2002: 98). He references handwritten notations on North's original score, where the words 'sexy, virile' appear alongside the instrumentation for muted trumpet whereas Blanche's dreams of her previous, seemingly unsullied life are underscored by a more classical soundtrack involving violins, and cello, with the note that it should sound 'magic-like, shimmering' (Butler 2002: 98). What is certainly clear is that the music blurs the boundaries between the diegetic and the non-diegetic in terms of whether it is internal to the plot or used to underscore the dramatic action from outside of it. For instance, in the opening scenes, the rolling blues piano that accompanies the images becomes the music heard by the characters in the bowling lanes, where Blanche meets up with Stella.

North also expanded the music for Blanche by developing two themes that worked as leitmotifs. The first is the polka theme that is associated with Blanche's memory of dancing with her husband before he shot himself. Whenever he is referred to in the film, however obliquely, the tune comes in and snaps off at the sound of a shot. The only exception to this is at the end when Mitch comes round to break up with Blanche. The music does not stop after the shot but goes on, perhaps indicating that Blanche's relationship with Mitch is as doomed as that with her former husband. However there is another theme, which North called 'Belle Reve Reflections', that is used not only to indicate that traumatic loss of the estate for Blanche, but also at other points in the film. For instance, it plays when Stanley breaks the news of Stella's pregnancy to Blanche. This might not

seem on the surface to impact Blanche but by linking this to Blanche's music of 'loss', the music comments on the action, suggesting that this will be another nail in the coffin for Blanche, by being cut out of the new family unit, as indeed happens at the end.

There was also more than one score for the film as North's original music suffered from cuts made in the film by the producers to satisfy the Catholic Legion of Decency, precisely because of the perceived 'carnality' of some parts of the score (Davison 2009: 68–72). This was the score that played during what has been termed the 'staircase scene', which comes about halfway through the film. Blanche and Stella are upstairs having been driven out of the apartment by Stanley's violence towards his wife after the card game. After a ducking in the bath by the other men to sober him up, Stanley comes outside and wails up to Stella to come down. To Blanche's surprise, Stella walks as if spellbound out of the upper flat and down the staircase into a passionate embrace with her husband. As Davison has painstakingly analysed, even though the original film passed the Production Code with a few minor changes, the Legion of Decency objected to the music scoring the scene precisely because it indicated Stanley and Stella's relationship was primarily based on lust. Therefore a replacement cue was written for the scene that avoided this connotation and was attached to the print of the film until in 1993, when in a less febrile moral climate, Warner Brothers released the Original Director's version that restored North's original music. This points to a key social and historical factor shaping adaptations between stage and screen, namely the far stricter codes of censorship for the cinema that affected what could be shown and heard on screen. North's score then expanded on the music for the stage production to explore more intently 'the characters, the setting, main motifs, crucial events and states of minds. The film soundtrack could thus be denoted as integral to and harmonised with the dramatic action' (Onič 2016: 59).

This chapter has argued that understanding of stage-to-screen adaptions can be expanded by looking at material aspects of performance, such as costume, acting, design and sound, and thinking about how they operate on stage and how they are configured in the screen adaptation. This distinguishes them from the adaptation of novels as both plays and films dramatize situations and involve actors performing written dialogue, interacting with settings and sound to make meaning. However, medium-specific conventions mean that these elements are reconfigured between adaptations. In the next chapter, I will reverse the focus on stage-to-screen adaptation to look at how the stage has adapted films and created performance events for audiences. Whilst some aspects such as questions around acting, design and sound are the same for screen-to-stage as they are for stage-to-screen adaptations, I shall also discuss what their staging strategies reveal about their relationship to the source film.

NOTE

1. Due to the limitations of length, I have omitted to discuss more broadly the very different identification processes that operate in film and theatre in relation to the actor and how this is facilitated by different perspectives on the action. Baron is particularly good on looking at how *mise en scène* helps to construct performance on film (Baron and Carnicke 2011: 11–31).

2

Screen-to-Stage Adaptation: Theatre as Medium/Hyper-Medium

But theatre is never a medium [...] one can make a movie 'of' a play, but not a play 'of' a movie.

(Sontag [1966] 1994: 25)

Susan Sontag's statement now seems to have been disproved by the exponential growth of stage adaptations of films, particularly in the last twenty years. This can be accounted for by Auslander's claim that '[t]he collapse of the distinction between fine arts and mass media has meant that the theatre now functions as a medium and has to compete for audiences directly with other media' (2004: 112). Theatre's relationship with other media is then implicitly altered within contemporary mediatized culture and this chapter will consider adaptation from screen to the stage, in the light of these changes. The first chapter examined space, acting, design and sound as key elements characterizing the performance text in the adaptation of plays to the screen and, as with stage-to-screen adaptation, adapting films involves a reconceptualization of form and aesthetics. This means an understanding of how cinematic space is translated into stage space, with narrative conventions such as flashback, ellipsis, editing strategies potentially finding a theatrical equivalence or being jettisoned altogether; how particular film performances are referenced and whether similar designs and sound are utilized. There is also the cultural memory of films to negotiate. Davis has distinguished between the text that he described as 'fixed in words' and the 'culture text' that is made by a cultural memory of the work; 'the author's text is located in a particular time and place; the culture text is still being created' (1990: 110).

This can be applied to film images and performance. For instance, Christiane Jatahy, the Brazilian director whose 2017 stage production of *Rules of the Game* at the Comédie Française updated the Renoir film of the same name, has said that for the generation now in its forties and fifties, cinema is a repository of memory and moving

pictures. 'The difference with books is that when you use this material, it's not only about the story, but the images the audience have from the film' (Jatahy cited in Sulcas 2018: n.pag.). Examining screen-to-stage adaptations then also means thinking about how and why particular images or sequences are recreated or referred to in the theatrical space. Changing the critical framework to move away from textuality to questions of performance allows a fuller understanding of adaptation between stage and screen because of the performative ways that these stage plays can relate to their cinematic predecessors. In an era defined as post-cinematic, which is characterized by a heightened awareness of the way cinema communicates, theatre can stage and interrogate cinema's operational modes, call into question their effects on audience's perceptual expectations and summon itself into being as a medium by comparison. Just as film throughout the first few decades of the twentieth century defined and identified itself in relation to theatre, it appears that theatre is now re-inventing itself through film.

Although some have welcomed the phenomenon of staging films, believing 'the idea of theatre cannibalizing film materials and the language of film is the sign of a confidence' (Beresford cited in Sulcas 2018), on the whole there is a sense that the prevalence of adapted films on stage points to a moribund, over-commercialized theatre, drawing on the audience's familiarity with known commodities to secure healthy profit margins. The critical disdain sometimes directed towards these works parallels that at one time given to screen adaptations of stage plays, when they were dismissed as 'canned theatre', as explored in Chapter 4. For instance, in his review of the adaptation of Almodóvar's art house classic *All About My Mother* at the Old Vic in 2007, theatre critic Michael Billington lamented, 'Who would want a copy, however well done, when they can have the original?' (2007).

Screen-to-stage adaptations in the United Kingdom at least are encouraged by the economies of contemporary theatre culture; popular with theatres sustained by touring programmes, where pre-recognition of the property has an obvious advantage in maximizing audiences. Regional theatres who have suffered the most from local authority funding cuts since 2011 can capitalize on film properties that audiences may have a local investment in (for instance the Crucible's 2013 stage adaptation of the Sheffield set British film classic, *The Full Monty* [1997]). As writer Helen Edmundson notes, 'the good thing about adaptations is that companies and theatres will tend to book them in advance. It's much harder with an original play' (cited in Sunderland 2014: 320). However, the adaptation of specifically films to the stage has largely escaped sustained critical attention, despite the recent growth of work on adaptation and the theatre (Laera 2014; Babbage 2017; Rees 2017; Reilly 2018). This is arguably exactly because they are seen to be parasitic, opportunistic and safe, relying only on satisfying the audience's desire for material that is familiar but produced in a different way. Bolter and Grusin's notion of 'repurposing' is useful here as they note that the 'industry defines repurposing as pouring a familiar

content into another media form', not in order to 'replace the earlier forms' but 'to spread the content over as many markets as possible'. However, in doing this, they argue, 'each of these new forms takes part of its meaning from the other products in a process of honorific remediation and at the same time makes a tacit claim to offer an experience that the other forms cannot' (2000: 68). This then opens up a critical space where investigation of these stage productions takes on board what the live staging of the film actually offers its audiences, moving beyond consider-ations of familiarity and profit chasing. For instance, Chris Goode, the writer of an adaptation of Derek Jarman's iconic film *Jubilee* (1977), produced for the Royal Exchange Theatre, Manchester in 2017, talks about his initial reluctance to work with film sources because of what he terms a 'cultural misunderstanding' of the roles of theatre and film. However, Goode says he had long been using *Jubilee* in his teaching as 'an example of what film can show us about theatre spaces', and began to think about transforming it into a stage work as the movie's 40th anniversary approached. 'There is a literacy to our interactions with film and the screen today, and I think it has made theatre artists more able to think critically around how film communicates' (Sulcas 2018). Celebrating the film's anniversary, with a restaging of it, points to the capacity of theatre to celebrate and memorialize key cinematic works, offering a collective, live event for audiences. This one-off encounter is given special significance in the context of a hyper-mediated world where recorded images are circulated endlessly across multiple platforms.

Adaptations of screen works such as Jarman's raise questions about author-ship, because of the way in which different authorial voices and/or inscriptions can be detected or are erased in the process and products of adaptation from screen to stage. This is particularly true of the 'art house' film to stage play, where the original film is directed by an 'auteur' and thus is often understood within the context of its director's whole body of work. This necessitates consideration of whose authorship is constructed or represented in the stage work, particularly in cases such as Ivo van Hove, when the latter is understood within a framework of signification that stresses the unity of his own work as director/auteur. On the other hand, as Sunderland argues, '[d]espite its apparent commercial advantage, companies may prefer to "brand" their productions without reference to prior authorship, textually cutting themselves loose from the source text' (2014: 324).

Unlike stage-to-screen adaptations, the staging of complete film narratives does not have much of a lengthy historical pedigree. Given the low cultural status of film as an art form throughout most of the twentieth century, this one-way traffic was perhaps to be expected. However, from the 1980s onwards, certain auteur theatre directors looked to classics of the cinema to provide starting points for their devised stage work. For example Robert Lepage's Canadian 1986 produc-tion *Le Bord Extrême* was a stage re-working of Ingmar Bergman's *The Seventh*

Seal (1957), a film that itself was centred around the transcendental power of actors and performance. Lepage has had a career crossing between theatre and cinema, as both director and actor, and this substantiates the argument that practitioners within performance cultures will often facilitate work across these borders. Since 2000, there has been a significant growth in straight play and musical adaptions of a range of films, from art house to Hollywood, across genres and historical time periods. It is surely no coincidence that these adaptations have become more prolific in the first decade of the millennium when the circulation of films through platforms such as YouTube or specialist film sites for classic films has grown exponentially. It can be argued then that the screen-to-stage adaptation is a response to a hyper-mediated landscape, which equalizes the cultural status of theatre with film.

The chapter will begin by looking in detail at the mechanics of David Eldridge's stage adaptation of the film *Festen* (1998), the first film made under the 'Dogme' manifesto that because of its concentration on dialogue and character would seem to lend itself readily to adaptation to the stage. However, I also want to argue that Eldridge's version (2004), in particular, finds ways to capture the 'haptic' textures of the film, characteristic of its adherence to Dogme rules. This then develops the argument to explore how theatre is able to adapt the sensory techniques utilized in film (Marks and Polan 2000; Sobchak 2004). I will then look at the work of one of the most prolific adaptors of films to the stage, Ivo van Hove, concentrating on a group of theatrical adaptations of works from the American independent film director John Cassavetes. I will argue that the 'enunciatory ambiguity' (King 2004) of Cassavetes' film style across a body of work is similarly translated into theatrical terms by the way van Hove uses the onstage interplay between live and screened action. The chapter will conclude with an examination of current stage adaptations of Hollywood films from Julie Taymor's adaptation of the Disney animated film *The Lion King* (1994) to the other end of the scale with a trend for minimalist adaptations of big Hollywood blockbusters.

Festen *and adapting 'affect'*

> The success of *Festen* onstage can be attributed in large part to [...] its re-orientation of the coherent space of the Dogma 95 location towards the closed space of the stage.
>
> (Thomson 2014: 142)

My first case study is the theatrical adaptation of the first Danish Dogme film, *Festen* (*The Celebration*, 1995). The particular aesthetic restrictions of the 'Vow

of Chastity', under which the original *Festen* was completed, offer enticing possibilities for transformation into plays because of the way that they foreground character and dialogue, rather than complicated visual effects. Set up by the Danish film directors Lars von Trier and Thomas Vinterberg amongst others, Dogme 95 was launched at a Paris conference in 1995 with 500 pamphlets scattered amongst the participants, announcing the Dogme Manifesto, a new approach to making cinema that repudiated the aesthetics of Hollywood movies. Proclaiming the ten filmmaking 'commandments', collectively known as the Vow of Chastity, von Trier and his co-signatories set out the restrictions by which Dogme films had to be made: with a hand-held camera; always on location; using only props already present at that location; sound recorded at the same time as filming; using whatever light available at the time and no credits for the 'author'.

Festen was co-written by its director Thomas Vinterberg and screenwriter Morgens Rukov (though they both acknowledge in the screenplay that much was owed to the contribution of the actors during the extensive on-set rehearsal process). It was then shot on hand-held digital camera by British cinematographer Anthony Dod Mantle according to the Dogme rules outlined above. During the shoot, Mantle's way of filming meant that the actors performed without an awareness of the camera, so 'they had to act in all directions at all times, in case they were on camera – just like stage actors who are constantly in view of the audience' (Rosenthal 2004: n.pag.). Vinterberg and his film editor Valdio Oskardottir then spent nearly six months editing over 64 hours of footage and turning it into a 100-minute film. It opened at the Cannes film festival in 1998 and was an overnight sensation, winning the Special Jury Prize before being screened in cinemas worldwide.

Festen, then, as a film might be deemed inherently theatrical. It is set in one place: the family hotel, where family and friends are gathering to celebrate the 60th birthday of the hotel's owner and family patriarch Helge. The family are still reeling from the effects of the suicide of one of Helge and his wife Else's children, Linda, when at the celebratory meal, Linda's twin brother Christian reveals that they were both systematically abused by their father when they were children. The film then tracks the repercussions of these revelations on the gathering. Generically, it can be understood as a family melodrama where explosive secrets are revealed that destabilize the household in question and expose as hypocrisy the appearances that they present to the outside world.

The first theatrical incarnation was written by the Danish playwright Bo Hr. Hansen in 2000, who described it as just needing 'to be translated into another language: from film to theatre language' (Thomson 2014: 142). The play was first performed in Germany in 2001 and then toured to France and Denmark the following year. This version was then revived by Romanian theatre company Nottara and performed at the Barbican in 2011. It follows the film closely and

included much of the original dialogue. It incorporated Linda as a character who provides a soliloquy to the audience before the main action starts.

However, this chapter concentrates on the Eldridge version because of how it finds solutions to translating the sensory qualities of the original film through the expressive potential of the theatre space. The play opened at the Almeida in March 2004, with Rufus Norris directing, design by Ian McNeill and starring Jonny Lee Miller and Jane Asher. It transferred to the West End and was nominated in 2005 for five Olivier Awards including Best New Play, and was the winner of the Evening Standard awards for direction and design. It transferred to Broadway in 2006, but was less of a success, closing after 49 performances. However, within a couple of years of its initial production, there had been 50 different productions staged worldwide in twenty different countries.

Eldridge is clear, in his published version of the play, that it was created in dialogue with Hansen, Rukov and Vinterberg (2013: 2). He describes setting out

> to find a shape for the story that related most intimately to the shape of the film in its rawest form. The film's intimacy comes through the use of the hand-held camera and at the Almeida it comes partially through the fact that the audience sits really close to the action and partially because I've placed less than a dozen people around the dinner table, not the 80-odd guests from the film.
>
> (cited in Rosenthal 2004: n.pag.)

In comparison to the film and first theatre version (and challenging the belief that theatre is verbal to film's visual), the dialogue is very stripped down, giving room for actors to create meaning in performance that encompasses what is not being expressed through dialogue. Eldridge also amalgamates some of the nameless guest responses in the film into one named character, called Poul, an anxious family friend, whose primary concern is the effect of the revelations on his depression. Whilst also providing a symbol of the older generation against the younger 'truth' seekers, he provides comic relief, in his inability to see the seriousness of the unfolding events. The reduction of the cast to fourteen means that the power balance between Helge and his family is given focus as it makes Helge's tyranny very easy to exercise at the now intimate dinner and allows the complex relationships between the siblings to come to the fore. Jonny Lee Miller, who played Christian in the original production, noted that the reduced size also gave the story a different dynamic:

> If you're at a function with a lot of people and someone drops a bombshell, as Christian does, it's a lot easier to paper over the cracks, for everything to

continue as normal [...] but if there's only about 12 of you, there's nowhere to hide.

(cited in Rosenthal 2004: n.pag.)

However, Eldridge also introduces a new character, the Little Girl, the daughter of Michael and Mette, to enable him to summon up Linda, the dead sister, whose ghostly presence is communicated in the film in several ways. She is shown in one scene towards the end of the film when she appears to Christian whilst he is sleeping, illuminated only by the half-light of a candle. Her appearance, like the Ghost in Hamlet, is thus kept ambiguous. Is she just a figment of his imagination or the actual manifestation of his sister's spirit, spurring him on to reveal the truth and preventing him from suicide? Linda's presence in the film is also communicated by the recurring motif of a high-angle camera view of the action, particularly in the scene where Helene and Lars find the suicide note in the light fitting. This seemingly unmotivated framing gives the idea that an unknown someone is watching events unfold from an impossible viewpoint. To recreate this on stage would obviously be impossible and yet the presence of the Little Girl in the play, who is often seen watching the action from the side of the stage, recalls these shots from the film. She serves as an unsettling and constant reminder of Helge's crimes, her youth and innocence highlighted as she is the only child on stage amongst adults. As she is at the age that Linda would have been when the abuse first happened, she is a poignant reminder of the 'ghosts in this house' that Helene refers to.

This effect is underpinned by a scene later in the play when Christian, after his second expulsion from the dining room, lies bleeding on the floor, as the guests conga around him, seemingly oblivious to his distress. They exit and the girl enters, dressed as a ghost, singing a song. He calls her by Linda's name and she runs off stage – Christian, as the stage directions describe, 'breaks into a broad smile [and] tears run down his cheeks' (Eldridge 2013: 23). This replicates the 'ghost' scene in the film, which in both play and film prompts Christian's decision to act on the incriminating suicide note, triggering Helge's eventual downfall at the end of the drama.

The Little Girl also contributes to the 'affect' in the final scene through her artless singing of a birthday song, where the lyrics are queasily reminiscent of the events just witnessed. The contrast between the very adult themes of death, abuse and incest, and the girl's innocent singing, brings into relief what the audience have just witnessed. In this scene, Christian, who is by now completely emotionally and physically depleted, approaches her and asks 'shall I come with you?' (Eldridge 2013: 24). The Little Girl shakes her head and Christian replies 'I miss you too' (Eldridge 2013: 24). There is a sense of catharsis for Christian in this exchange, who we feel will now be able to move on with his life. The effect is stronger in the play because of its repositioning in the narrative as this scene comes at the end, as

opposed to Christian's encounter with Linda's figure, which comes much earlier in the film.

A visceral use of sound and lighting in the play functions as a literal translation of what Thomson has described as a 'haptic' style of filmmaking (2014: 34), with uncomfortably close framing on characters at key moments and the way the jumpy hand-held camera focuses on particular objects, such as the crisp white sheets and tablecloths.[1] This is again reinforced in the film by certain key sounds such as the tinkling made by the tapping of knife on cut glass cueing a speech at the table, which comes to be identified with a renewal of Christian's shattering accusations against his father. In the play along with the Little Girl's childish singing, we hear the offstage sound of children's laughter, introduced from the beginning, mixed in with sounds of dripping water, creating a sense of unease, particularly once the accusations are made against Helge and the audience are aware of Linda's suicide in the bath. The complex aural qualities of the piece are contrasted by the relative simplicity of the set, containing just one wall, one door, a curved table with twelve chairs and a bed. The set was lit by lights from the side, creating a chiaroscuro effect and casting shadows across the structures.

Emblematic of the film's successful transition to the stage is the bedroom scene that comes in the first third of both film and theatre adaptation. In the film, this sequence was created in post-production by cross-cutting between Helene and Lars in Linda's old room looking for any clues to her suicide; Michael in his bedroom with wife Mette; and finally Christian with Pia in his bedroom, as she takes a bath. These three bedroom scenes are therefore thematically linked by the cross-cutting between them, which emphasizes the sound and textures of water: from the close up of water in a glass being swirled contemplatively by Christian, to the sound of Michael's shower, to a long-held shot of Pia from under the water looking straight to camera. Tension is also built up in the cross cutting between Helene and a reluctant Lars hunting for clues left by Linda, following arrows and eventually finding a note left tucked into a light fitting being interspersed with Michael and Mette's explosive argument and lovemaking and Pia submerging herself under the water, echoing Linda's suicide in the bath. A denouement is reached as Helene reads the suicide note with a tear falling down one cheek and then suddenly goes 'Boo' to Lars to stop him from reading it over her shoulder. There is a rapid cut on this verbal cue to Michael falling over in the shower, grabbing the curtain as he goes down and then to Pia suddenly emerging from under the water, expelling her breath. Such an organization of material would be impossible on stage as Eldridge explains:

> On screen you're cutting away to the next scene all the time and often the cut tells the story [...] on stage you're trying to sustain the action. Too

many scene changes, inelegantly done, make for a tiresome evening in the
theatre.

<div align="right">(Eldridge cited in Woodward 2017: n.pag.)</div>

His solution ingeniously retains the links between sex, death, family and drowning
that are implicit in the film version. All the scenes are played out simultaneously
over one bed in the centre of the stage with each couple seemingly unaware of
each other, changing the central metaphor to that of the bed as all the characters
are linked to it. As Lars and Helene stand on the bed to try and reach the note in
the light fitting, Christian refuses Pia's sexual advances, whilst Michael and Mette
weave through the others, throwing shoes, viciously arguing and then engaging
in frantic lovemaking. The climax comes as Michael orgasms at the same time
as the note is found. This organization of stage space retains the idea that these
characters are linked together and signals that they are oblivious to each other's
pain. The potential and explicit sexual encounters hint also that these characters
are connected by something beyond the normal family bonds. It also retains the
tension created by the editing in cross cutting quickly between the different scenes
and on the (literal) climax to all three scenes.

Overall then, Eldridge's play is a creative response to the impossibility of
a wholesale transfer of the film to the stage. It seeks to communicate not just
the story and characters, but also the textures and disturbing haptic sensibil-
ities of the film, through theatrical means. This means finding ways to translate
the 'affect' in film, defined here by Del Rio as referring to 'the body's capacity
to affect and be affected by other bodies, therefore implying an augmentation
or diminution in the body's capacity to act. Affect precedes, sets the conditions
for and outlasts a particular human expression of emotion' (Del Rio 2008: 10).
Thomson has described how new media technologies, such as more sensitive
and smaller cameras, emerged during the 1990s and led to a 'renegotiation of
the concept of realism' as they demanded the viewer 'enter into an affective
contract through strategies of pathos, shock or marked reference to the senses'
(2014: 31). She concludes that with Dogme films in particular, the style of the
film engaged the spectator emotionally as they became a 'co-creator of the film
text' by and through this affective encounter (2014: 32). Obviously, the recip-
rocal space between audience and actor demanded by live theatre is underpinned
by such an affective contract, and it's notable that in reviews of the theatre pro-
duction, critics articulate their response in terms of this sense of bodily and
sensory engagement. Mark Shenton for instance recalled that he 'was by turns
stunned, appalled and completely gripped from beginning to end by one of the
most electrifying nights I've ever had in a theatre' (jonnyleemiller.co.uk n.d.: n.
pag.). This testifies to the fact that Eldridge manages to adapt the film in terms

not just of content but of its particular aesthetic and find ways to translate this successfully into theatre.

Ivo van Hove: Adaptation of films or staging of movies?

> It makes no sense to turn a movie into a theater play unless there's really an urge to do it because it was intended to be a movie. I only do that when I think I can tell something which I cannot do with any existing play. A movie is made by the edit. The big challenge for me then is to invent a world for it theatrically.
>
> (Ivo van Hove cited in Magaril 2014: n.pag.)

In terms of screen-to-stage adaptation, the Belgian theatre director Ivo van Hove is one of its most prolific exponents. Throughout his 38-year career, van Hove has to date directed twenty stage adaptations of films, including an adaptation of Joseph Mankiewicz's *All About Eve* (1952), starring Gillian Anderson in the Bette Davis role (2019). However, this represents something of a departure for van Hove, who has been hitherto more associated with adaptations of art house films from well-known European and American avant-garde directors, such as Ingmar Bergman, Michelangelo Antonioni and John Cassavetes, alongside a more traditional repertoire from Shakespeare to Miller. As Julie Sanders notes, van Hove's adaptation of films to the stage therefore redraws the boundaries of the theatrical canon, enfranchising films as classic texts to be put alongside more conventional stage plays (2018: 170–78). In this way van Hove can attach his name to textual products that already carry a certain cultural capital within particular western audiences and this facilitates the circulation of van Hove's work across the world. His theatre productions nearly always play in elite international venues with ticket prices to match, such as the National Theatre in London or the Brooklyn Music Theater in New York.

Van Hove himself positions cinema as providing an alternative classical 'repertoire', untouched in stage incarnations by others and thus offering the possibility of being able to communicate his own authorial presence through a particular interpretation of the material (Goriely 2018). There is also clearly both creative and commercial potential inherent in the adaptation of a particular type of auteur cinema where the original director is a 'known quantity' but not necessarily around to influence van Hove's creative process. For instance, the negotiations between El Deseo (director Pedro Almodóvar's production company) and the producer Duncan Sparrow regarding the adaptation of the former's *All About My Mother* (1999) went on for some time from when Sparrow originally contacted the Spanish director in 2002. Almodóvar had been unhappy with previous stage incarnations of his films as they were too dependent on outrageousness without

being sensitive to the core values of his work, but apparently relented when he read Samuel Adamson's script (Wheeler 2010: 823).

Many of the films that van Hove adapts are the product of directors who are known for moving between theatre and film in their careers. Pellegrini therefore suggests that 'one possible reason to produce a stage adaptation of these filmmakers' works, therefore, could be to illuminate the theatrical roots of their more recognizable cinematic and stylistic techniques' (2014: 155). Goriely expands on this to argue that all the films adapted by van Hove 'evince a certain "theatricality"', understood here as 'a global and constitutive echo that passes between works of cinema and theatrical art' (2018: 320). Taking this into account, it is perhaps surprising then that van Hove himself claims to work only from the screenplays of the films, rather than from a detailed knowledge of the films themselves. However, whilst the screenplay is officially the starting point, van Hove often mentions the importance of his recollection of viewing the films and how they became formative experiences in his creative memory. It's clear then that the stimulus for these adaptations as Goriely argues occurs 'through the intermediacy of the picture, not the text' (2018: 344).

Most of the films that have been utilized as material by van Hove can be characterized as art house films, with anti-classical narratives and an emphasis on character rather than action. It is useful here to refer to David Bordwell's much quoted essay, 'The art cinema as a mode of film practice' to identify a distinctive feature of this type of film:

> Ideally, the film hesitates, suggesting character subjectivity, life's untidiness, and author's vision. [...]. Uncertainties persist but are understood as such, as obvious uncertainties, so to speak. Put crudely, the slogan of art cinema might be 'When in doubt, read for maximum ambiguity.'
>
> (1979: 60)

Therefore nearly all the films that van Hove has adapted have 'generic' (as Bordwell would term them) characteristics that offers the adaptor moments that lend themselves to interpretation, giving space for the theatrical auteur to insert themselves into the text's matrix of meaning.

There are also similarities to all van Hove's film-stage works that can be attributed to a continuity in van Hove's approach to the process. For one there is a scenographic connection across the productions as they are all designed by van Hove's partner and lifelong collaborator Jan Versweyveld. Therefore, there are continuities in design for the productions such as a use of screens within the stage space to convey either characters in close up or wide-angled views. Van Hove also tends to only have a short (three-week) rehearsal period prior to opening the production. This often means that he uses the same actors, so has a repertory

company who move around with him. Because the films he chooses to adapt are often character-focused pieces that demand complex and intense performances, he often talks about engaging people who are familiar with his way of working so that he operates from a basis of already established trust.

> I need such stability, because as a group we understand each other from the first rehearsal onwards and over the years a relationship of trust has developed. I have come to believe very strongly in the advantages of an ensemble. Actors are completely central to my work as director.
>
> (van Hove cited in Willinger 2018: 35)

The first film van Hove adapted for the theatre was from avant-garde American film director John Cassavetes. Often called the 'godfather' of American independent cinema, Cassavetes started his career as an actor and used his acting work in films such as the *Dirty Dozen* and *Rosemary's Baby* to finance his work as a director. His directorial debut *Shadows* (1959) came out of an improvisation exercise in the studio in New York City, where he taught an alternative system to Method Acting. He believed that the acting system had become moribund and self-indulgent at this time and wanted to bring back an element of play to the actor's approach to character (Carney cited in Seitz 2006: n.pag.).

This emphasis on the actor's performance was to be a key feature of Cassavetes' directorial style and approach. Even though the films were not improvised when shot, they were initiated through improvisations between actors on given scenarios. These improvisations were then shaped into scripts by Cassavetes and shot on a very low budget, usually in 'real' locations rather than studios. The performances were facilitated by 'anti-filmic techniques' that do not construct a performance in a given scene through montage and post production but allow a performance to unfold before the camera (Viera 2004: 153).

Cassavetes often emphasized in interviews that his films were not made to be easily understood and required an active spectator to engage with complex material (Cassavetes and Carney 2001). This points to the ambiguity that Bordwell argues is essential for the workings of art cinema. Similarly Cassavetes' description of his characters as not being able to express or understand themselves, 'like real people making their way through concrete but continually changing social situations, they improvise as they go along' (cited in Viera 2004: 155), echoes Bordwell's analysis of one of the effects of ambiguity in the art film is in its appeal to 'real life – that's how things are' (1979: 58). This ambiguity is facilitated by the emphasis on performers, particularly when Cassavetes uses a close up so that the ambiguity can play out over the faces of the actors signalling contradictory emotions. Cassavetes' style then, in a similar way to

Festen, potentially lends itself to the stage because the range of meanings are generated by the actor.

Faces (1968), a black-and-white film depicting the slow disintegration of a marriage, was the second film to be directed by Cassavetes and starred his wife Gena Rowlands, whose performance was nominated for a Best Supporting Actress Oscar. It was shot on grainy 16mm film stock that gives the impression of immediacy and authenticity and is set over one twelve-hour period. In terms of a distinctive aesthetic, the camera makes much use of the close up – honing in on the human face, that the director calls 'the greatest location in the world' (cited in Lunn 2016: n.pag.). Its theatrical adaptation by van Hove, called *Koppen*, premiered at the Holland Festival in 1996. Van Hove said his immediate response to the film as a possible source of adaptation was to laugh, 'but then I read the script and it was written just like a play, eleven long scenes' (cited in Trueman n.d.: n.pag.).

The design of the production was very specific. There was no identifiable acting area and the space was filled with beds. Van Hove describes it thus:

> To make it more uncomfortable, we separated the couples in the audience. It was an intimate situation, but everybody was absolutely alone. The theatrical space was unified and the spectators were part of the scenography.
>
> (Thielemans 2010: 456)

The space was arranged so that the audience were scattered amongst the actors on beds, and the actors moved amongst them, sometimes sitting on the beds with audience members, sometimes playing scenes from behind them. Despite van Hove's denial of the influence of the film itself, this then can be seen as spatial equivalent of Cassavetes' intimate filmic style that concentrates on close ups of the actor's faces in order to bring the spectator into closer contact with the characters and their relationships in the drama. Goriely argues that in different ways both the theatre and the cinema audience are

> transformed into passive and invisible accomplices, if not voyeurs of Robert and Maria's escapades, whether they're in the intimacy of their house, the artificial atmosphere of nightclubs, or the apartment where Jeannie arranges her dubious encounters.
>
> (2018: 340)

Actors and acting also operate to cross-reference performance in the film, with similar acting styles deployed in the play, mimicking that found in the Cassavetes' films. The actress who played the part of Jeannie (Chris Nietvelt) not only looks quite like Gena Rowlands who played the character in the film but has the same

uninhibited gestures and mobile expressions of her cinematic progenitor. Other actors in the play, like in the film, give the impression that their expressive, uncontrolled gestures are signalling an inner agitation (Vimeo 2008: n.pag.). Music in the play follows the film's jazzy motifs; there is a live pianist and one character sings a jazz-inflected song live on stage. Characters dance together in time to the jazz music at intervals throughout the piece, with the overall effect being that critic Steven Druckman likened it to 'the experience of being both outside and inside a Cassavetes film' (cited in Thielemans 2010: 457).

Van Hove's next adaptation of a Cassavetes' work was the 1977 film *Opening Night*. The project apparently derived from the latter director's admiration for the Bette Davis vehicle *All About Eve* (1952), a film that coincidentally van Hove was to adapt in 2019. Cassavetes' idea was to do a backstage drama and he wanted to explore the theme of ageing through focusing on an actress who had devoted her life to the theatre and was publicly very successful but whose private life was failing. Myrtle, played by Rowland, is an actress in her forties, who, whilst rehearsing her comeback role, witnesses a teenage fan being run over outside the theatre. She then becomes haunted by her figure, which leads to a breakdown during rehearsals. On the opening night of the play she gets so drunk she can barely stand but the play is a success and the film ends as the group celebrates backstage.

The film was shot over a five-month period from November 1976 to March 1977 and although it had a slightly higher budget than his previous work, it was still entirely financed by the director. Cassavetes only gave the actors the information their characters had about other characters and situations so that their reactions would remain spontaneous. Parts were re-scripted and re-shot and Cassavetes shot a higher than average amount of footage, sometimes keeping the camera running after a take to keep the performances fresh.

Maria Viera describes how the film is determined by the characters behaving in a particular environment and as such there is not a conventional plot or denouement.

> The performances are grounded in a conception of character that shows the influence of both the naturalist and the modernist traditions; the characters are shaped by their specific social environments yet those environments are the source of fragmented, indeterminate psychological and social identities.
>
> (2004: 160)

In typical Cassavetes' style, the film is driven by the performances, particularly that of Gena Rowlands who plays Myrtle, and her relationships with her ex-partner (played by Cassavetes himself) and married director Manny (played by Ben Gazzara). Ambiguity is also embedded in their performances, with actors creating layers of subtext for their characters' motivations and then playing them

simultaneously. For instance, just after the girl has been knocked down, Myrtle, highly agitated, goes back to her apartment accompanied by Maurice. The latter is pressing her to leave, as the rest of the cast are waiting for them in a cab but Myrtle refuses. She downs several drinks and then impulsively kisses him. He refuses to be drawn to her on the basis that he has an unsympathetic role in the play and it wouldn't benefit him to be emotionally entangled with her. The camera stays on Myrtle at the end of the scene and, as Viera argues, it is unclear whether her meek 'OK' at the end of this sequence is submitting to his authority or saving face (2004). Similarly it's unclear whether Maurice is still interested in re-kindling their relationship or if his concern for her emotional well-being by accompanying her upstairs is simply because of her economic importance to him by providing him with work. Therefore performances serve to obfuscate character motivations and intentions and the ambiguity is emphasized by the use of close ups again on actors' faces at key points in the scene. It is also underpinned by where scenes are set. Myrtle's apartment is very grand (there is a concierge at the entrance) but almost completely empty. Only a small side bedroom looks lived in and messy, indicating an inner chaos behind an ordered public façade.

This aspect of the public and private faces of Myrtle as an actress and as a woman is central to van Hove's adaptation, which was produced in the 2005–06 season and performed in Dutch. The *New York Times'* review indicated that one of the challenges for the adaptation was to translate the film's multiple locations that corresponded to 'personalities and inner states' into one singular spatial formation (Sellar 2008: n.pag.). Versweyveld's set therefore contained an actual stage set within the set, so that both backstage and onstage could be seen by the audience, thus underlining Cassavetes' use of the stage as metaphor, for the blurring of boundaries between public, private and personal spaces. Audiences were divided between the actual audience in the auditorium and specially selected audience members who provided the audience for the play within the play. The adaptation still centralized Myrtle but the unknown fan, knocked down at the beginning, became a constant onstage presence, representing the youth that Myrtle tries to recapture. The production also used screens on stage to recreate the intimacy of the close ups from the film by live filming the actors so the audiences could see faces in close up at the same time as taking in the actors' position in the whole stage space. This gives the audience responsibility for cross cutting from the 'wide shot' to the close up. Van Hove claimed that the camera framing was like that used in soap opera and likened the screens to masks in Greek theatre where intimate human expression could be communicated on a broad canvas (Willinger 2018: 110). Screens on stage are an important feature of van Hove and Versweyveld's design aesthetic. Whilst very obviously referring to the existence of a filmed version of the same text, they also work to give differentiated perspectives

on the action, both objective and subjective. Therefore the audience's view of the action on stage is in 'perpetual movement' (Goriely 2018: 341), which corresponds to the camera work in the original film. King argues that the camera movements in the movie are underpinned by an 'enunciatory ambiguity', so that instead of a scene being constructed by shots and reverse shots, it is unclear to whose perspective the frame is communicating. King calls this 'free indirect affect' and contends that it is introduced from the very beginning of the film:

> From behind the wings to the edge of the orchestra pit, from on stage to the rear of the audience, the look of the camera remains mobile and in the middle of things, declining to fix itself to a privileged eyeline, declining to state where one look ends and another begins, avoiding easy paths of identification. The camera's look, this sequence seems to indicate, is to remain at all times oblique and indirect.
>
> (2004: 107)

In the play, cameras constantly follow Myrtle around as impolitely as possible, capturing her body and to an even greater degree her face, and projecting that image onto several screens, the largest of which dominates the stage. A part of the audience – in an intra-diegetic manner – is invited to be the audience watching the play-within-the play in which Myrtle is constrained to act and maintain her image as 'grande dame' of the theatre. This multiplicity of perspectives therefore emphasizes the inner world of the protagonist, her public image and the challenges facing her as an actress, and echoes the enunciatory ambiguity identified by King in the film.

> We are often left unsure whether what we're seeing is of the play or outside it, whether the actors are playing to the mini-audience that has been assembled onstage or the larger one beyond it.
>
> (Brantley 2008: n.pag.)

As in all of these productions, form and content align: the staging points to the way in which the original Cassavetes' film depicts Myrtle's crisis as an actress threatened by advancing age, questioning her very selfhood, yet forced to utilize that self as the basis for her art, under the pressure exerted by her male colleagues and collaborators, as well as the audience, who in fact propel the compulsion to 'act'. The co-presence of different media in the piece also draws attention to the differences between acting for the camera and acting on stage and works as a deconstruction of the dominant cinematic conventions shaping acting on screen. We are placed in a kind of hall of mirrors, where the self/selves are not revealed

by performance in a traditional Method sense but instead produced by it; a by-product of live and mediated performance.

Van Hove's third adaptation of a Cassavetes film was *Husbands* in 2012 for Toneelgroep Amsterdam, which toured in Europe during the 2012–13 season. The film was van Hove's 'first love' and Venning notes that van Hove wanted to adapt the film before *Opening Night* but was refused permission initially by the Cassavetes' estate (2009: 466). The film was made by Cassavetes in 1970 and is similar to his other films, in that it offers little concession to the audience in terms of narrative progression and sympathetic characterization. It is also full of emotional intensity in its depiction of the inner lives of three middle-aged American men, at a moment of existential crisis in their existence, after the death of their mutual friend. The director himself played Gus, with his frequent collaborators Peter Falk and Ben Gazzara playing Archie and Harry. It is, again, very much an actor's film, intensively worked through by the actors in rehearsal but given space in the film itself to develop spontaneous characterizations. The film is marked by a thematic continuity with Cassavetes' other works in showing life as a performance and performance as life, with the paradoxical need to express something genuine and real in that performance. In common with other Cassavetes' films, the three protagonists have made little progress in relation to the crises in their lives, with one running away to London and the other two returning to their previous suburban existences. Van Hove's interpretation of the film centralizes the theme of acting out.

> I see *Husbands* as a play that is all about performance. Three men having a crisis who indulge in drinking, singing, gambling, sex and women. The men cross all the boundaries of their daily existence and then comes disillusionment. Or the way out?
>
> (van Hove cited in Toneelgroep Amsterdam n.d.: n.pag.)

Versweyveld's set design was set on an angle showing two walls in wood panelling that provided the space of the basement where the three protagonists go after their friend's funeral. Two screens, a smaller one within the set itself and a larger one above the set and facing the audience, projected close ups of the protagonists. Van Hove's adaptation was faithful to the film, although he used theatrical means to comment on the film by having the three female characters who the men encounter played by the same actress to highlight the protagonists' problematic attitude to women.

Overall, van Hove's adaptations of these Cassavetes' films are not as straightforward as Eldridge's stage re-working of *Festen*. Van Hove's insistence

in working from the screenplays rather than the films themselves is undermined by the close visual similarities in evidence between film and stage adaptations. Yet these works can also be read in relation to the broader sweep of his directorial works as a way of challenging the established canon of classic theatre. There are also traces of reflecting on the medium specificity of theatre through the references to the film sources in the adaptation, which has come to be a marker of the screen-to-stage adaptation in the new millennium. As Julie Sanders has argued:

> The complex relationship between his theatrical creations and their adaptation of pre-existent artworks, is not a simple matter of remaking or even repurposing for a new medium. It is a philosophical question about what is possible in theatre.
>
> (2018: 78)

Adapting Hollywood

Contrary to the critical rapture with which van Hove's adaptations of films have been greeted (one exception being the generally lukewarm reception to *Ossessione* at the National Theatre in 2017), adaptations of Hollywood films have been generally dismissed as having more commercial than artistic aspirations and often are found to be painfully lacking in comparison to the film. Michael Billington's review of a stage adaptation of Mike Nichols' *The Graduate* (1969), in 2000, is a case in point:

> What we are left with is a thin story about a morose kid who chucks his chances in life and gets away with it. In the movie we accepted it because of Hoffman, the Simon and Garfunkel score and Nichols's glitzy stylishness. Without those magic ingredients, *The Graduate* simply ends up looking sophomoric.
>
> (Billington 2000: n.pag.)

In terms of the predominance of stage adaptations of films on Broadway (a trip with my daughter in October 2019 saw us choosing between *Frozen*, *Waitress* and *Beetlejuice*), Wickstrom reminds us that this market largely consists of tourists passing through New York and so productions are designed to appeal to an international audience (1999). Adaptations of well-known and loved films offer this transient audience a familiar product, which provides them with a predictable element in what might otherwise be a high-risk purchase. As Green observes, such productions 'can target a potential audience that includes those otherwise

put off by the aura of high culture that surrounds theatre' (2011: 3). In some cases, these adaptations have been understood in terms of franchise culture where a brand disseminates its product across multi platforms to ensure profitability. Thus reproduction and replication are essential to maintaining brand identity. Parody argues this model responds to the seismic technological and industrial shifts post 2000 that 'have produced media landscapes dominated and defined by all kinds of remediation and cross-platform production' (2011: 211). Thus 'performance' is reconfigured as 'content' to be repackaged and redistributed across multiple locations. Yet not all adaptations of Hollywood films operate within mass or franchise theatrical culture. There has also been a recent vogue for solo performances and alternative, 'fringe' adaptations of popular films, which are playful in their engagements with not just the narratives but the cultural meanings engendered by these textual products.

Two examples from opposite ends of this broad spectrum are *The Lion King*, which marked the corporate giant Disney's second adaptation of its animation portfolio into theatrical entertainment and is still playing in theatres worldwide nearly twenty years after its premiere, and a very low budget adaptation of Spielberg's *Jurassic Park*, produced for the Edinburgh Fringe and the UK small theatre touring circuit in 2015. On the surface, these adaptations couldn't be more different, with *The Lion King* replicating the popular success of the animated film with a high concept and budget musical theatre production, whilst Superbolt's DIY *Jurassic Park* exploits its inability to match the sophisticated visual effects of its predecessor. One is the product of globalized neo-liberalism whilst the other comes out of fringe theatre culture in the United Kingdom. However, they both exploit the potentialities of the live theatrical encounter in terms of utilizing the human actor's body to apprehend the fantastical, with *The Lion King* marking the change from animation to live performers and *Jurassic Park* from computer-generated imagery (CGI) to effects physicalized by co-present human beings.

The Lion King, the musical, had its Broadway premiere on 13 November 1997 at the New Amsterdam Theater and since then has gone onto to spawn 24 versions globally and become the highest grossing musical of all time. Disney's purchase and refurbishment of the New Amsterdam, initially for their stage adaptation of *Beauty and the Beast* in 1995, was part of Disney Theatrical Productions' (DTP) gentrification of the old theatrical district in New York, now dubbed New Times Square. This marked a shift in the composition of Broadway by bringing together both entertainment and retail provision in the same area (Wickstrom 1999).

Signalling their desire to break down cultural hierarchies, Disney hired the 'avant-garde' theatre artist Julie Taymor to helm the adaptation from screen to stage. Julie Taymor's own account stresses her determination to make the stage

adaptation different from the film, stating that 'a production I directed and designed would neither duplicate the film nor aim for realism, but would have its own distinct look and personality', thus explicitly intervening in the text with her authorial signature (Taymor and Greene 1997: 21).

Taymor instigated changes by grafting a coming of age/prodigal son story onto the film narrative. There was more space and psychological development given to female characters such as Nala and the narrator was made female and given a name, Rafiki, and a function in the story, as a kind of shaman. The music of the original animation was expanded with new songs by Elton John and Tim Rice but also from the South African musician Lebo M. Published accounts again emphasize the personal nature of the undertaking for Lebo M, who escaped from Soweto at the age of 14, because of apartheid. M recalls:

> The *Lion King* project came to me at a crucial and critical time in my life and my country's history, when serious changes were taking place. Most of the characters in the movie became human beings to me, because I associated Mufasa with Mandela, and I associated Simba with myself.
>
> (cited in Taymor and Greene 1997: 19)

Most distinctively, Taymor wanted the human actor and the animal that they were playing to be visible to the audience. Therefore some of the actors wore masks that sat above their heads or the human actor would manipulate an animal puppet. Each puppet was designed to allow for the actor to move like the animal, so, for example, the actor portraying a giraffe played it on four stilts to give the illusion of four long legs. This visibility was extended to the stage set. Taymor and designer Richard Hudson created a Pride Rock that emerged from the stage floor in full view of the audience at the beginning, exposing the mechanics of the scenery. All these elements were bought together in the opening number as each animal moved through the audience to gather on stage and present themselves to the audience. Thus theatrical spectacle that announced its difference from the film was embedded in the production from the start.

> Magic can exist in blatantly showing how theatre is created rather than hiding the 'how.' The spectacle of a stage transforming, of Pride Rock coming into being before one's eyes, is more visually compelling, more entertaining than drawing a curtain and seeing the piece of scenery already in place.
>
> (Taymor and Greene 1997: 29)

This particular emphasis on theatricality in the adaptation of *The Lion King* was very much the source of the critical approval the production engendered

from the beginning. However, this meeting of the avant-garde and the commercial has not been without controversy. Whilst David Savran argues that Taymor and her team's modifications of the film for the stage production can be understood as codifications that manage 'to preserve something of the uniqueness that has always been expected of a theatrical performance' (2003: 87), Wickstrom is more critical.

> The rhetoric of complexity and artistry as the special attributes of the theatre become a kind of alibi for the commodified Disney context in which the production takes place, all the while facilitating the circulation of objects and images from the play as commodities. This circulation is both abstract – on the level of general commodity formation – and quite literal, as consumers and objects for purchase move from the theatre to the store next door.
>
> (1999: 293)

Thus Disney can be understood as drawing on the cultural capital of the 'avant-garde' theatre to remediate the film and generate profit within a neo-liberal globalized culture industry. By 2001, Disney's new corporate model for major Disney productions therefore involved a 'beloved Disney property' shaped by the vision of an 'accomplished avant-garde artist', with the promise of both commercial and critical success (Boehm 2003: 34).

However not all adaptations of Hollywood films are franchised corporate behemoths. At the Edinburgh Fringe Festival in 2015, two companies gave very different renditions of their source texts. *Nathan Cassidy: Back to the Future* by Nathan Cassidy and Superbolt's production of *Jurassic Park* at the Assembly Roxy were clearly framed as fan tributes to these films, in which the impossibility of recreating the films' visual effects onstage became a kind of affirmation of the uniqueness of the live theatrical experience. Collins has noted in her review of the Edinburgh festival that year that its 'spirit' was 'marked by a form of nostalgia, a harking back to, and a yearning for, a notion of a more "stable" past in the face of a frightening and uncertain future' (2015: 257). She argues that this was manifested in the abundance of adaptations of films to the stage, where a sense of absence and of loss is encoded in the shadowy co-presence of the original film alongside these stage renditions.

Adapted from Michael Crichton's novel, *Jurassic Park* (1993) was the film that rescued its director Steven Spielberg from the critical and commercial disaster of *Hook* (1991). The film is a cautionary story about the cloning of dinosaurs to populate a wildlife park on a small island off the coast of Costa Rica. The film was one of the first to use CGI to spectacular effect in the creation of the dinosaurs and one of its most iconic moments is when the audience sees these

creatures fully for the first time. In typical Spielberg fashion, up to this point, the audience have been teased with the promise of the spectacle of the dinosaurs but just given small glimpses (e.g. an eye peeking through the foliage), to enhance their anticipation. During owner Hammond's (Richard Attenborough) welcome to his visitors, the camera catches palaeontologist Dr Alan Grant (Sam Neill) as he looks off camera, amazed at what he is seeing. We then cut to the object of this look, as we see the dinosaurs in their full glory. Grant's look then epitomizes the dual discourse that is mobilized by the film as the character marvels at the cloned animals and the extra-diegetic spectator is equally entranced by the wonders of what they know to be computer-animated dinosaurs. The pleasures and pitfalls of cinema itself are thus invoked by the film, in that the extra-diegetic spectator is aware of the dinosaurs' artifice, yet nevertheless succumbs to the thrills that their reconstruction produces.

Jurassic Park's distinctive logo (the shadow of a dinosaur on a red-and-yellow circular background) also has a dual function in the film. In Hammond's gift shop the characters are shown souvenirs of the park with the same logo that matches the souvenirs sold in cinema foyers at the time. This intra- and extra-diegetic brand universe extends to Universal Studios' *Jurassic Park* rides, utilizing effects developed for the film, as King argues, 'a theme-park ride based on the movie about a theme park, a ride that delivers the visitor conveniently to its retail outlet' (King 2000: 42).

The film therefore positions itself as being both part of and critiquing capitalist production by embodying the contradictions between the film and its merchandising allure and its self-reflexive awareness of the audience as consumers. As Geoff King concludes:

> We can let ourselves go, surrender to the 'wonders' of convincingly-rendered dinosaurs [...] but at the same time retain an element of distance and control through our awareness that we are allowing ourselves to delight in an illusion; and, further, that we are delighting in it precisely because of its quality as illusion.
>
> (2000: 56)

This self-reflexivity about the cinematic illusion is addressed by the stage adaptation in a number of different ways. Firstly they frame the adaptation by setting it in the 'unlikely', in the Hollywood sense, setting of Lyme Regis Community Centre, where a family have gathered to remember their late mother. As the website goes on to relate:

> When things go wrong, family feuds are faced with the rapturous roar of DIY dinosaurs. This laugh-out-loud spin on Spielberg's classic is a

theatrical celebration of cinematic nostalgia and a moving reminder of the ones we love.

<div align="right">(Superbolt Theatre n.d.: n.pag.)</div>

The adaptation's reconfiguration of the iconography of the film is evident from the set that is made up of a sand-coloured carpet and groups of house plants running along either side. These everyday domestic plants are witty reminders of the rainforest location of most of the film, but also have a practical function marking entrances and exits and foliage for the actors or the dinosaurs to hide behind. This is a way to reference a key *image* in the film, that of the first moment when the dinosaur is seen by the film audience after a big build-up as an eye blinking in the dense jungle foliage. In the play, an actor positions himself behind a plant and frames his eye with his four fingers, signalling this moment and provoking a kind of double recognition; of the image and its stage recreation.

The first moment of seeing the full set of dinosaurs in the wild in the film is also given prominence in the adaptation through ingenious means. Lighting is used to flood the stage with green light as music from the film score is played through the speakers. The actors look out at the audience as if in awe at seeing the dinosaurs but then they turn round and cleverly use their bodies to actually turn into the dinosaurs they are seeing. As actors trained in physical theatre at Lecoq, their ability to suggest these animals with small changes of posture is highly skilled. The same double bind for the audience exists as in the film, by suspending disbelief to succumb to the theatrical illusion and wonder at the means by which it is achieved through human creativity and actorly skill.

This playfulness with scale is demonstrated by another moment when a remote-control toy helicopter flies close to the audience's heads, whilst a sound recording of a full size one is played in the auditorium. The referential power of objects in the theatre space is further shown when 'a rucksack becomes the gaping mouth of a Velociraptor' chasing after the children and 'the sudden opening of an umbrella behind the head of one of the performers accompanied by high-pitched screeching summons up a Dilophosaurus' (Collins 2015: 258). Thus part of the appeal of the stage adaptation is how inventively it actually *fails* to be the film, instead imbuing objects with rhetorical power to imaginatively reconstruct key moments of action in the film.

Hanging in the middle of the stage in front of black drapes, and a constant presence during the onstage action, is the *Jurassic Park* logo, which, as has been discussed before, has a double function, in that it both denotes the location of the action and points to an extra-diegetic brand identity existing outside of the theatre production. However, the effect, when contrasted with this minimalistic rendition of a blockbuster Hollywood film, seems to point to the way that this live

theatrical encounter exists outside capitalism. In common with other stage adaptations of films (discussed in Chapter 6), Superbolt's *Jurassic Park* also works to summon up nostalgia for what it perceives is the 'lost world' of family viewing. As one of the company members states in *The Guardian*, 'These mainstream classics brought families of all kinds together, which seems to be happening a bit less today as we consume entertainment more individually' (Walters 2015). Therefore the opportunities for community engendered by the coming together of audience and performers in the same space facilitates a kind of longing, not just for the film but for the event of collectively seeing the film, however much its referent is more of an imagined past than a reality.

Both *The Lion King* and *Jurassic Park* can then, in different ways, be understood in relation to the commodification of culture effected by changes in global capitalism in the new millennium. As Stuart Nishan Green has pointed out, 'analyses of the remediation of cinema on stage must take into consideration social and cultural factors specific to the period in which a particular play [or, in the context of the present study, film] was written or performed' (2011: 42). Whereas *The Lion King* materializes the Disney brand identity in combining a well-loved film source with an explicitly theatrical reinvention to diversify its product base, *Jurassic Park* utilizes the live theatrical encounter between performers and audience to articulate a longing for a pre-lapsarian collective engagement with the original material in particular and cinema more generally.

In conclusion, the rapidly growing popularity of screen-to-stage adaptation suggests that theatre makers are transferring material from recorded to live media with a range of different stage strategies.

> That Broadway and Off-Broadway artists are drawing their sources from the world of independent film speaks to an expanded cultural understanding of the unique ways in which texts and media might converse with one another.
>
> (Grossman 2015: 33)

This suggests that there are creative and not just commercial reasons why theatre might choose to engage with the film canon or draw inspiration from cinematic productions and use the staging of these texts to demonstrate their reading and/ or affective experience of it. That this seems to be a practice that has characterized the first two decades of the twenty-first century suggests not only that theatre can be understood now as just another medium, another way of extending 'content' through repurposing, but also that theatre offers a particular way of experiencing a film anew. In the next chapter, I will be extending my analysis of adaptations between stage and screen by showing how in the twenty-first century, the cinema has put forward a particular way in which audiences can experience a play in a

new way, the live broadcast of plays to cinema screens, thus expanding the notion of performance examined to enfranchise its status as live event.

NOTE

1. See Yoshitaka (2013) for a definition of the haptic in relation to Deleuze's '*logique de la sensation*' (1981).

3

Stage-to-Screen Adaptation and the Performance Event: Live Broadcast as Adaptation

The scene is the Printworks multiplex cinema in Manchester on an April night in 2010. The curtain has just gone down in London on the first half of the National Theatre production of Alan Bennett's hit play the Habit of Art, *starring Richard Griffiths. The theatre audience in London applauds enthusiastically and the cinema audience at the new NT Live screening of the performance in Manchester look round at each other, with slightly bewildered expressions as if waiting for someone to give them a cue. An usherette then appears at the bottom right hand corner of the auditorium and indicates that the audiences should leave the cinema, so some then shuffle out of their seats down the corridor and out into the main atrium of the Printworks where a rope barrier has been erected to separate this audience out from the other cinema audiences, channelling them towards a bar area hastily reconfigured from a popcorn and ice cream stand. White wine is offered in plastic cups. As the theatre patrons sip their wine, they gaze out over the rope barrier to where small groups of teenagers in hoodies, holding oversize cartons of Coca Cola and popcorn, jam money in constantly beeping banks of slot machines. This is now getting disturbing [...] not least for the teenagers in hoodies.*[1]

What I have found thrilling about these broadcasts is the event of it. This is no second-hand experience. You do not sit back in the cinema thinking how much better it would be to be sitting in the theatre, because you feel part of the same live audience.

(Doran 2014: 11)

These two quite opposing descriptions of a live cinema broadcast indicate how quickly audiences have accommodated themselves to this still fairly recent type of cinematic experience. The first passage describes one of the inaugural live cinema broadcasts and demonstrates how uncertainty from both the audience and the host venue about how to classify the screening led to an almost comical mixing of theatre and cinema-going rituals and reversals of cultural hierarchies. However the second passage, written four years later, shows that viewing codes have become more established and it's clear that Doran (perhaps not co-incidentally as the Artistic Director of the RSC) does not consider it a problem for the cinema audience to be dislocated in space from the theatre audience, significantly describing his pleasure as one of engagement with the 'event'. This chapter will extend the analysis of adaptations between stage and screen to consider the notion of the performance event through examining the recent case of live theatre broadcasting to cinemas. As Wardle has argued, these broadcasts trouble traditional comparisons between live theatre and recorded film (2014: 134). Whereas the previous chapters tracked differences in the performance elements between stage and screen, the 'liveness' of the live broadcast, I argue, adds an extra dimension to be considered in the adaptive process; that of the theatrical 'event'. Adaptation in this sense is much more than adapting the theatrical to the cinematic, as discussed in Chapter 1; here, it is about adapting the theatrical event because a new event is created, one that is qualitatively different than the event of witnessing the play in the theatre. I argue that theatre seeks to appropriate the benefits of the cinema – its reach and reproducibility – whilst claiming to preserve what is deemed to be essentially theatrical – the live 'event', defined here by Sauter.

> Theatre manifests itself as an event which includes both the presentation of actions and the reactions of the spectators, who are present at the very moment of the creation. Together the actions and reactions constitute the theatrical event.
>
> (Sauter 2014: 11)

This locates the event in terms of the spatial and temporal co-presence of both the performance and the audience. Obviously, what live theatre broadcasts offer their audiences is the promise of temporal simultaneity, but at a distance from the event itself. There is therefore the allure of liveness – being a co-witness to the event as it happens, with the audience in the cinema mirroring the audience in the theatre auditorium – all sharing access to the 'same' experience. This is clear from a telling phrase in the NESTA (National Endowment for Science, Technology and the Arts) report on the thinking behind NT Live, the first theatre to cinema broadcast in the United Kingdom, that 'the intention was to preserve a sense of event so that the collective experience of the performance should remain consistent for all audiences' (NESTA n.d.: n.pag.).

In this chapter I will examine how the preservation of 'a sense of event' has been embedded in emerging practices, from a public emphasis on the 'liveness' of the event and developing conventions of presentation to how social media is used to reconfigure a 'collective experience' for the audience in the digital age. As Hadley contends, 'social media has the potential to expand the ways in which spectators engage with a theatre work, and, equally importantly, the range of spectators engaging with a theatre work' (2017: 5). However, I will also investigate how evolving patterns of digital spectatorship and participation have led to a reconfiguration of 'liveness', marked more by the perception of it by audiences than a 'being present' at the moment of creation. This can be evidenced by the number of what have been termed 'encore' screenings (using self-consciously theatrical terminology) where the live broadcast of theatrical performance is repeated in the cinema some days or months after it first occurred. This is often for practicality – the worldwide audiences for live cinema broadcasts are often in a different time-zone when the performance is actually taking place and so a time delay allows a viewing at a more socially acceptable time. But it is also often to maximize audiences for a particular play (often where there is a star performer) and cinema broadcasts of, for example, Benedict Cumberbatch's *Hamlet* for NT Live can take place years after the actual live transmission. Therefore these performances of live broadcasts are not just separated spatially from the cinema audiences but temporally as well. Research has claimed that audiences still respond to these events as if they were live (NESTA n.d.: n.pag.).

The growth in live theatre broadcasting to cinemas is almost matched by the growth in academic scholarship on the subject (Barker 2012; Cochrane and Bonner 2014; Wardle 2014; Wyver 2015; Stone 2016; Sullivan 2017; Way 2017; Hitchman 2018; Aebischer et al. 2018; Wyver 2019). This work has vastly increased the frames of reference and understandings of live cinema broadcasting, although only Way has thought about the live broadcast in relation to a notion of the event (2017). I will look at the work of the two leading UK theatre companies who currently broadcast their repertoire live to cinemas. NT Live is the dedicated in-house production company of the Royal National Theatre (RNT) in London, set up in 2010 for audiences to 'Experience the best of British Theatre at a cinema near you' (National Theatre Live n.d.a: n.pag.). I will examine the rhetoric of 'liveness' associated with the NT Live brand and how this facilitates adaptation of the theatrical event for cinema audiences. The RSC (Royal Shakespeare Company) started live broadcasting later than the RNT in 2014 and I will look closely at a production of *Romeo and Juliet* (RSC 2018–19), experienced by the author both as a performance and as a live broadcast in order to analyse what adaptations are made to the live performance to transmit it to cinema audiences. This means I can draw on academic debates, interviews with production staff and my experience as an

audience member to provide a more nuanced understanding of the actual production, without of course claiming to speak for the entire audience. One factor affecting access is that NT Live does not release productions on DVD because they feel that it would change the nature of the experience. This means that, quite like theatre productions, the opportunities for close analysis are framed by either one viewing or by viewings of encore screenings when available.[2] The RSC do release their broadcasts after they have exhausted the possibilities for public screenings, so a closer scrutiny of shot choices and live mixing is possible here, though with the caveat that it's received on a television screen within an individual rather than collective viewing context.

The repertoire of live broadcasts has developed since the first NT Live broadcast in 2009. Aebischer et al. point out that most live broadcasts favour classic play texts that are set on proscenium stages and are incapable of engaging with site-specific or participatory work in which the audience is part of the co-creation of the performance (2018: 3). However even this paradigm is no longer applicable with the broadcast of performances that have different kinds of staging such as the Bridge Theatre's *Julius Caesar* in 2018, which organized the play as a promenade performance in which the audience were an integral component.[3] Greenhalgh also points out that as live broadcasting has become more established, there has been a growth in productions of Shakespeare in the theatre as these are seen as more appealing to international audiences in the cinema (2018: 22). Whilst the broadcast of Shakespeare is at the heart of the RSC's access policy (and underpins their use of the medium for their Schools Project), it is evident that the RNT have also increased their production of Shakespeare plays over the last twenty years (perhaps not coincidentally whilst straight film adaptations of Shakespeare seem to have diminished). Whilst the cost of live broadcast would seem prohibitive to many smaller or even repertory companies, the growth of companies willing to broadcast productions on an ad hoc basis might seem to offer the possibility of a more varied live broadcast repertoire in the future.

Whilst the broadcasts are often framed by Artistic Directors of publicly funded institutions as fulfilling their access and engagement remits to justify this income, it is clear that they also represent the opening up of opportunities in an increasingly globalized cultural marketplace. Susan Bennett has detailed how the growth of live theatre broadcasts in the United Kingdom can be linked to the Lottery-funded UK Film Council providing substantive capital investment for digital projectors in cinemas countrywide, thus prompting the need to find new revenue streams to refinance the outlay (Bennett 2018: 42). The growth of commercial companies such as More2Screen whose team broadcast theatre from the West End, alongside opera and music events, is testament to the commercial potential of live cinema broadcasts. This is linked to ideas of 'eventness' as what is being sold is

an 'experience' that is distinguishable from other cultural activities in the global marketplace. In this, it is an essentially neo-liberalistic enterprise in the way that David Harvey describes:

> The social good will be maximised by maximising the reach and frequency of market transactions and it seeks to bring all human action into the domain of the market.
>
> (Harvey 2007: 3)

Such demand for new 'experiences' has driven what the final section of this chapter will explore, the 'eventness' of 'live cinema'. I argue that the live broadcasting to cinemas of material *as it is being shot* can be understood in the same way as the adaptation of a theatrical event in the cinemas, in that it harnesses audience and event temporal co-presence, even if it uncouples them spatially.

The adaptation of live theatre performance to the screen is not of course only a recent phenomenon. Cultural antecedents, in the United Kingdom at least, can be traced back to early television drama in the brief period between the beginning of television broadcasting in 1936 and its closure before the Second World War. As I have detailed elsewhere, the first OB (outside broadcast) of a performance directly from the West End was J.B. Priestley's *When We Are Married* in November 1938. It was marked by many of the same blurring of the boundaries between theatrical and filmic conventions and the same cultural anxieties as the live theatre broadcast to cinemas today (Lowe forthcoming 2020). Director Basil Dean hailed the live broadcast as one that most approached what he termed 'a genuine theatre condition', distinguishable from the excerpts of plays performed at the Alexandra Palace studios and thus implicitly occupying a more elevated position in the cultural hierarchy because of their 'liveness'. One can also see many of the same paratextual conventions in the broadcast, such as an announcer to specifically guide the television viewer through the theatre event and a visual unfolding of the theatre programme in the frame, as if the television audience were leafing through it (Lowe forthcoming 2020).

However, it is clear that technology at the time was relatively crude and the quality of the live relay onto television screens was somewhat uneven. In fact after the war, the live broadcast from a theatre tended more towards variety than straight theatre with moves towards single-camera film adaptations of plays or multi-camera studio productions for television rather than the live broadcast of particular performances. The exception to this was the broadcast of a production of *Hamlet* in 1964 live from Broadway over two days to 2000 movie theatres in the United States, with the idea that several cities could experience the same performance simultaneously. Starring Richard Burton and directed by John Gielgud, seventeen cameras were used to film the performance. The technology

used for the transmission was called Electronovision and the broadcast was named Theatrofilm. The film was supposed to be destroyed after the transmission to preserve the sense of the live event, but copies of it were retained and it formed the basis for a Wooster Group re-enactment of the film onstage in 2006.

The live broadcast of cultural 'events' in the United Kingdom effectively started with the New York Met Opera's broadcasts to cinemas worldwide in 2007 and then the technology was adapted for the theatre for NT Live in 2009. In this chapter I will be concentrating on those streamed performances that have been live mixed simultaneously to being broadcast, rather than the digital productions that have filmed several productions and then mixed them in the editing suite to be broadcast either at a later time or to be accessed at the viewer's convenience. Examples of this include the 'Globe Player', the online on-demand player from Shakespeare's Globe Theatre in London, which has several productions on its site that can be downloaded by viewers for a small fee. Although this is an interesting area for further research, I am concentrating on the live broadcasts of theatre to cinema because of the particular focus of this book in looking at the way performance is adapted between the two mediums. By altering the audience's experience of the live performance through technological intervention, the live broadcast is a key site for the operation of theatre to cinema adaptation that focuses significantly on the 'event' of the performance and thus 'appropriates, refashions and indeed adapts the techniques, forms and social significance of both film and theatre for artistic and economic purposes' (Hitchman 2018: 45). Like Hitchman, I will be using the term 'broadcast' as although it is a term that is usually used in connection with television, I think that it most appropriately describes the parameters of the event. It is testament to the fact that this is still a developing phenomenon that a more precise terminology has not yet been agreed on and so various terms have been used by scholars from Barker's 'livecasting' (2012) to Cochrane and Bonner's use of 'relay' (2014). The terms used are important because certain ways of describing these broadcasts, such as relay, suggest a minimum of interference in mediating the theatre production for the cinema; important when 'liveness' is openly advertised as characterizing the experience for audiences. However, as John Wyver suggests, there has to be some 'inevitable and intentional creative mediation'. This involves controlling elements of the preproduction process, such as placement of cameras, setting of audio levels but also an openness by the director to capture whatever happens on the night, which means 'constant small adjustments by camera operators and others responding with sensitivity to the live encounter between a cast and an audience sharing the same space' (Wyver 2015: 290). Actors also talk about the differences between screen and stage acting and how they might 'adapt' their stage performance whilst it is being relayed through the cameras. For instance, in an interview with Helen Mirren to mark the tenth anniversary of the

first NT Live broadcast, she explained that the actors had to constantly calibrate between the audience in the theatre and the cinema:

> The unique challenge of live-streamed theatre [...] is that acting for camera is completely different to acting for a live audience. Which is why live theatre is more of a gamble than streaming opera or ballet, where audiences don't expect naturalism [...] We couldn't suddenly, quietly and in a more natural manner mumble the words in a lovely way that would look fabulous on camera but nobody more than two feet away could hear.
>
> (Ivan-zadeh 2019: n.pag.)

The question of the actor's experience of the live theatre broadcast is one that has only been really explored by Sharrock (2018) and offers much potential for further research. There are many conflicting testimonies from actors about their understanding of the effect of cameras during the livecast from Ralph Fiennes' documented hatred of the process (Sanderson 2019: n.pag.) to Ian McKellen's more nonchalant dismissal of it having any effect on his performance at all (cited in Sharrock 2018: 96).

Therefore the live broadcast represents a challenge to standard accounts of stage-to-screen adaptation, because whilst it is translating material from one medium to another, including the actor's performance and how it's presented to the audience, its liveness also denotes that it's translating what surrounds that material, namely the theatrical event.

NT Live

NT Live's first transmission, on 25 June 2009, was a performance of Racine's *Phèdre*, filmed on six cameras by director Robin Lough in the Lyttelton Theatre. The production was a translation by Ted Hughes and was directed by the RNT's Artistic Director, Nicholas Hytner. In a convention that has now been established as core to these broadcasts, the featuring of Mirren was strategic in appealing to both theatre and cinema audiences; as a well-known international stage and screen actress, she had recently won an Oscar for Best Actress for *The Queen* (Frears, 2009). The performance that night played to approximately 900 people on the South Bank, but was then seen by an additional 14,000 in the United Kingdom and a further 14,000 in the United States and Europe – in other words, 96 per cent of the audience that night watched the performance in cinemas (NESTA n.d.: n.pag.).

This first performance was the result of a new initiative by Hytner, to investigate the possibilities of exploiting new digital technology in UK cinemas in order

to expand audiences for the RNT's repertoire. He appointed David Sabel, who was trained in both theatre and business management, as the first producer of a two-production 'season' that included *Phèdre* and *All's Well That Ends Well*. Both Hytner and Sabel were at pains to emphasize from the outset of the project that it was an experiment in increasing access for established theatre audiences and building new ones to justify the contribution of public funding to the RNT, where, in the language of Blairite Britain, cultural value was invested in the idea of public access and engagement. Despite the RNT's touring, audiences for RNT productions very much depended on proximity to their main theatre building in London, with ticket prices (despite some subsidized cheaper-on-the-day tickets) set prohibitively high. Digital technology had been used to broadcast opera, most notably with the Metropolitan Opera in New York, but this was the first time it had been tried with the theatre. It was initially broadcast to what were broadly defined as 'art cinemas' in the United Kingdom, across Europe and the United States but made its way into the multiplex under the banner of 'alternative content'. Tickets were priced at rates higher than the average cinema admission to differentiate these broadcasts from other films in the host cinema, but were still below the average theatre ticket.

From the start it was clear that NT Live was both a commercial and critical success. By April 2010, the National Theatre had produced four full-length productions for NT Live. These productions were initially shown in a self-consciously theatrical 'season' of NT Live broadcasts (adding to the sense of event), whereas now they have settled down into relatively regular screenings of selected performances from the repertoire about every two months. The choice of broadcasts reflects the mixed repertoire of classics and new writing that makes up the RNT's stable of productions, although arguably they lean more towards plays that are already established. NT Live as a distinct specialized broadcasting unit now also facilitates screenings from other theatres under their distinctive 'brand', which has been uncoupled from the RNT. These include productions such as Ivo van Hove's *All About Eve* at the Noel Coward Theatre, London (2019) and the Manchester International Festival's transmission of Kenneth Branagh's *Macbeth* (2013). NT Live's evolution has been swift. As of 2019, it broadcasts to over 2500 venues across 65 different territories, with approximately 700 venues in the United Kingdom alone (National Theatre Live n.d.a: n.pag.).

Everything is publicized through NT Live's own dedicated website, through trailers in the cinema and on social media, with individual Facebook pages and Twitter accounts both for the NT Live brand and for individual broadcasts. NT Live relies heavily on cinema-style trailers that are shown on social media accounts and in the cinemas transmitting the broadcasts to raise audience awareness of what is next in the programme. The trailers initially utilized recognizable film

genre conventions presumably to attract what was assumed to be non-traditional theatre audiences to this new kind of cinematic event. For instance a 2011 trailer to publicize *One Man, Two Guvnors* drew clearly on Guy Ritchie's British comic gangster film *Lock, Stock and Two Smoking Barrels* (1998) in both visual aesthetics and sound. Both trailers featured gravelly cockney male voice-overs naming the characters accompanied by freeze frames from the play/film. Both had a fast-paced editing style and foregrounded the more clearly recognizable actors in the film/play. In the case of *One Man*, this meant featuring James Corden, who was recognizable from his television series *Gavin and Stacey* (2007–10) as well as from film roles such as Timms in *The History Boys* (2006). As NT Live has evolved, it is noticeable that trailers have focused more on the actual stage shows themselves, without recourse to film trailer conventions to attract audiences. For instance a trailer for the RNT production of *Small Island* (2019) showed actors delivering key lines from the theatre show under written titles demonstrating its five-star reviews from a variety of publications (National Theatre Live n.d.b: n.pag.).

The NT Live shows are produced in-house with filming integrated early into the production process. Performances are shown to the camera director who then, in collaboration with the stage director of the show, puts together a potential shot list. On the night the performance is transmitted using multi-cameras and mixed live on air to give a sense that the camera could potentially capture impromptu moments of performance. Presentational aesthetics of these productions to a certain extent depend on the original staging strategies but can be generalized as

> a balancing act between wide stage shots (to maintain overall production design and to convey blocking), two shots (for key dialogue scenes) and semi close ups (close enough to make monologues and moments of focused emotion emphatic but semi for the sake of theatre's larger bodily gestures).
>
> (Barker 2012: 19)

As the live-to-cinema practice has developed, there has been some debate as to whether individual theatres have developed a kind of 'house style'. For instance, John Wyver in a review of the live broadcast of the NT's *Hamlet* in 2014 drew attention to NT Live's over-use of the close up in their broadcasts, which in the case of the *Hamlet* then effectively closed down the remote audience's understanding of the meta-theatricality of the set and staging strategies of the original production.

> The cameras closed in on the action, framing the characters within the set and excluding (apart from frequent glimpses of the tape-marked floor) the frames, poles, and bars of the self-reflexively theatrical design.
>
> (Wyver 2014: 262)

It is open to question whether this was a cinematic framing of a star performance from Cumberbatch but publicly NT Live is keen to emphasize that the screenings don't necessarily try and change performance for the cinema space but show the original directorial strategies of the show. Tim van Someren, who directed the screen version of James Graham's *This House* in 2013, tells actors, 'our aim is to film your performance, not shape your performance for film'. He claims that the 'key is to remember it's not just a play – it's tonight's performance at the Olivier theatre', a distinction that makes clear that this is an adaptation of a *performance* rather than a play (Trueman 2013: n.pag.).

Robin Lough has described how particular shots might be used to interpret a moment of stage action and re-present it to the cinema audiences but claims that nothing should be too obvious:

> A crane shot or a gentle track can greatly enhance the drama as long as it is done subtly. The cinema audience should always feel totally engaged with the stage production without ever noticing how the transformation to screen is taking place.
>
> (cited in Sandwell 2012: n.pag.)

There are also subtle changes in costume, lighting and sound levels to render what is on stage suitable for transmission by the cameras. Traditional stage make-up is often deemed too heavy for the camera, which is high definition and therefore picks up every detail. As NT Live's make-up supervisor Giuseppe Cannas explains, 'HD is extremely unforgiving [...] Everything needs to be toned down: eyebrows, mouth, contouring, thickness of foundation'. Even stage wigs are redone to replace thicker hair creations with more natural 'camera friendly' hair (Trueman 2013: n.pag.).

Therefore adapting the performance makes it possible for the cinema audience member to encounter it 'as if' they were in the theatre. This extends to whether the actual theatre audiences are seen in the shot or not. Greenhalgh claims as live broadcast conventions have developed this has also become a matter of 'house style' claiming that once the broadcast is underway, they are rigorously excluded by NT Live so as to give the cinema audience the same perspective as a member of the theatre audience (2014: 255). However, there will often be footage of the theatre audience entering the auditorium so as to give the remote audiences the same sense of gathering anticipation, even if it is effectively a visual reminder of the spatial dislocation from the site of performance. Shots of the actual equipment needed to produce the broadcast are necessarily excluded so as not to draw attention to the means of production although with some types of staging such as promenade it becomes logistically impossible to

remove all evidence of the cameras and it seems as if audiences are now more accepting of these traces.

However, to give cinema audiences a kind of bonus viewpoint on the action, there is evidence of directors allowing the camera to offer perspectives on the stage action that would have been impossible in the theatre, such as a bird's eye view of the set of *The Curious Incident of the Dog in the Night-Time* (2012) or a long pan up to the cluster of lights that framed the stage after each act of Tom Stoppard's *The Hard Problem* (2015). In these cases, the director can make explicit adaptive interventions that privilege the cinema audience's perspective on the action and make them more of a typical film spectator than a theatre audience member. However, it is not just the visuals that are adapted for the cinema audience but also the sound, which has to be mixed to give the approximate acoustic effect in the auditorium but without special sounds being 'added' for the cinema audience. There is also the question of how much actors adapt their performances for the camera. Because of the principle of the transmission consisting of the performance rather than creating a new performance, there is no evidence of, for instance, direct audience address in the theatre being redirected towards the camera. The aesthetic with soliloquies is therefore to direct them past the camera to the theatre audience. However, many of the actors who appear in these productions are skilled screen as well as stage performers. Whilst publicly denying that performances are changed, it may be difficult to resist creating small moments of business that capture the camera's attention. Comparing a viewing of *Habit of Art* (2010) at the cinema with the theatre, I was struck by how much the camera seemed to favour Richard Griffiths playing W.H. Auden over Alex Jennings as Britten. This might be because the former was the more engaging of roles, but Griffiths is such a consummate and watchable screen performer that it is understandable that a live mix might privilege his varied expressions and gestures.

Geoffrey Way has argued therefore that these transmissions 'remediate' the performance and thus depend on the impression of immediacy. This involves the erasure of the medium to appear to give unmediated access to the live performance. Way goes on to argue that

> Through an emphasis on immediacy, the National Theatre focuses on access to live performance provided by the broadcasts, revealing in the process their reliance on established theatrical conventions recognizable to audiences to establish a sense of 'eventness'.

<div align="right">(2017: 396)</div>

In adapting the 'event' of theatre then, the idea of 'liveness' is key. From the beginning, NT Live have actually been keen to position themselves as the *antithesis* of

recorded media, because of the relationship of the broadcast to the theatre performance and the way that cameras can capture the immediacy of a performance as it happens. In an article tellingly entitled, 'It's about getting back to the core of what the theatrical experience is about', David Sabel (Head of NT Live 2010–16) claims that

> Part of the reason why we were attracted to this concept in the first place is that it is live and even when it's not live, it still has a residue of being live. Our lives are becoming more and more about on-demand and having content when you want it, and NT Live is the reverse of that because it is about getting back to the core of what the theatrical experience is about, which is gathering with a group of people and experiencing something in one time and place.
>
> (Sandwell 2012: n.pag.)

The inclusion of the phrase 'residue of being live' is crucial to this statement and central to NT Live's philosophy, emphasized by its refusal to release these productions on DVD. For NT Live, the broadcast, whether live or encore, has to be experienced collectively in the cinema. This then raises pertinent questions around ontological differences between stage and screen. For one, as Hitchman has detailed, it complicates Benjamin's concept of the 'aura' that he deemed essential in distinguishing the 'live' from the mechanically reproduced as with live-casting – the 'here', in terms of spatial co-presence, is divorced from the 'now', of temporal simultaneity (2018: 7).

Therefore in NT Live's foregrounding of the concept, 'liveness' does not pertain to the ontological properties of theatre and film but is determined by historically and culturally specific conceptions of the live. Auslander argues that the concept of liveness has expanded with the emergence of new technologies so that audiences now understand a range of events as live and conceptualizes these events in terms of their relationship to time and space from what he calls 'classic live' – involving performers and audiences being physically and temporally co-present – to other forms of liveness where audience and performers may not share the same space but are interacting at the same time. With the advent of virtual/Internet and mobile technologies he suggests that 'as a live experience, spatial co-presence has become a "less" important condition of liveness' (Auslander 2008: 47). Auslander has later qualified his remarks to emphasize that it is not technological determinism that causes these responses in terms of changes in technology per se but rather the 'claims to liveness' that are embedded in the work itself: 'It is crucially important to note that it is up to the audience whether or not to respect the claim and respond to it or not' (2012: 6).

'Liveness' in this expanded sense of the term is central to the event being adapted. As the NESTA report explicitly states:

> Liveness – at this new kind of event, savouring a fleeting moment, is part of the pleasure, just as it is in the theatre. NT Live presents the live transmission as more than a regular cinema screening: it is branded as a special event.
>
> (NESTA n.d.: n.pag.)

The adaptation of the performance is therefore also embedded in 'branding' or paratexts that emphasize the broadcast as an event for its cinema audience. From the start of the project, there has been an introduction to cinema audiences about half an hour before the performance in which a presenter (usually Emma Freud) welcomes in the cinema audience, from either a position outside on the balcony of the National Theatre, where London landmarks such as the River Thames and Big Ben are clearly in view, or from the stalls of the theatre itself, where the sights and sounds of the theatre audience taking their seats seems designed to heighten the expectation of the cinema audience. There is also additional content in the interval that is played to the cinema audience, usually a chat between the presenter and the director of the stage play (never the screen director as this would disrupt the idea of the theatrical event being privileged in the broadcast). The cinema screen often displays a clock counting down to the second half. Sometimes a sense of event is conveyed by the timing of the performance. For instance, with *Timon of Athens* (2016) it was made clear that the NT Live performance also happened to be the final theatrical performance of the play.

Research into the live theatre broadcast has demonstrated that audiences have responded in a positive way to these claims to liveness. The 2010 report by NESTA described how audiences had a 'strong emotional response' to NT Live, to the extent that they sometimes experienced the play 'more deeply' in the cinema than live in the theatre. Audiences have also responded to the time-delayed broadcasts in the same way as if they were being broadcast live. The NESTA report states that it was 'a surprise to find that these screenings appear to work just as well, suggesting that the atmosphere of the screening and the brand are as important as the instant relay' (NESTA n.d.: n.pag.).

The sense of preserving the status of the live event is also embedded in contracts associated with the NT Live broadcast, which have evolved since the project started. Initially as different Equity laws govern actors' performances on stage and screen, there were cases where actors would refuse to take part in the live broadcasts because they needed to be contracted differently. Now when actors sign up for roles in the theatre, their contracts include a clause that allows for filming of NT Live as an *extension* of their theatrical performance rather than a recording

of it. Furthermore there is a set time limit on the period when the broadcast can be shown from the date of the performance. Although initially no DVDs were made or streaming allowed, the recordings are now allowed to be used by educational establishments.

'Liveness' in this sense is therefore a crucial aspect of creating an 'event' for audiences and I would finally like to look at how the audience's experience of the theatrical event is being adapted to fit new and emerging technologies.

> Although audience members are no longer physically located in the same performance venue, many are using social media to voice their presence in new ways and create their own communities of reception.
>
> (Sullivan 2018: 59)

Sullivan argues that 'connectedness' and 'interactivity' are replacing co-presence, with the collective 'live' audience of the performance being reconfigured across space and time through social media sites such as Facebook and Twitter (2018: 61). On Facebook there is a specific NT Live page with individual postings counting down to the next screening, audio-visual content generated by the RNT about the production (e.g. rehearsal footage or interviews with actors) as well as user-generated content such as postings from around the world giving real-time responses to the screenings as they are happening. This sense of, as Sullivan describes it, 'experiential aliveness' is even more pronounced on Twitter, with its restriction to 280 characters per tweet encouraging participation and connection with other NT Live audiences not just before and after but during the broadcast. As Sullivan's investigation into Twitter responses demonstrated, many tweets stressed the location where the user was watching the broadcast, thus drawing attention to where audiences had gathered and in doing so helped 'create a sense of international reception that nevertheless foregrounded the local' (Sullivan 2018: 63).

What is notable about the use of social media with regard to NT is the building of a new type of audience, with specific competencies and expectations who think of themselves, despite their dislocation in time and space, as a 'community', as described by NT Live's former director David Sabel (TEDx Talks 2013: n.pag.). The fact that Sabel's comments were made as part of a TEDx talk broadcast on YouTube, a platform that in itself has the facility to create online communities defined by their interests, suggests how NT Live has strategized its communication of these events to audiences. This idea of an audience spread over different spaces is promoted by initiatives such as the NT Live Backstage app that can be downloaded onto an audience's member's phone and listened to during the live broadcast to give individual users an 'enhanced' experience. Nicholas (2018) has detailed her use of the app to download a digital programme with audio commentary during

the encore screening of *Coriolanus* in September 2015. The app invited audiences to join in with the 'experiment' and described the commentary as a 'world first for stage and screen'.

> Digital spaces can thus become conduits through which a proportion of the audience may perform consciously and deliberately *as* an audience: as individual's voice their reactions, read those of others, and talk back to the production, a sense of community develops around the broadcasts.
>
> (Nicholas 2018: 78)

Therefore NT Live develops a sense of engagement and involvement to reinforce the sense of event, adapted from the live performance and appropriated for the digital age. As Way has argued, 'this is a clear and significant shift from earlier conceptions of the role of liveness in the theatrical event that made physical presence a defining aspect' (2017: 398). Similar patterns of engagement can be seen in the next case study, the RSC Live broadcasts, although the key difference is that after the broadcasts, the recordings are released on DVD.

The RSC

As I am interested in how the screen adapts the performance event (rather than the play or the production), the next section moves on from the broad overview of practice represented by NT Live to examine a case study of a particular broadcast, the RSC's *Romeo and Juliet,* part of their 2018–19 season, transmitted live to cinemas on Wednesday 18 July 2018. Following on from Wyver's work (2014; 2015; 2019) on the RSC live broadcasts, and recognizing that protocols for the analysis of these screen events have not yet been fully developed, I will look closely at the creative decisions taken in adapting the performance to the cinemas. Greenhalgh has suggested that successful mediations 'satisfy the often unconscious desires of an audience through a shifting gaze continually responding to the emotional dynamics of the performance unfolding on the screen' (2014: 259). I will think through how camera movement and framing might articulate this shifting gaze to make sense of the spatial strategies and performances of the theatre production. However, rather than supposing that these respond to the 'unconscious desires' of the audience, which suggests that audience's responses to films are untethered from their previous experience of screen media, I will examine how much of the camera movement and editing can be understood in relation to established televisual and/or cinematic storytelling practices and conventions.

The *RSC Live from Stratford upon Avon* programme started somewhat later than NT Live. It was not until 2013, with a strategic change in leadership at the RSC from Michael Boyd to Gregory Doran, that the organization allowed their productions to be broadcast live from their Stratford base. Although some RSC productions had been filmed (see Wyver 2015) the change in policy was publicly announced as allowing the company to more fully justify their remit as a publicly funded institution, accessible to a broad range of audiences. Wyver claims that there were also other reasons for introducing the live broadcasts – firstly as the RSC were interested in creating an archive of its productions that could be used in the future by educational and corporate institutions. Secondly, that by being able to broadcast its productions overseas it could increase awareness of the RSC brand, thus potentially raising the number of overseas visitors coming back to Stratford to see plays live. Thirdly, he argues that it was originally thought there would be a financial benefit to the company from making the live broadcasts and the DVD sales of them thereafter, though in fact the gains have proved to be less lucrative than originally thought and 'each broadcast has required investment from the company's discretionary fund' (2014: 290). The RSC's live broadcasts have required an entirely new approach to actors' contracts for their work in the theatre, so that they include live broadcasts as an extension of their performances but also give some revenue back to the performers from the sale of DVD rights around the world in perpetuity. This is important as with earlier attempts to broadcast productions some actors had resisted having their work filmed (particularly as a film contract would be more financially lucrative than their theatre work). It is significant that the first RSC Live broadcast had David Tennant as Richard II. Tennant, who had just left the television role of *Doctor Who* (2005–10), offered name recognition for audiences who might not be attracted by one of Shakespeare's lesser known plays. The branding of RSC Live invokes a sense of place, by making a virtue of the fact that it's transmitted from Shakespeare's birthplace with the tagline 'Live broadcasts to cinemas around the world from Shakespeare's home town'. This is obviously similar to the NT Live broadcasts that visually identify where the theatre is located so that the audience's perception of the 'event' is sustained. However, because the RSC release the broadcast on DVD about four months after it has been made, 'unlike NT Live they have a distinctive blend of liveness and archivability' (Stone 2016: 632). Whilst these states appear mutually exclusive, though, in a similar way to NT Live, 'the *impression* of liveness – the trace the live presses onto its mediation and/or the viewer's apprehension of this trace – remains central to the marketing of performances and justifies their existence' (Aebischer et al. 2018: 45–46).

The 2018 RSC Live production of *Romeo and Juliet* was produced by John Wyver. The theatre production itself was directed by RSC associate director Erica

Whyman and designed by Tom Piper. Having been fortunate enough to personally attend camera rehearsals and the broadcast, my aim is to contextualize my analysis of the processes of mediation from stage to screen with reference to the broadcast's broader circulation on selected social media sites, in order to argue for its unique status as event.[4] The initial production premiered in May 2018 at the RSC in Stratford. It was initially well received overall with reviewers picking up on the youthfulness and ethnic diversity of the cast and the freshness of the approach to the text. For instance, *The Stage* described it as benefiting from 'two hugely appealing performances from Karen Fishwick and Bally Gill as the star crossed lovers' (Tripney 2018).

In terms of the pre-broadcast process, Wyver explains how they made a single-camera recording of *Romeo and Juliet* with one camera and single-mic audio from the back of the stalls during a normal performance when the production is more or less fixed. This became a 'base recording' for the screen director to write a camera script with a list of between 800 and 1000 shots. The recording was also shared between the associate producer, lighting director, the camera supervisor, audio supervisor and script supervisor, who put together the camera script before rehearsals (Wyver 2019 email). Then there was a first camera rehearsal about a week before the broadcast. The day before this the camera team get taken through the recording shot by shot. The first camera rehearsal is undertaken without an audience and after this, the single-camera recording is destroyed.

Framing choices are governed by, as Wyver puts it 'what was interesting in that moment' and what 'made a great shot', suggesting that whilst thinking about conveying the original production, directors and producers are also thinking cinematically about what works aesthetically on a flat screen (personal communication, 2018). Cuts were often determined by who was speaking and most cuts were in the pauses between people speaking. The lengths of shots were driven by the story so that this would come over clearly to the cinema audience. Wyver described this as constructing 'with clarity the narrative of the performance, for an attentive audience assumed to be viewing with others in a darkened auditorium' (2015: 43). Close ups could be used if the theatre director thought it was an important moment to capture, but on the whole fewer close ups were used than would be for television, even though the relay would be watched on television monitors, because they don't always work for the big screen (personal communication, 2018). Wyver said that he thought a lot of decisions were made by intuition and by the team's experience in knowing what worked and what didn't. Peplar added that the aim was to translate the feeling of being in the space (personal communication, 2018).

The recording of the first camera rehearsal was then projected the next day on a cinema screen for both the stage and screen team (but not the actors, in case it affected their performances). Wyver pointed out that sometimes because the mixing

was done live on a monitor, a televisual grammar might emerge that would not be appropriate for big screen transmission. This viewing was then crucial for making sure that shots, framings and pacing were appropriate for the cinema event. From the de-brief after this screening, the screen director re-worked the camera script, in advance of the second camera rehearsal on the day before the broadcast, in front of an audience. This broadcast was run as it would be on the night, with the insertion of recorded material and a live introduction. This dummy run also served as a back-up for the actual transmission in case anything went wrong on the night.

There were six cameras in the auditorium, with three tracking cameras that were able to go from left to right alongside the three sides of the apron stage. Then positioned stage left was a highly mobile crane with a long arm that could sweep up and along the stage. There were two fixed cameras; one again stage left but slightly behind the crane and one at a higher level, to enable the fixed camera to take in the full height of the set. The idea was to cover the stage from every angle – but due to the nature of the stage with the audience on three sides, the broadcast team said they were not averse to showing the audience if needed or indeed hiding the cameras if one of them came into the shot, as this was the experience of the audience itself. As with most broadcasts, some of the stalls' seating had been removed, entirely from the stage left side of the auditorium, underneath the crane arm and in the direct line of one of the fixed cameras.

This set up of the cameras gives complete coverage of the stage area but as Robin Lough, one of the most prolific live broadcast directors, has explained, the task of the production team is to think how these cameras can be used to convey the story, not just in terms of the action on stage but capturing moments in actors' performances that reveal motivation and subtext (Lough quoted in Wyver 2015: 296).

The set itself was fairly simple but with certain aspects that potentially presented problems in filming. The main focus was a large golden metallic-coloured cube, open on two sides so it could be turned one way to present a solid block or, when rotated, an inside space. It was in this space for instance that a band played at the Capulets' party, or provided an interior setting for Friar Lawrence's cell. When showing a solid block on two sides, it provided both the balcony, the marriage bed *and* the final tomb where Romeo takes the poison and Juliet, finding him, kills herself. The apron stage in front of the cube had two diagonal walk ways stage left and stage right that went from the stage out to the back of the auditorium and provided exits and entrances for the cast.

For the Tuesday performance, a central problem for the broadcast team was the indisposition of the actor (Michael Hodgson) playing Capulet and so there was an understudy playing the role. This was his first time playing it, he hadn't been through the camera rehearsal as Capulet before and had other roles to play in the production. On the actual night the original actor was restored, but this gave the

live broadcast an extra tension for the crew as this was effectively only the second time the actor had been through the production with cameras. For many of the actors, as they were all quite young, this was their first time doing a live broadcast and a few of them talked about watching the rest of the cast on the live monitor backstage, during the production (personal communication, 2018).

From this broadcast, the production team were able to isolate potential problems. For instance, there were make-up and costume people constantly watching the broadcast on the monitors in the van. The make-up designer noted that Juliet had wiped her eyes and smudged her mascara during the final scene – not a problem if on stage but very noticeable in any close up. The producer also noted that an actor's shirt needed to change colour to burgundy to render it more effective on screen. Sound was also very technically challenging, with 120 sources of sound needing to be mixed live and mics from the actors and the music needing to be balanced out. As audio was mixed to picture, levels needed to be constantly adjusted so that the sound acoustically matched the space and figures represented in the frame from a wide shot to a close up on somebody speaking. Lighting needed to be tested during this performance as one of the challenges of this particular production was that the set was quite dark and the production team needed to work with the available lighting onstage whilst making small adjustments to make the action visible to the camera eye. Wyver said that cameras are extremely sensitive to light now so will mostly be effective in rendering a wide variety of lighting states visible on screen (personal communication, 2018).

Key also in terms of the adaptation of the event was a sense of its transmission via social media on the night of the performance. There was a team in the OB van who were in constant interaction with the Twitter feed, posting comments such as 'tell us what you thought' and 'first half over'. Hayley Peplar reiterated that participation was important to the production team and social media was one way of documenting reception and interacting with audiences. This was reinforced by the various pre-recorded sequences that were inserted into the show such as a behind-the-scenes look at the recruitment and participation of local young people in the production and the live sequence with presenter Suzy Klein who was placed in the auditorium as people were entering and conducted a quick chat with director Erica Whyman for cinema audiences only. During these sections, the address of the Twitter conversation was available to the cinema audience and they were constantly exhorted to give feedback to the producers.

One of the most interesting aspects of the whole experience was how different the performance was on the Wednesday of the live broadcast from the other times I attended. This might have been expected for the camera rehearsal on the Tuesday, in the tradition of saving energy for the 'big' night. However, I found that a live performance watched several weeks later, without any of the cameras in position,

didn't equal the live broadcast performance in terms of energy and excitement. For a production whose success really depended on the playing of the young people involved, Wednesday's performance was electric and really changed the whole dynamic of the play. This is significant as scholarship often concentrates on the broadcast itself but there is not much writing on the experience of the theatre audience on the night.[5] It is often assumed that the theatre audience will 'suffer' from the presence of distracting cameras and the removal of seats. However, from this experience, it seemed that an awareness that their performances were being seen by an expanded audience meant the cast were playing at the top of their game and the experience of the play was significantly improved for the theatre audience on the night of the live broadcast.

The analysis that follows is made up of some observations on both nights and then from a more considered analysis of the broadcast sent via a private Vimeo link. In terms of substantiating my argument around the adaptation of the theatrical event, I was particularly interested in four key areas: How a sense of the stage space was established and maintained by the camera; how the camera mediated performances by the actors and what effect it had on the production; when particularly cinematic (i.e. ones that would have been impossible from a theatre audience's point of view) shots were deployed and why; how social media was used to heighten the sense of event for the audience. In this I was interested in the changes in the production between watching as a live audience member and watching the screen broadcast to understand how the experience of watching the play was adapted to the screen, although it should be noted that I never actually saw the broadcast live in the cinema, only on TV monitors during transmission and then privately at home on a laptop.

The beginning of the performance on screen actually starts slightly before the stage performance. A shot to the extreme right of the stage is held for about a minute, as a voice-over (Suzy Klein – having previously established that she is the cinema audience's eyes and ears at the scene) can be heard giving a simple background to the story. The shot is an odd one and perhaps is designed to recall the same angle on the stage occupied by Klein when she was introducing the performance. It also allows the cinema audience to clearly see the theatre audience on both the left (far) side and right (near) of the thrust stage, as well as those in the circle on the left side. These audience members in focus, whether by accident or design, all seemed like teenagers, which arguably made it seem like a different type of experience than might have been expected from a typical Stratford Wednesday night performance. The house lights at this point were still on and the audience were talking.

Klein then cued the action by saying 'first a chorus sets the scene' and the camera switches to an extreme angle from the opposite side as all the younger members of the cast and the teenage extras run on from the four corners of the

stage and address their comments out to the audience. There was no perceptible change in the lighting at this point and when the chorus all start speaking the lines at once, the shot switches to the crane shot that can not only pan from right to left across the stage but also pick out individual speakers who might then be important in the story.

Therefore in the opening moments, the scope of the stage space is communicated and its relationship to the audience. The ensemble staging of the chorus opening is made clear, whilst the camera also works like a human eye to pick out individual faces, whilst scanning the whole. I also wondered if the choice to include the young audience members quite extensively in these initial framings was evidence of one of those serendipitous moments (after all how would they know what age the audience seated here would be on the night?), when the camera director would see that the people on stage were reflected in the audience, thus underlining one of the key elements of the stage production's dramaturgy – that of the play mirroring the experiences of young people today.

A key moment from the end of the play when the camera is also working to interpret the whole stage space for the audience is Romeo's death scene. In a reversal of conventional film grammar, rather than focusing in on the couple during this scene, the crane moves away from them and re-focuses to take in the whole stage space. The logic for this becomes clear (though is slightly obscured by the dark lighting at the back of the stage) as the cinema audience become aware that the actors who played Tybalt and Mercutio walk slowly out along the left and right sides of the stage respectively whilst the death scene is taking place. This theatrical use of space links the deaths of Romeo and Juliet with the deaths of other young people in the play and encourages the audiences not just to focus on the protagonists but on all the young victims of violence.

Close ups were used sparingly on the whole in favour of half body framings or wide-angle shots. However, there were several interesting moments when close ups were used to emphasize particular relationships between characters and convey the detail of actors' performances. The first of these clearly communicated Benvolio's thinking that Romeo's secret love might be for himself rather than a woman. On the line, 'who is that you love?' (Act I, scene i, line 207), the actor playing Benvolio (Josh Finan) came forward in expectation and then on Romeo's answer, 'a woman', in the same swift moment, turned round and moved away so his misunderstanding and complicated feelings for Romeo escape the latter's attention but not the audience. The theatre audience also laughed at this point to underline their comprehension of the dramaturgy of the exchange. This moment was clearly caught, if not somewhat over-exaggerated by the particular framing of the scene in which Benvolio's face looking longingly at Romeo was caught in close up from over Romeo's shoulder.

Another close up that actually made a performance more comprehensible than when witnessed in the theatre was the close up on Lady Capulet (Mariam Haque), when the Nurse (Ishia Bennison) is chattering on about how she weaned Juliet (Karen Fishwick). From a distance one could see her awkward stance and slight distance from the Nurse and Juliet, which communicated her exclusion from the relationship. However, the screen adaptation gave prominence to a crucial close up on her face that showed her conflicted expression and attempts to interject before she is able to stop the Nurse with the line, 'Enough of this'. This is able to express to the cinema audience a much more complicated set of emotions from inadequacy and fear to irritation and weariness at the Nurse's overbearingness. The fact that the camera saw fit to focus on her during the Nurse's speech perhaps is designed to facilitate communication of this point and emphasize the actor's interpretation of the situation of the character here. The effect was that in my re-viewing of the transmission on screen, I had much more sympathy with the character as a loving but displaced mother, who is painfully aware that she is constrained by her position and can barely contain her resentment of the Nurse for replacing her in Juliet's affections. This simply didn't come over in the theatre performance. Similarly, the performance of the actor playing Friar Lawrence (Andrew French) was given more focus by the framing at the end of Act 2 just before the interval, which makes the audience understand that despite the reassurances he gives to Romeo after the killing of Tybalt, he is deeply worried by the consequences of his actions. This was a strategy that was repeated quite a few times throughout the screen transmission and arguably portrayed Friar Lawrence more sympathetically as the cinema audience were able to see in close up how often he would keep silent but be conflicted about it. Such close ups actually give much more light and shade to these secondary characters and allow their complex characters to be more clearly communicated than in the stage production.

In terms of camera movement, a key use of the crane is when Mercutio dies on top of the box after her fight with Tybalt and the crane pans up to take in all of the stage from a bird's eye view, a perspective that implicitly asks the audience to think on the implications of Mercutio's death for all the characters pictured in the frame. This is evidently an interpretation of a moment, giving a viewpoint that would be impossible in the theatre, and demonstrates how this performance is adapted for the cinema audience.

As noted before, the use of social media to frame an event, such as a live broadcast, can demonstrate how audiences have been reconfigured in the age of the Internet and points to the way convergence culture moves content across multiple media platforms. Looking at Twitter for instance is 'useful for understanding how people use new communication technologies to form new social connections and maintain existing ones' (Gruzd et al. 2011: 1294). In the case of *Romeo and*

Juliet, a continuous invitation was sent out for audience members to engage and the closure of the broadcast was announced by the team as 'and that's a wrap', followed by a reminder of the next RSC production. There were also tweets and retweets from the director of the show, Erica Whyman and two of the stars, all operating from their own accounts. However, the majority of tweets were coming from the producer out to the audience, rather than an exchange of views, and pointed towards more of a top-down dissemination of information rather than an exchange. Most tweets also seemed to come at the end of the performance, rather than during it, somewhat negating the argument that social media allows an audience to perform as an audience (Nicholas 2018: 80). This may be because, notwithstanding the young people in the audience that night, the typical RSC audience demographic wouldn't normally use Twitter and demonstrates that it's difficult to make generalizations about audience behaviour through these channels.

In the final section of this chapter, I would like to briefly examine the live shot and streamed to cinema production, *Lost in London* (2017), because of the way that it can be interpreted as an adaptation of the theatrical event, albeit one essentially conceived of as a film. The film, written and directed by and starring Woody Harrelson, was shot in one take and streamed live, as it was being filmed, to one cinema in the United Kingdom at 2 a.m. and 500 cinemas in the United States on the night of 20 January 2017. It purports to recreate a night in London that Harrelson claims actually happened to him, when he was thrown out by his wife after tabloid revelations about his infidelity and ended up being locked in a police cell after an altercation with a taxi driver. The film had 24 locations, including a restaurant, a nightclub and Waterloo Bridge (whose sudden closure due to the discovery of an undiscovered Second World War bomb almost derailed the show) and more than 30 actors. A particularly challenging aspect of the whole endeavour (as in the RNT/RSC live broadcasts) was balancing the sound. The production used over 150 microphones to both pick up the dialogue from the actors and the different environments, including music in the nightclub scenes, and then live mixed in pre-recorded music and a phone conversation with Bono and his wife. In a similar fashion to the live broadcasts, Harrelson ran two camera rehearsals prior to the broadcast, during one of which they lost the feed. This was alluded to in the pre-broadcast interviews, presumably to heighten audience anticipation. My analysis of the event reveals several parallels with the live broadcast of theatre to cinemas, namely an emphasis on liveness and the deployment of similar paratexts to frame the event and extensive use of social media to invite audience participation.

The one-shot movie has obvious precedents such as *Russian Ark* (2002) and *Victoria* (2015), yet there have been few precedents in shooting a movie live and simultaneously streaming it to cinemas, with Blast Theory's *My One Demand*

(2015) being one of a handful of previous examples.[6] Sarah Atkinson (2017) also identifies live televisual broadcasts, such as the 30th anniversary episode of *EastEnders*, as establishing conventions that were utilized in this event. Harrelson himself in an interview with *Screen International*, when asked why he wanted to make it this way, identifies the meeting of theatre and film in the conception of the project.

> Initially, I wanted to shoot the story in real time and this got me thinking about the merging of theatre and film. I thought, 'How is that theatre if there is no live audience?', so then I thought that we could live stream it.
>
> (Harrelson cited in Aftab 2017: n.pag.)

The apparent extreme difficulties of the endeavour were highlighted in a stream of paratextual materials released in the lead up to the cinema broadcast and on the night. The first of these was a trailer published on YouTube on 16 January 2017, entitled '"*Lost in London Live*" announcement trailer', featuring a direct address by Harrelson to camera against a live background of London landmarks and a soundtrack of pomp and ceremony music. He announces that this January he 'will be doing something that has never been done'. This direct address was interspersed with stills spelling out 'First Time Ever' and 'Filmed and Broadcast Live'. Harrelson's endearingly shambolic persona was emphasized in the trailer and there were comedic references to other events that have tried to do something impressive and failed. At one point, Harrelson shows the audience a picture of the Hindenburg Air Disaster whilst talking about his production (Moviefone 2017: n.pag.).

The preamble to the London and US screenings was filled with clips of well-known celebrities such as Ed Norton and Jennifer Lawrence similarly addressing the camera as if speaking to Harrelson himself, whilst teasing him for taking on what was constantly referred to as a great mistake of judgement on Harrelson's part. After the live screening, the audience were presented with a live Q and A with Harrelson and key production personnel. The film subsequently had a limited release by Picturehouse cinemas and is now available as a download from the usual pay platforms.

In a similar fashion to the theatre live broadcast, the event was framed by substantial activity on social media. Atkinson's discussion of Twitter activity surrounding the broadcast demonstrates that audiences spent much of the time trying to define what they were witnessing and often alluded to the event as a mixture of theatre and film, made possible by advances in technology (2017). For instance one Twitter response claimed that '*Lost in London* is a 21st Century art form. It's live theatre; it's also a movie. It truly puts the event in Event Cinema' (T32). Atkinson also gave audiences on the night a questionnaire (Atkinson was also

present at the event) asking audience members to describe what it was that they saw. Again the recourse to understanding the experience as a mixture of stage and screen viewing conventions was striking:

This medium was a true screenplay – a live play performed on screen. (Q3)

The live film is somewhere between a play and a traditional film. It's got the energy of a play with the variety of options available on film. (Q15)

This is stage and film copulating. It's entirely new, yet completely familiar. (Q33)

As Atkinson concluded 'there was a constant reference to the hybridity of the form in which the aesthetics and formal practices of film and theatre, screen and stage are seen to merge' (2017: 703–07).

Central to this is the sense of event drawn from the theatre experience, distinguishing it from standard cinematic fare, particularly for the London audience who were unusually gathered in a cinema at 2 a.m. and were in close proximity if not spatially co-present at the moment the film was being made. Therefore its liveness was clearly a large part of its appeal and the ephemeral nature of the event, constantly at the forefront of the audience's minds through an insistent emphasis on the technological challenges and the possibility of unexpected lapses, which paradoxically would 'prove' its liveness. In fact on a viewing of the post-produced DVD a year after the event, one wonders if it was pretty much the only 'pleasure' of the film as the version I watched (apparently with limited post production to even out technical issues) was plot-wise extremely tedious and seemed designed to showcase the apparent humility of its main protagonist whilst being insidiously self-congratulatory. Indeed there seemed to be a shift in address so the audience were not being asked to immerse themselves in a fiction, but instead to admire how the whole event was being orchestrated.

I have argued in this chapter that what I call the 'events' of theatre and cinema in adaptation studies have been largely ignored because they have been understood in oppositional terms as live and recorded media. However, both theatre and cinema share the fact that they usually involve going to a set place, at a set time, for a set duration, to share an event with an audience and the live broadcast takes advantage of this to create what has been termed a 'new medium' (Hitchman 2018). Current developments in digital technologies have impacted the relationship between theatre and cinema because of their impact on spatial and temporal aspects of the 'events' of theatre and cinema. These technologies are developing extremely quickly, so that what once seemed like a novelty (NT Live) has soon

become an established part of theatre repertoires, cinema schedules and the experience economy. In fact the RSC have already experimented with recording audience responses in different mediums by tracking the heart rates of audience members watching a live staging, live broadcast and Virtual Reality transmission of their production of *Titus Andronicus* (2018). They are currently undertaking a multi-partner project to 'explore what it means to perform live using emerging technologies with the intention of delivering an immersive live performance on multiple platforms in 2020' (RSC n.d.: n.pag.).

Similarly, the National Theatre's immersive Storytelling Studio has been established to investigate how 'virtual reality, 360 degree film, augmented reality and other emerging technologies can widen and enhance the NT's remit to be a pioneer of dramatic storytelling' (National Theatre n.d.: n.pag.).

Such advances indicate that the nature of the 'event' is changing and whilst simultaneity is foregrounded still, even when what is shown has been recorded some time previously, spatial co-presence is being reconfigured so as to be simulated, through multiple sites of attendance and presence.

This points to how technologies are driving changes in audience experience of theatre and cinema as media. In the next section of the book, I intend to examine the broader industrial and cultural factors impacting on adaptations in more detail, by looking at stage–screen adaptations in the United Kingdom at three crucial moments in history. The first chapter looks at the stage–screen adaptation in the first few years of the introduction of sound to film, a technological invention that many saw as creating a new medium in the same way as the live broadcasting discussed in this chapter.

NOTES

1. Opening to paper given by author at *Disturbing Live Adaptation* conference (Sweden, 2013).
2. NT Live do give access to researchers to view the recordings in the NT Archive in London, but it's not public access and as it's played on a television screen it is a very different viewing experience to a collective encounter in the theatre. During the COVID-19 crisis in 2020, National Theatre Home exceptionally broadcast a series of its NT Live productions on YouTube, due to the closure of the theatre building. However, a sense of event was still paramount as rather than releasing them all at once, the productions were given a Thursday night premiere and then kept online only for a week. Other theatres in the UK have responded to the closure of theatres by putting productions online where possible.
3. Although attendance of an NT Live screening of the 2019 Old Vic production of Noel Coward's *Present Laughter* suggests that Coward's plays might well be resistant to live-casting, Coward's brand of brittle affectation, which can be nuanced in live performance, seemed one-dimensionally artificial on screen.

4. I interviewed two key members of the production team, the producer John Wyver and the associate producer Hayley Pepler. I also attended the second camera rehearsal of the production in front of an invited audience on Tuesday 17 July, in which the sequence of shots was recorded as if on the night. Half of this I spent watching the production and the other half in the OB unit, watching a monitor that was divided up into the view feeding into each camera alongside an overall feed of the production. I then watched the actual live broadcast in the auditorium on the night.

5. Barker (2012) explores the live cast from the audience perspective through the collection and analysis of nearly 650 audience questionnaires, completed by cinema-goers at Picturehouse live theatre broadcasts in 2009.

6. Atkinson identifies Peter Greenaway's live multimedia project *Tulse Luper Suitcases* (2003) and Francis Ford Coppola's project *Twixt* (2011) in which the film was remixed live by Coppola himself in response to audience reaction (2017).

PART TWO

HISTORIES

4

The Introduction of Sound and 'Canned' Theatre

Are the works of leading British dramatists to be purchased by America for talkies, their plays to be returned in tins to this country as legitimate Shaw or Barrie or Galsworthy?

(Dean 1931: n.pag.)

This chapter looks at a key period in British cinema in the relationship between film and theatre – the introduction of sound to film and its immediate aftermath. [1] Whilst Hollywood's transition to sound has been well documented, the equivalent period in Britain has been somewhat 'overlooked' (Porter 2017: 87).[2] According to existing histories of this transitional period (e.g. Low 1997), the theatrical modes of expression evident in film adaptations of this time would be enough to render them unworthy of critical attention, as they would seem to represent, at best, a demonstration of early British sound film's uncertain and undeveloped aesthetics and at worst a wholesale abnegation of cinematic principles to those of a more culturally legitimated mode of expression. Yet, as Christine Gledhill has argued in relation to the 1920s, thinking of the relationship between theatre and film as mutually antagonistic 'inhibits registration of the slow and circuitous, too-and-fro [*sic*], liminal movements of infiltration by which new perceptions and practices unfold within the old, circulating from one arena of cultural production and social reception to another' (2008: 15). Gledhill and others (Burrows 2003) have thoughtfully mapped the pre-synchronized sound era in this way but there has been surprisingly little published on the immediate early sound era that followed it. As producer Basil Dean's rallying cry above indicates, issues of ownership and cultural identity were brought to the fore in this period. The promotion of British film adaptations of specifically British plays was publicly positioned by Dean as a strategy for resisting Hollywood's market dominance and a way of drawing on and benefiting from Britain's distinctive

and unique cultural assets. Legitimacy is key here; it is no accident that Dean's words conjure up visions of coffins being repatriated from abroad and it's clear that the potential appropriation of key playwrights' work by American producers was seen by Dean and others as a significant own goal by British cinema in the ongoing war against Hollywood's domination of global markets. Not everyone thought this way though and there were a number of directors and critics, particularly those associated with the Film Society, such as Ivor Montagu and Adrian Brunel, who feared that the introduction of sound would severely compromise the essential art of film and that a closer alignment with the theatre would further undermine it as a distinct art form.

This chapter will examine this period in some detail because understanding these debates enables us to locate these film adaptations within a specific socio-historical context so that, for instance, debates about fidelity can be understood as being activated by and within particular socio-historical conditions. In order to fully comprehend Gledhill's notion of 'new perceptions and practices' it is useful to use archival sources and autobiographies to track the responses of a range of practitioners, such as Dean, George Pearson, Brunel and Montagu, Tom Walls and Alfred Hitchcock. Existing work on film adaptations of British stage plays has not always considered the views of those people working in the industry at the time (a laudable exception being Napper's discussion on the adaptation of *Journey's End* to the screen in 1930) (Napper 2013). Whilst obviously being wary of such sources being more broadly representative, I believe that, as Ian Macdonald has argued in relation to an earlier example of the relationship between stage and screen in British cinema, looking more closely at 'contemporary practitioners' own understanding of their cultural experience as well as notions about how their own field worked' (2010: 75) allows us to reframe research around questions of practice and process rather than texts and artefacts, important when issues of performance are being investigated.

I will examine Dean's attempt to create 'legitimate cinema' out of plays by established authors by examining his adaptation of John Galsworthy's *Escape* (1930). Through looking at issues such as the retention of the playwright's dialogue and the ideas around the social function of drama both on stage and on screen, I will trace the particular cultural values that were articulated by the adaptation process and can be evidenced in the film. This historicized account will also look at how adaptations per se were seen as a way of articulating ideas about national cinema at this time. In the case of *Escape*, it is clear for Dean that the coming of sound brought a sense of urgency to bear on filming stage plays, as adaptation was seen to showcase skills that were seen as particularly 'British', such as the writing and speaking of dialogue by respected playwrights and trained actors. It was claimed therefore that this form was particularly suitable in responding to the changes in the industrial landscape after the Quota legislation of 1927 by articulating projected 'national' values and thus distinguishing British films in a

global marketplace. Therefore, 'fidelity' was positioned as a cultural (and commercial) imperative, as the playwright, rather than the film director, was seen as the key figure in the adaptation. The chapter will also examine early play adaptations by Hitchcock, in particular *Juno and the Paycock* (1931). These adaptations are usually ill thought of by critical scholarship on Hitchcock because of what is perceived to be the incompatibility between his developing cinematic aesthetic and the dialogue-heavy stage play. Hitchcock had a very different attitude to Dean, in that he publicly deplored early sound's potential dependence on theatrical material, and made the case for 'cinematic' rather than 'theatrical' values to be privileged in the adaptation of plays. Yet, Hitchcock was a keen theatre-goer with a respect for the work of playwrights and performers and therefore I contend that his theatrical adaptations are a unique hybrid of theatrical and cinematic elements, mostly erased from consideration of Hitchcock's oeuvre because they do not fit in with his established auteur narrative. The chapter concludes with an examination of a different type of theatrical material; the Aldwych comic farces and their adaptation to screen, because they serve as an example of the kind of work that was designed to commit star performances to celluloid (from leading players, Ralph Lynn and Robertson Hare) rather than the dialogue of canonical authors.

It's impossible to clearly define the beginning and end of the early sound period but it is possible to see how prevalent film adaptations of plays were from existing scholarship on this period. For example, Shafer has calculated the number of British films based on stage plays during the 1930s:

Year	%
1930	38.4
1931	47.8
1932	35.3
1933	29.3
1934	36.1
[Then falling every year to...]	
1939	18.4

(2003: 3)

The number of stage adaptations reached a peak in 1931, where almost half of all British films had their origins in the theatre. This fell to 29 per cent in 1933, recovered to 36 per cent in 1934 and then continued to fall until the end of the decade. However, in the early 1930s we can see that stage plays still made up from a half to a third of all British films. Many initial histories of the early sound period in British cinema (Low 1997; Richards 1984; Ryall 1996) and accounts from contemporaries such as Sydney Gilliat (Gilliat in Aldgate 1998: 223) have seen this influence of the

theatre on British cinema at this time as wholly negative, with Low describing these film adaptations disparagingly as 'canned theatre' (1997: 228), arguing that these works contributed to the poor global reputation of British cinema in the late 1920s and early 1930s. Even Murphy talks about 'parasitic effect' of the West End play on the development of British cinema in the early sound period (1984: 158).

Whilst the films discussed in this chapter are no great undiscovered masterpieces, they need re-examining with a greater sensitivity to the particular historical and cultural circumstances that determine how and why these adaptations were produced. The coming of sound heralded an even greater cross pollination between cinema and theatre personnel. As Geoff Brown has pointed out, unlike in Hollywood where the production centres of theatre and film were on opposite sides of the country, the nearness of West End theatres and the majority of film studios meant that many actors, for instance, filmed in the day and performed on stage at night (Brown 1986:143). Basil Dean is an interesting figure to examine in this matter because whilst on paper he appears to have been a pivotal figure in British film in the 1930s, from setting up the first British sound studio at Ealing to producing Gracie Fields and George Formby pictures in the 1930s, critics have not always treated him kindly. It is noticeable that much of the criticism of Dean derives from his being seen as a theatrical 'interloper' amongst the film 'community'. For instance, Adrian Brunel dubbed him 'the Basilisk' after working with him on the 1927 film *The Constant Nymph* and describes in his autobiography how the creative and personal divisions between them during the shooting of the *Nymph* could be understood in terms of 'theatre vs film' (Brunel 1949: 143). The film director Thorold Dickenson's verdict on him was more damning; as has been widely quoted, he described him as a 'theatre man – he made canned plays' (quoted in Stollery 2010: 4). The ending of the Dean-directed *Loyalties* in 1933, another Galsworthy adaptation, has been seen as a case in point. Here, the keen cinematic sensibilities of Dickenson as editor were deemed to be responsible in the face of the stubbornly theatre-bound Dean for replacing the conventional off-stage suicide ending with its much-praised point-of-view shot of the main character plummeting to his death (Stollery 2010: 6).

Whilst it is not the intention of this chapter to specifically rehabilitate Dean's work, it is notable that a lot of the comments seem directed at him for what he was *not* rather than what he was; not an auteur type of director but a producer; not a film man but a theatre man. They are informed by a critical position that sought to preserve and promote the artistic validity of film by defining it in terms of its essential expressive difference to the theatre. Such a project gained a particular urgency after the introduction of sound as it was feared that the addition of spoken dialogue to film would reduce it to an inferior copy of the stage. These views were perhaps best represented by the Film Society, whose members included Adrian Brunel, Anthony Asquith and Michael Balcon. At the time of the coming of sound, its members 'were

enamoured with the uniquely cinematic technique of montage and overtly antipath-etic to theatrical and literary values' (Gritten 2008: 271). Yet to understand theatre and film in terms of binary opposites is unhelpful when looking at how Dean under-stood the practice and purpose of adapting a stage play to the screen, because of how his work crossed between the two mediums, without initially (and perhaps naively) making clear distinctions between them as signifying systems or cultural practices. It is perhaps helpful at this point to understand Dean's background up until his entry into the film world, to gain a richer understanding of why he sought to encompass both theatre and cinema in his practice as a director/producer.

Born in 1888, Dean began his professional career as an actor in 1906 with a touring company and then joined Annie Horniman's newly formed Gaiety the-atre company in Manchester in 1908. In 1911 he moved to Liverpool, where he became the first Head of the Liverpool Repertory Company (afterwards known as the Liverpool Playhouse). In 1913 he moved to London, where amongst other jobs he was assistant director to Herbert Beerbohm Tree and then in 1919 formed the Reandean company, which premiered many productions over its five-year his-tory. His work in repertory theatre had instilled in him a respect for new writing (Horniman had gained a reputation for introducing new regional writers such as Stanley Houghton to the stage) and an abiding interest in promoting what was termed 'new drama': plays that sought to faithfully represent contemporary society and hold up to examination social attitudes and values. Whilst there were con-temporaries such as J.T. Grein at the Royal Court in London working with new writing, Dean was one of the few working in the heart of the commercial theatre. He pioneered a model of commercial/experimental programming that was gained from his experience in repertory and still operates today. Above all, he was com-mitted to the theatre as a forum for debate on contemporary issues, a sensibility that he brought to bear to his film work as he firmly believed that, because of its greater audience reach, drama on screen could and should operate in the same way.

It is perhaps not a coincidence that around the time of his involvement with *The Constant Nymph,* Dean started to publish his thoughts on the relationship between stage and screen, providing us with a context in which the writing of the screenplay for *Escape* can be located. Dean seems to have been initially attracted to films by 'a love of experiment – hemstitched with ignorance' (Dean 1938: 175) and from the beginning saw them in terms of their potential to provide an alternative viable mode of dramatic expression to the theatre. This has to be understood in relation to what Dean and other playwrights such as J.B. Priestley saw as the decay of the theatre due to the excessive commercialization and high rents of the West End which they believed were killing the spirit of drama (Gale 2008: 5). Far from wanting to simply showcase stage plays on film, Dean approached the cinema as an experi-ment, in which he thought you could try out new dramatic techniques. 'The artists

of the Renaissance experimented in various media. It should be our fun to experiment and fail' (Dean 1927: n.pag.). At this time, the 1927 Cinematograph Films Act was also about to change the production base of the British film industry. Up to this point the majority of the films exhibited in Britain were American. The Act was designed to boost production so that a larger number of British films could be shown on British screens and it sought to achieve this by imposing a 'statutory obligation on renters and exhibitors to acquire and show a minimum quota of British films out of the total number they handled, British and foreign' (Dickinson and Street 1985: 5). The Act also legally defined a British film in terms of the nationality or domicile of the persons involved in the production of the film. One result of the legislation was to induce a rush of companies to be set up to take advantage of the increased demand for the production of British films. Dean was no exception to this, although his company initially had a particular emphasis on combining stage *and* film production by making talking films and funding the Guild Theatre out of the back of the profits.[3] A letter to John Galsworthy in Basil Dean's archive shows how Dean thought the project would be 'mutually helpful' to both stage and screen in Britain, by making talking films drawn from the Guild Theatre repertoire, with actors who could work in both mediums. He began his letter by telling Galsworthy how the project had garnered the public support of high status authors such as Arnold Bennett, Noel Coward and Somerset Maugham. Dean saw the company as formalizing a relationship between theatre and cinema by enabling British cinema to draw upon existing and indigenous cultural capital, in terms of the work of world-renowned British playwrights and using them to establish British films in the international marketplace. He foresaw the connection would give British production companies leverage with the American companies who had sought co-production agreements with British companies in the light of the 1927 Act.

> We have here something statesmanlike that can be of real service both to the British film industry and the British theatre. Barrie [...] is going to make strong representation to Famous Players that he would like his plays done by this Company, and he is going to tell them that an arrangement like that would influence him considerably in the price that he would ask them for talking rights.
>
> (Dean 1929a: n.pag.)

It is also clear from this letter how much the introduction of sound to film had raised the stakes in terms of the relationship between American companies seeking to fulfil their quota obligations and film production in Britain. Both wider public debates about the relationships between stage and screen in British culture and the formation of Dean's company had a specifically nationalistic import in terms of how the talkie could be used more strategically than the silent film in the context

of Hollywood dominance of the industry to develop a specifically British cinema with its own indigenous identity.

That is not to say that this was not a considerable challenge when at the time it was unclear how the industry would be affected by the talkies. For many the arrival of synchronized sound to film had meant that the rule book had been torn up and filmmaking practices were thrown up in the air with little idea of how they were going to settle. For instance, Gritten has described how, for screenwriters in particular, the introduction of sound created a blank page in which the technique of the talkie was developed by a process of trial and error (2008: 262). Central to this process were debates around the function and handling of dialogue in the talking film. Gritten eloquently explores how, for scenario writers such as Brunel, dialogue posed a threat for screenwriters in the new medium as they feared that 'visual storytelling would be usurped by a dialogue based telling of the story' (2008: 267). Yet there were other contesting views of how dialogue could function in the talking film. These attempted to engage both with a particular notion of effective naturalistic playwriting practice in which dialogue and performance were crucial for the communication of ideas and with what was understood to be the different, more visual demands of storytelling for the screen. For Dean, 'the handling of dialogue' became a primary concern in his public and private pronouncements. For instance, he stated that 'there is no properly authenticated technique' for the 'talkies' and argued that 'we need to regain all those qualities in storytelling that the screen has fought so hard to develop but we also need to use sound symphonically and words not as a strange encumbrance forced upon us by a wayward public but for the expression of ideas' (Dean 1929b: n.pag.). This point is crucial for understanding Dean's stance in his work with Galsworthy in adapting *Escape* for the screen, for he felt that dialogue was critical in articulating the central ideas of the drama for both stage *and* screen and thus finding ways to retain the original author's dialogue became a central concern of Dean's developing screenwriting technique.

The other consequence of his belief in the importance of dialogue was, as Dean understood it, to give the author more prominence in the cinema. In Hollywood, the author was seen as merely a cog in the wheel of an industrial production machine, with the producer holding all the power. Yet in the United Kingdom, writers had more cultural status and Dean therefore called for 'a new generation of combined dramatic and cinematic writers to be trained. [...] The most profound change will come when the author is regarded as of more importance than the studio executive' (Dean 1929b: n.pag.). Bringing the author back into the frame was seen to have a crucial importance in the project of developing a specifically national talking cinema in Britain, because of their perceived ability to write meaningful, spoken dialogue. 'Great opportunities have been lost in England [...]

America has been allowed to get a stranglehold on a new industry for the successful development of which we are uniquely fitted' (Dean 1930: n.pag.).

Escape thus can be understood as a project that mobilized the challenges and opportunities of the shift to talkies for the United Kingdom, such as finding a balance between the visual storytelling of the silent cinema with a move to using the spoken word to express ideas. This was particularly difficult when, as Porter details, voice recording equipment during filming was initially quite primitive (2017). Cameras had to be encased in padding so that the sound of their operation wouldn't be picked up by the microphone. Actors also had to deal with the technical challenge of performing to a camera *and* a microphone. Initially, the actor was often caught out trying to shape their performance according to the requirements of the stage and finding themselves severely compromised by the very different performance conditions of sound film. In an entertaining article about the making of her first picture in 1930, veteran stage actress Louise Closser Hale drily described the lead up to her first take, after discovering that her carefully planned performance was severely compromised by the restrictions of the filming process:

> I must walk into the toe-marks without looking at them. I must speak distinctly but not too low or too high. I must not project my tones. I must not sit down or get up on my lines, or show my teeth. I must speak new words that had been given me a short time ago. I must forget the old committed words. I must be spontaneous and natural. I walked into the toe-marks. I did not rustle the letter. I did not pound the table. I managed my new speeches. I reached my peroration. In velvet and chinchilla, a great lady of the old school, I delivered my ultimatum to the abashed officer of the law. And I said, 'Whoever that baby is, she's got to give the woman up!'
>
> (cited in Cardullo et al. 1998: 64)

Escape the play was originally produced not by Dean (who had produced *Loyalties* in 1922) but by Leon M. Lion at the Ambassadors theatre in London in 1926. It tells the story of a 'good' man who is sent to Dartmoor prison for accidentally killing a policeman, whilst defending a prostitute he encounters in Hyde Park. Whilst doing convict labour outside in the fog, he breaks free and both the play and the film show his encounters with various characters from different walks of society whilst he is on the run, from an off-duty judge fishing in the local river to a family having a picnic. He eventually ends up seeking sanctuary in a church and gives himself up to save the morally conflicted parson from lying under oath. The play is a dramatization of a conflict of morals and is trademark Galsworthy, in that it calls upon its audience to question their 'natural' assumptions about contemporary values, in this case, 'guilt' and 'innocence'. It

is notable how many times reviewers saw the play as being more suited to cinematic rather than theatrical modes of expression. 'I have an obstinate conviction that Mr. John Galsworthy [...] cast a curious eye on the flickering film and in an idle moment sat himself down and made himself a scenario' (*Punch*, 18 August 1926). Evidence seems to indicate, then, that *Escape* occupied an ambiguous position as a stage play in the first place, straining beyond the limits of theatrical representation towards a more cinematic method of representing the environment in which the action takes place.

Filming *Escape* was therefore an attractive proposition for Dean. He first mentions it in a letter to Galsworthy as early as 1927 but it is clear that by the following year, after witnessing the first talking pictures, Dean saw how the new medium would be more appropriate.

> I should very much like to have the opportunity of chatting over with you the position which is likely to be created in the theatre world by the development of talking pictures. It is conceivable that by timely action the theatre might regain a great deal of influence over the screen and at the same time make certain that an author's work was not shamelessly misrepresented.
>
> (Dean 1928a: n.pag.)

After extensive negotiations with Paramount fell apart (detailed in Lowe 2011), in January 1930, Dean signed a contract with RKO to make British–American co-productions in Britain, using American technical expertise and supervision. *Escape* therefore very quickly became this co-production's first venture, with Dean careful to reassure Galsworthy about RKO's more measured approach to the writing of the screenplay, which included removing the spurious love interest (Dean 1928b: n.pag.). In terms of casting, Dean had initially engaged Clive Brook for the main role and had already shot some footage of him criss-crossing Dartmoor. However, Brook was under contract to Paramount by the time the film came to be made so Dean had to search elsewhere. Leslie Howard was considered, as well as Colin Clive, but the latter couldn't be released from his engagement with the play *Journey's End* (1930). Eventually Dean approached Gerald du Maurier, a celebrated stage star and actor manager, for his first talkie film role. Dean and du Maurier had collaborated previously as director and star, with du Maurier latterly agreeing to be the first chairman of Associated Talking Pictures, the company set up by Dean to combine theatre and film production. Dean was fairly candid about du Maurier's reason for agreeing to appear in the film ('money problems'), because he knew that du Maurier hated films, but recalled that he gave an excellent performance, 'although he was somewhat over

age for the part' (1973: 113). Daphne du Maurier's biography of her father gives a more circumspect account of his experience of working on the film:

> When a scene consisting of two lines and movement to a door, has been played for the fortieth time and is still not right and it's hours over time and you've a headache like a load of bricks and an empty stomach there was nothing, according to Gerald which bore a greater similarity to unadulterated hell.
>
> (2010: 89)

A range of other seasoned stage and screen actors were engaged to play the other parts, amongst them Edna Best, Mabel Poulton and Austin Trevor in the same role of the Parson as he had played on stage. Camera crew were brought in from America. All of these 'selling points' were trumpeted in the first frame of the film that proclaimed 'Stars of the British Stage and Screen photographed and recorded under American supervision and produced by Basil Dean in England in the first Associated Radio picture'. Production on the film progressed relatively smoothly, with Galsworthy evidently approving of the company's respectful attitude to his material. RKO were keen to centralize Galsworthy in the publicity for the film, with Dean enquiring if Galsworthy would consent to a group photograph on the set of the film and relaying how RKO are 'begging that you will allow us to make a talk interview that can be used as a means of announcing the film in New York and the other large cities a week before its arrival' (Dean 1930b:n.pag.). This demonstrates that this American company at least saw Galsworthy, rather than the film's stars or director, as a key factor in attracting audiences across the United States. Dean also emphasized in publicity the way the film could showcase the 'English countryside' for audiences in a way that the play obviously couldn't, which recalls the 'opening out' effected by the stage-to-screen adaptations discussed in Chapter 1 (1973: 110).

The film was released in the United Kingdom in August and in America in November 1930, but despite this and a world release by RKO, Dean notes in his autobiography that filming on location had pushed up production costs too high to recover its negative cost of £42,762. He also claimed that the exhibitors in America kept 'tinkering' with the negative of the film as they thought its 'atmosphere' was too specifically British and thus were unsure of the film's appeal to American audiences (1973: 123).

Reviews of *Escape* in British newspapers and trade magazines were generally positive, with *The Times* highlighting its suitability as a talking film. It is notable that the review also mentions how much the performance of spoken dialogue contributed to the successful effect of the film. 'It would indeed be a hard and brutal world which could resist the dog-tired voice with which Gerald du Maurier pleads

for shelter or the hopeless tones in which he discusses the possibility of getting away from Dartmoor' (Anon. 1930a).

The film therefore does foreground its stage origins by following the play closely and using essential parts of the dialogue in each of the scenes. In the main it is shot frontally with players organized horizontally across the frame. However, there are also various sequences where montage effects are used to communicate themes, most notably in the four-minute section devised by Galsworthy, which opens the film, depicting a fox hunt at the end of which we are introduced to the central character Matt Denant. The action then cuts to London, where Matt is seen taking a walk in Hyde Park and picks up where the play starts. The parallels between Matt and the hunted fox that Galsworthy was keen to bring out with this introductory sequence are then sustained throughout the film. It's remarkable how much this sequence echoes those of the opening scenes of *Gone Too Far* and *Fences* discussed in the first chapter, as all three start with sequences that emphasize figure movement through a set of locations to establish the protagonists in their social environment.

There is also a scene about 47 minutes into the film as the policemen close in on Matt, which seems designed to showcase the audio-visual properties of the medium, much like the celebrated 'Knife' sequence in Hitchcock's *Blackmail* (1929).[4] We hear cymbals crashing, which appears to be the only extra-diegetic sound in the film, until we see Matt, framed in a long shot bent over with his hand cupped over his ears, as if to drown out the sounds in his head. Superimposed over his figure in the four corners of the frame are constantly changing images of the policemen on bikes and in cars, the face of the inspector searching for him, a huntsman's horn, the marching boots of the convicts and a newspaper seller with the headlines proclaiming '5 years for murder' and the scene from the beginning with the prostitute that led to his conviction. Against a jumble of horn sounds, cymbals and jaunty music from the beginning, the images build to a crescendo until Matt staggers forward and falls down in a dead faint. Therefore the images are able to express Matt's inner state of distress in ways beyond the capacity of the theatre play by transcending the bounded time and space of the play, to revisit moments both visually and aurally that have brought Matt to this crisis point.

Du Maurier's performance here is one of the few moments in the film in which he employs more gestural acting, clutching the sides of his head and sinking to the ground. The only other time is when he is hiding out under a bridge and with his whole body framed by the camera, he raises his hands up to heaven as if to ask for divine intervention in his plight then, exhausted, falls down. Otherwise his performance is remarkably restrained, his gestures contained and his voice almost indistinct in the speaking of the dialogue. This is partly to show a character who is constantly trying to make himself blend in to each of the social situations in which he finds himself, but there also seems to be a desire on du Maurier's part to put his chin down,

keep his head still and let his eyes communicate his wariness. Of course this might be response to the very real technical challenge of performing in the early talkies, but it's also a performance style that crossed over between theatre and film. Du Maurier was noted as a stage actor for his naturalistic performance style, a 'delicately realistic style of acting that sought to suggest rather than to state the deeper emotions' (du Maurier 2010: 67). One key gesture that becomes noticeable throughout his performance is du Maurier reaching his hand inside his coat to cover his heart, which communicates both the physical toll and spiritual pain of his flight.

As with the play, the effectiveness of the film lies mainly in the way it explores and challenges society's attitudes and values, through Matt's encounters with representative character types and in their differing responses to his situation. This is achieved predominantly by dialogue, which articulates the characters' moral positions and performances that 'give a more nuanced life to what are basically abstract conceptions, such as justice and faith' (Anon. 1930b). A good example of this is in the scene where Matt interrupts two sisters (Madeleine Carroll and Marie Ney) having tea in their front room. Miss Dora (Carroll) manages to send the pursuers off in the wrong direction and Matt emerges from hiding behind the curtain to thank the sisters. Dora goes off to look for a more suitable hiding place and Grace remonstrates with him to give himself up if he 'calls himself a gentleman'. Matt, with his hands on his hips, shrugs and takes the opportunity to escape through the French windows. When the pursuing group come back to search the house, the scene hinges on whether Miss Grace will let them know that they have seen the convict. The moment is heightened by the construction of shot. The pursuers are shot from behind outside the door frame as they re-enter the lounge to where the sisters are standing facing them. From this position the camera tracks in over some distance to end on a close up of Miss Grace's face as she finally answers 'No'. The spoken debate in this scene between the two sisters allows the audience to ponder the morality of the situation, as well as injecting an amount of tension, maintained through to the end, as to whether the less sympathetic of the sisters will actually carry out her threat of exposing the convict's whereabouts. The interest of the scene therefore is to be located not just in the visual storytelling but in the exploration of a complex and ultimately unresolved social issue (in the case of this scene, community versus individual notions of justice) presented predominantly through dialogue and performance. The actors deftly suggest their characters in a scene lasting no more than three minutes, with this being the only time they are seen in the film. Carroll, dressed in riding breeches to presumably suggest a more 'modern' outlook, has fashionable bobbed hair and communicates her impatience with convention by more exaggerated gestures and swift, impulsive movements around the room. Ney, dressed in a dowdy dress, is more still and reticent in her speech, often sitting down rigidly at the table, though betraying her anguish by twisting her hands together.

The concentration on dialogue in *Escape* ran contrary to both Hollywood norms, where speech was often used sparingly to add narrative value or support character development (Marion and Sherwood 1937: 117), and to those within British film culture, such as Hitchcock or Balcon who saw a foregrounding of dialogue as potentially supplanting visual with aural storytelling. It would therefore seem to relegate *Escape* to a third division kind of cinema, decried by both contemporary commentators and later historians as remaining hopelessly and unproductively stage bound. And yet the film holds the attention *because* rather than *despite* its over-reliance on dialogue, because it is the dialogue and the performances that express the spoken word that regulate the dynamics of the piece and provides the audience with access to its central ideas. This chimes with Lawrence Napper's investigation into the adaptation of *Journey's End* from stage to film in 1930, using its producer George Pearson's diary to illuminate the reasoning behind the construction of a key moment in the film, emphasizing how the camera was used to frame the actor's performance, rather than create meaning through montage.

> I suggest that the technician steeped in visualistic cinema might think it evidence of genius to bring me to a close up of Stanhope's wallet – a glimpse of Madge's photo – trembling fingers handling it [...] all a puerile trick that suggests I have no imagination. It is not the wallet that matters – it is Stanhope. Behaviourism not exhibitionism of trifles. For God's Sake, give me credit for knowing what is in that wallet – but let me see into Stanhope's soul when HE handles it.
>
> (Pearson quoted in Napper 2013: 24–25)

Thus in both films the camera is used knowingly to allow performance to communicate key moments in the narrative, rather than an Eisenstein utilization of montage. This is not necessarily better or worse, but more a different mode of cinematic communication and one that I argue characterized many of the stage adaptations in the early sound period, giving these films a distinctive hybrid theatrical/cinematic identity.

However, Dean was only one example of a director who adapted stage plays to the screen and I now want to turn to the work of Alfred Hitchcock during this period. Hitchcock has, of course, a much more secure place in the history of film than Basil Dean, with relatively recent scholarship looking in more detail at his British films in the silent era and in the decade before he went to Hollywood (Barr 1999; Ryall 1996). However, arguably, more critical attention has been given to those films that either resemble his American films or demonstrate early signs of his directorial style, such as the shot from the landlady's subjective point of view up through a glass floor of feet pacing up and down in *The Lodger* (1927). Although *The Lodger* was adapted from a novel, four out of the ten films Hitchcock directed

before the introduction of synchronized sound were theatrical adaptations, and he was to direct a further four before 1934. A *Guardian* article described his silent film adaptation of Noel Coward's *Easy Virtue* (1928) as an 'odd little film that doesn't fit' (Patterson 2008: n.pag.). It is this sense of 'not fitting' the established Hitchcockian profile or, as Ryall describes it, the 'absence of coherent thematic authorial identity' in these early films that has perhaps led to their critical neglect (2011: 273). It probably hasn't helped their cause that as Hitchcock became established as an auteur from the 1950s onwards, he was notoriously protective of his image, with most published interviews emphasizing the originality of his films and his total control over their presentation. Thus any works that were clearly more famous stage plays first were conveniently edited out of this auteur narrative (Palmer and Boyd 2011). Therefore, despite the fact that much of his early material was adaptations of novels and stage plays, the general critical consensus is that these adaptations show Hitchcock at his weakest, unable or unwilling to suppress what are deemed to be the 'theatrical' elements in order for the 'cinematic' elements to flower. Indeed, some critics have explicitly interpreted some aspects of Hitchcock's *mise en scène* during this time as a subversive assertion of cinema's rightful independence from theatrical means of expression. For instance, William Rothman tracks how Hitchcock uses theatre as a metaphor in *Murder*, filmed the same year as Basil Dean's *Escape*, in 1930. The film was not actually based on a play but a novel about the stage by Clemence Dane and Helen Simpson (who later turned it into a play, demonstrating 1930s middlebrow culture's adaptability), entitled *Enter Sir John* (1928). Rothman claims the film declares itself explicitly anti-theatrical:

> *Murder*'s invocations of the stage are framed by and frame a succession of views that can be identified with no piece of theater, real or imagined. In the camera's gestures, Hitchcock's authorship is declared and our acts of viewing acknowledged. *Murder* ends with a gesture that is the most decisive declaration that what Hitchcock has made and we have viewed is not a piece of theater but a film.
> (Rothman 2012: 104)

Rothman here is referring to the end of the film where we see Diana, the actress mistakenly found guilty of the titular murder, embrace the man who saved her from hanging, the actor manager Sir John. We see them embrace but then the camera pulls back and we realize we are actually watching them onstage in a new play, thus offering the multiplicity of viewpoints in a single shot that only the cinema can create.

Charles Barr is more sympathetic to these films and takes a closer look at the cultural influences on Hitchcock during this time. He argues that Hitchcock was

a keen theatre-goer who publicly acknowledged the debt he owed to the 'well-made play' in the constructions of his screenplays.[5] He concludes therefore that it would 'be wrong to marginalise the stage influence as if it were in conflict with and a drag upon, the other more authentically cinematic ones' (Barr 1999: 14). Napper has also drawn attention to the influence of the Film Society group in the retrospective canonization of *Blackmail* as the only 'true' Hitchcock film of his early sound period, at the expense of his latter stage adaptations.

> The writers of *Close Up* went wild for Hitchcock's *Blackmail,* cementing its
> position in the canon of Hitchcock's great achievements in a way that tends to
> overshadow the sound films he made immediately afterwards.
>
> (Napper 2013: 22)

Close Up was a magazine, founded by Kenneth Macpherson, the poet HD and English novelist Bryher in 1927, which ran until 1933. It aimed to critically assess film as an art form in this period of transition (Donald et al. 1999) and therefore, on the whole, it aligned itself closely with the critical position of Brunel and Montagu's Film Society, which, as we have seen, had a vested interest in promoting what were deemed to be more essentially cinematic modes of expression, such as a montage and a constantly moving camera. In a similar way to the marginalization of Dean in the history of British cinema, it would seem that Hitchcock's play adaptations have lost their place in British cinematic history because they refuse to conform to these definitions of the 'cinematic'.

One of these sound films, Sean O'Casey's *Juno and the Paycock* (1930), will be the focus of this discussion, analysed in terms of some of the issues identified previously, namely the retention of original dialogue and presentation of the dramatic material.[6] It is notable that this was also a film adapted from an established playwright with a high degree of cultural cachet. Unlike many other of Hitchcock's adaptations, where the source was downplayed to establish and promote Hitchcock's authorship, *Juno and the Paycock* was marketed on the basis of the original author rather than the director. One passage from the film's pressbook, though mentioning Hitchcock by name, makes it clear that this screen adaptation was authorized and thus legitimized by O'Casey:

> The story told by the film is the same as that of the play from which this talking
> film was derived, but it differs from the stage play in that Hitchcock has, so to
> speak, re-expressed it in cinematique-sound terms. This necessitated some fur-
> ther passages of dialogue which were written by Sean O'Casey, the measure of
> his appreciation of the new form of his work.
>
> (*Juno and the Paycock* 1930)

It was made by British International Pictures (BIP), characterized as a 'business environment' by Ryall in his narrative of Hitchcock's early career where, Ryall claims, Hitchcock languished in projects that were foisted upon him, before leaving the company for the more 'creative' environment of Gaumont-British, where with Film Society alumni Michael Balcon producing, he was able to develop a more clearly defined 'Hitchcockian' style with films such as *The 39 Steps* (1934) and *Sabotage* (1935) (Ryall 2011: 263). John Maxwell, the head of BIP, was certainly known as an astute businessman and saw opportunities with the introduction of sound for expanding markets to English-speaking Commonwealth countries, calculating that it would be possible to make films with budgets of up to £50,000, 'if this lucrative non-American market could be effectively tapped' (Murphy 1984: 155).

The first theatrical production of *Juno and the Paycock* was in 1924 at the Abbey Theatre in Dublin. The play, set during the Irish Civil War, tells of the trials of the Boyle family who gain and lose an inheritance and a son who has turned informer against the IRA. Its London premiere was on 16 November 1925 and it was then reasonably regularly revived throughout the 1920s and 1930s. The original Juno, Sara Allgood, revived her role in the original and West End productions and Hitchcock's film. Sean O'Casey was apparently reticent to have his stage play turned into a film, but was persuaded by Ivor Novello, when he was brought by the latter to Elstree studios to meet with Hitchcock, when filming *Champagne* (1928) (The Hitchcock Zone n.d.a: n.pag.).

The film follows the stage play reasonably faithfully although there is an extended first scene, where an orator is calling for unity in front of a city crowd and Hitchcock misses out the notorious final coda of Captain Boyle and Joxer's drunken duologue.[7] The orator is played by Barry Fitzgerald, who famously played the original Captain Boyle, and O'Casey wrote this new scene as a sign of faith in the cinematic version of his work. If the orator's speech however is vague in terms of articulating a clear political position, the camera movement is perhaps less ambiguous as it pans out until a sign for Parnell Street is seen clearly to the right of the frame.[8] On the words 'unity and 'peace', there is the sound of gunfire and the camera cuts to a window where a group in suits, dressed differently from the predominantly working-class crowd, are seen aiming their machine guns into the street. Captain Boyle (Edward Chapman) and Joxer (Sidney Morgan) then repair to the pub before heading home and the action picks up where the play begins.

Throughout the first few scenes, the framing often emphasizes the on-screen space as a performance space, enabling us to infer meanings from the interactions between characters and the performances of the actors. For instance, in the pub scene, Captain Boyle, Joxer and Maisie Madigan (Maire O'Neill) are positioned horizontally next to each other in front of the bar, with Captain Boyle attempting to get a free

drink from his companion. In the scenes in Juno's house, the dialogue and action of the play are followed fairly faithfully. However, there are occasional flourishes with the camera (that later became trademark Hitchcock) such as the long track into Johnny's (John Laurie) frightened face at the end of the 'Act', as the family chat about drinking to 'the bright ones that are coming'. Here, his inner thoughts, which he has to keep hidden from his family because they might betray his true allegiances and put his family in danger, are communicated by the concentration on his face. Laurie's performance, particularly the focus on his eyes, flickering to the right and left, is emphasized here and Hitchcock contextualizes his jitteriness with a sudden cut to the image of a window and the sound of rapid gunfire, before fading to black.

In a similar sequence to *Blackmail*, later in the film, sound is used even more expressionistically. As Captain Boyle, Juno, Joxer and Mrs Madigan sing a song round the table to accompany the records on their new gramophone, the camera moves sideways away from the happy group to a medium close up of Johnny's anguished face. Still staying on his face we see his reaction to the sound of praying and mournful singing of the funeral outside and then the voices of Juno and her family as they stop singing and declare their intention to go outside. With the camera still focused on Johnny we see his face, reacting with despair to the distorted sounds of praying outside. There is a quick cut to a figure who enters the room, but then Hitchcock returns to the framing of Johnny's face with only the legs of the figure visible behind him. The figure is an IRA man, who has come to 'invite' Johnny to a meeting, to help them identify the informer. Johnny begs not to go, looking up to the figure and clinging to his legs and the camera maintains this extraordinarily long focus on Laurie's expressive face until the figure leaves the room and we hear the sound of rapid gunfire, cutting quickly to the open window again, marking the end of a unit of action as effectively as a theatrical curtain.

Press reaction in the United Kingdom was generally positive, with many applauding the play's successful transition to the screen.[9] For instance under the headline, 'Something new', the *Daily Express* hailed it as being 'of the stage and yet it is miles removed from the stage' (Anon. 1930c). Even more fulsome was theatre and film critic James Agate's almost rapturous approval of this early sound film, noting 'the excitement that this passage communicates around sound cinema, specifically for British productions'. Agate proclaims:

> Bravo, Elstree! Bravo, Mr. Hitchcock! Bravo, the Irish Players! And bravo, Mr. Edward Chapman! British International Pictures Ltd. and these fine artists have between them put together one of the most remarkable films that it has ever been anybody's pleasure to see [...] I desire to say, and to say with all possible emphasis, that here is a film which completely justifies the talkies.
>
> (cited in Napper 2013: 17)

This demonstrates how the more positive contemporary reactions to these play adaptations have seemingly been edited out of British film history, in favour of a Film Society inflected narrative that privileged what it deemed to be the essentially more cinematic outputs of Grierson and the documentarists or those experimenting with Soviet montage techniques. Similarly the Hitchcock 'narrative' has meant that *Juno*'s qualities as a film have been overlooked, particularly in terms of how his camerawork serves the performances by the actors.[10] This is borne out by the final scene when the camera dissolves between the statue of the Virgin Mary and the desolate figure of Juno to emphasize their shared status as martyrs. The camera then pulls back from this close up to show Juno trudging across the apartment, with all her possessions having been removed by the bailiffs, making her figure eventually dwarfed by the scale of the empty room. It also allows for the full force of Allgood's performance to be seen and most importantly heard. The ringing vibration of her anguished tones in the empty space as she articulates her loss are underlined by the echoing sound, which was rendered in production rather than post production, because synchronized sound technology was in its infancy. Allgood's delivery of the lines reverberating around a domestically eviscerated, empty space emphasizes Juno's fate in particular and women more generally as the victims of patriarchal society.

The final set of films examined in this chapter, the Aldwych farces, also demonstrated a privileging of continuous performance by the actors, so as to best serve loyal audiences who had followed their comedy heroes from theatre to the cinema. Sutton has argued that

> [t]he British comedy film of the 1930s emerged from a very mixed pedigree, a meeting of the new technology of sound on film with a number of traditions inherited from the silent cinema, pre-cinematic forms of music hall and variety and more recent stage traditions such as revue and farce.
>
> (Sutton 2000: 28)

Scholarship on British comic films of the early 1930s had been fairly indifferent to their charms, describing them as cheap fillers, taken from the stage solely to fulfil quota obligations with ready-made scripts and using well-known stage stars. For instance, Rachael Low describes these films as often 'plotless revues', dependent on 'the talents of their comic performers' and thus 'the bastard offspring of film studios and various branches of live entertainment' (Low 1997: 90). Janet Moat in her review of the Aldwych farces in the public-facing *BFI Screenonline* website is equally dismissive of them for now familiar reasons: 'There was little attempt to make the films much more than photographed stage plays, and their rhythm and momentum remain theatrical rather than cinematic' (BFI Screenonline n.d.:

n.pag.). Sutton is one of the few scholars who see significance in their attempts to reconcile a model of popular Hollywood cinema with 'specifically British generic forms and inflections' (Sutton 2000: 92) and I will examine one of the most popular of the films, *Cuckoo in the Nest* (1933), to trace its adaptive strategies and understand it in relation to a more positive interpretation of its theatrical qualities in terms of the actors' comic performances.

The Aldwych farces were a distinct subset of the comic film of the early 1930s. Based on a run of successful stage properties in the 1920s and named after the West End theatre where they were first performed, they were written by Ben Travers, following a reliable formula with the recycling of particular character types within stock situations. *Cuckoo in the Nest* was the first of Travers' plays to be produced at the Aldwych theatre in the 1920s and kickstarted a long-running and immensely popular run of his farces, usually produced and performed by a core company: Tom Walls, Ralph Lynn and, coming in somewhat later, Robertson Hare. In *Cuckoo* they were joined by the celebrated stage actress Yvonne Arnaud playing the part of a somewhat ingenuously 'continental' woman who finds herself accidentally stranded with Peter (Ralph Lynn) when they both miss the train taking them and their respective partners to a house party. They end up having to stay at a hotel and pretend to be married so that they don't get kicked out by the fiercely principled landlady. Complications ensue as they are pursued by Peter's wife and her father and mother, the latter determined to expose him as an adulterer.

Most studies of farce emphasize the centrality of live performance, which manifests itself in the close association of writers and a team of actors and as Leslie Smith argues is demonstrated in 'the peculiar importance attaching in farce to stage business, to timing, movement and gesture and to the use of stage space [...] Pieces of stage business, difficult to visualise in reading farce, come alive with hilarious effect in performance' (Smith 1989: 10).

This is borne out by the section in Ben Travers' autobiography *Vale of Laughter* describing how the original *Cuckoo in the Nest* production was developed (incidentally he credits Gerald du Maurier, star of *Escape*, with introducing his work to Tom Walls when they were looking for a replacement for a show in the Aldwych that had closed prematurely). Travers tells of how the first two acts were developed in tandem with the cast so that by 'the end of the second week, the first and second acts had been cut, re-invented, transcribed, gagged and generally tinkered into fairly promising shape'. However this meant that the original third act 'seemed about as applicable as a death-knell' and Travers had to 'rewrite the whole bloody thing' in just three days, whilst suffering from whooping cough (Travers 1957: 87).

Travers also wrote in admiration of Ralph Lynn as an actor because he felt that he understood the nature of character in farce – in that they were motivated by serious and valid reasons but it was the thwarting of the achievement of their aims that created the comedy. He described him as having a great gift for timing and was full of admiration for the way he relied on instinct and the impromptu in performance, adding lines that would seem innocuous on paper, but would always get a laugh because of how he performed them. He wrote that 'nobody ever appreciated as well as Ralph how intensely serious is the business of being funny' (1957: 94). However, it wasn't just star performances and Travers also credited the ensemble in finessing the play in performance, such as the way Arnaud was able to effectively play the straight man to Lynn's 'silly ass', feeding lines to him and allowing the comic interplay to develop.[11]

As the Aldwych farces were wildly successful, it was no surprise that the whole company was snapped up by Herbert Wilcox in 1930 for a fairly low-budget screen adaptation of Travers' second play, *Rookery Nook*. It was very successful financially, making £150,000 according to Wilcox from a budget of £14,000 (Murphy 1984: 154). Then in 1933, Michael Balcon wooed Walls away to sign a contract with Gaumont-British and *Cuckoo* was the first of the farces to be filmed. According to letters in the Balcon collection, there were several disputes between producer and director as, according to Balcon, Walls was a pretty lackadaisical screen director and infuriated him by overruling him in the choice of actors (Michael Balcon Collection 1934). According to Sutton, Balcon was also annoyed at the terms of the contract as Walls got approval of story and cast and the right to direct the films (2000: 87).

The press book for the film demonstrates the drawing power of the stars by putting them at the top of the billing along with Ben Travers as writer. It also emphasizes the familiar in the film rather than the new, describing it as a

> Riotous farce in the best Ben Travers tradition giving scope for stars and the familiar stage team to put over a generous helping of their characteristic nonsense with Walls immense as an alcoholic old major.
>
> (*Cuckoo in the Nest* 1933)

However, whilst being bound to replicating the theatrical performance for its audiences, the film is not without classical editing techniques, as can be demonstrated when Peter's in-laws encounter various impediments to their arrival at the hotel, whilst Peter is wrestling with having to share a room with Arnaud's Marguerite. Here the editing cuts between the two couples to increase the anticipation of the audience. Stollery argues that the editor on *Cuckoo*, Alfred Roome, was able to

gradually utilize what might be deemed to be more cinematic methods of cutting between different but related dramatic spaces to increase the tension.

> These differences between the play script and the film suggest a consensus within the production team around Roome's view that it was often better to do a bit, then to cut away to the other story, then to cut back to that bit.
>
> (Stollery 2010: 10)

However, this presumes that cross-cutting only happens in film, whereas for instance theatrical melodrama in the nineteenth century used cross-cutting between scenes to heighten emotion. Some of the editing techniques used in the film can be understood then, as Stollery admits, 'as an inflection of theatrical precedents as well as a departure from them' (2010: 5). This is because of the idea of the scene being used as 'a stage', where the most common framing is the long shot, and close ups were only used to give a detail relevant to the overall performance.

An example of this is in the scene where Peter is seeking advice from his permanently intoxicated father-in-law (Tom Walls) as to how to explain what happened the previous night to his wife when she arrives. It's all standard farce fare with classic stereotypes; Lynn as the amiable silly ass and Walls as the irascible drunken Major, slow to react to most things in the conversation but spritely when anything can be interpreted as an invitation to go to the bar. The scene that lasts six minutes overall is shot mainly with the two side on facing each other in mid shot. There are minimal shot reverse shots and close ups are only used to underpin the distinctive performance details of farce, e.g. the Major's barely focusing eyes underpinning his nonsensical ramblings about 'Hitchcock stayed here with his wife' (a mispronunciation of the character's name but surely also a nod to the real life director here). There is only one break in the sequence two minutes in, where there is a cut to what is happening simultaneously in another scene, and then it's back to the same framing of the performers.

What this section demonstrates is how the filming preserves the performance space. There is little cutting and the camera allows for gestures and small bits of business to be seen, for the pace to be developed by the performers instead of the editing and seemingly superfluous details like silly walks are given the time and space to be enjoyed, important when the actors are playing the same characters (Ralph Lynn's silly ass for example) across a range of films. The emphasis is thus on preserving recognized and recognizable performances by key actors, building on the audience's knowledge of their repertoire of gestures, movements and voices, built up by their previous incarnations on stage *and* in the cinema. Such adaptive strategies cannot be criticized for lacking in cinematic imagination as they are

designed to serve the performances rather than the narrative. It seemed to have worked as John Sedgwick's POPSTAT table puts *Cuckoo in the Nest* as one of the most popular comedies produced in 1933 (2000: 143). Therefore, in the case of comic material transferred from stage to screen, because they are dependent 'not just on pre-existent material, but on pre-existent audience expectations about that material [they] don't actually have to reinvent theatre for the cinema to be extremely pleasurable or funny, or to be, indeed, cinema' (Sutton 2000: 160).

However I also want to suggest that preserving the essence of these performances also served another function. There is a recurrence in all these films of a sort of public acting out from, as we saw before, the sisters feigning ignorance of the convict's whereabouts to the police, to Lynn and Wall's absurd rehearsal of the former's innocent account of his activities the previous night. Jouvert even claims that Hitchcock's retention of the original dialogue and narrative structure of *Juno and the Paycock* have a performative function and that through emphasizing the piece's anti-illusionist qualities, Hitchcock is clearly matching the play's exploration of the performance of identity.

> Instead of transposing the material into traditionally 'cinematic' terms, Hitchcock draws attention to the theatrical or artificial nature of the source material itself [with] mannered performances, exaggerated visual styles that emphasize their theatrical origins, or narrative structures that self-consciously foreground the explicitly dramatic heritage of the narratives.
>
> (The Hitchcock Zone n.d.b: n.pag.)

The ghost of the proscenium arch, and the fairly static approach of the camera, therefore create stages for performance where public/private roles and moral values, in a rapidly changing social world, could be denaturalized – rehearsed and tested, put on and discarded. In this way then rather than escaping from the stage, the stages remained in these films as providing performative spaces where the idea of playing roles *outside* of one's customary social spaces could be explored. This concurs with Napper's perceptive analysis of British comic films of the 1930s. Napper challenges the notion put forward by scholars such as Low and Brown that these films simply mobilized consensus and argues that in a time of rapid social change, 1930s comedies were often marked by a 'tension between a communal sense of belonging and the acknowledgement that such belonging was temporary, contingent and marked by the boundaries of class' (Napper 2012: 66).

Therefore the characters in *Cuckoo in the Nest* find themselves outside of their normal social spaces, in a classic comic scenario of so-called sophisticated metropolitans marooned in a temporary provincial setting, where their behaviour is scrutinized by disapproving locals. As Napper argues, the 'restrictions of class in

these films' is often codified in terms of space and comedy ensues from the 'dissonance between the protagonists' mode of being and the expectations and social codes' of the new spaces they find themselves in (2012: 68).

All of which is emphasized at this time by the relative novelty of hearing English voices on screen. This was facilitated by the introduction of sound to film, which, as Sutton argues, 'immediately removed them [characters] from the dreamlike world of silent cinema and placed them in a different relation to their viewers' (2000: 89). Therefore as soon as Ralph Lynn opened his mouth, a certain placing of the character was inevitable, vocally locating him within a clearly recognizable upper-class identity. The comedy derives from poking fun at this identity and seeing it as contingent, opening up the possibility of class itself being a performance. Of course it also allowed for the verbal dexterity of the play to be transformed intact, with the music hall banter providing a key part of the rhythm of the piece overall. Thus we get the dim local boy (Roger Livesey playing a rather well-enunciated local yokel) engaging with the upper-class interloper, as the vicar overhears their conversation...

'Where's the cow?'
'Being milked.'
'Where do you milk a cow?'
'You know where they milk a cow.'

Then cutting to the vicar with Hare's classic catchphrase linking him to performances that have gone before across both theatre and film:

'I say there, have a care, have a care.'

In conclusion then, this period is ripe for a re-examination of the competing discourses on offer as British films made the transition from silent to synchronized sound. The particular case of *Escape* for instance allows for a more graded understanding of the relationship between theatre and cinema during this time. Locating its production within a particular sociocultural context enables us to better understand issues such as the retention of key bits of dialogue and the preservation of the performance space in the adaptive strategies used. Similarly, the Aldwych farces were designed to showcase performances and this was imperative to retain in their translation to the screen. Even Hitchcock's sense of staging in *Juno and the Paycock* posits class and national identity as essentially performative. Therefore it is more useful to see these films in terms of a shared performance culture that utilized the resources and practices of both stage and screen industries, but in the

end have been perhaps marginalized by film historians because of their failure to conform to expectations of what was deemed to be specifically cinematic worth.

In the next chapter, we move forward 25 years to another period in British cultural history when the relationship between theatre and cinema was clearly brought into view: the exchange of material and personnel in the 'New Wave' period of the 1950s and 1960s.

NOTES

1. Parts of the Dean section in this chapter were previously published in Lowe, V. (2011), '"Escape" from the stage? From play to screenplay in British cinema's early sound period', *Journal of Screenwriting*, 2:2, pp. 215–28.

2. As this book went to press, the *Journal of British Cinema and Television* had a special themed issue entitled, 'The Transition from Silent to Sound', 17:2, 2020.

3. This company, Associated Talking Pictures (initially called Empire Talking Pictures), was formed on 2 May 1929.

4. In fact Dean claims in his autobiography that *Blackmail* is often erroneously cited as the first British talkie when it was actually conceived of and mostly shot as a silent film and converted later. Dean asserts that *Escape* was in fact 'produced as the first all British talkie to be made in the English countryside' (1973: 122).

5. Barr evidences Hitchcock's knowledge of the 'well-made' drama of the time by quoting Hitchcock's description of the literary influences on his work: 'I have derived more from novelists like John Buchan, J.B. Priestley and John Galsworthy and Mrs Belloc Lowndes than from the movies. I like them because they use multiple chases and a lot of psychology' (1999: 8). He also discusses how Hitchcock repeatedly tried to set up a film adaptation of J.M. Barrie's *Marie Rose* and, through using the Hitchcock papers at the Margaret Herrick library in the United States, demonstrates how his vivid memories of the 1920 production acted as a 'consistent and explicit reference point' in films such as *Vertigo* (1956) (1999: 14).

6. Hitchcock also made three other stage adaptations during this time, *Number 17* (1932), Galsworthy's *The Skin Game* (1933) and *Waltzes from Vienna* (1934).

7. Jack Morgan details how a key character, the tailor Nugent, was transformed from an Irishman into an offensively stereotypical Jew. Morgan describes how O'Casey was apparently unaware of this fact until 1955 when he was contacted by two outraged spectators of the film and was appalled at the substitution (1994: 215).

8. Charles Parnell (1846–91) was an Irish Nationalist who had led the fight for Home Rule in Ireland in the 1880s. Is Hitchcock's point here to give tacit approval to the Nationalist cause?

9. Although Charles Barr argues that the reception in Ireland was more mixed and puts this down to casting and censorship issues (2011).

10. Hitchcock was famously publicly dismissive of actors but a close examination of his working relationships with Donat and Carroll on *The 39 Steps* (1935) shows that he was actually extremely respectful of their skills (Lowe 2009).
11. Travers also credited Arnaud with getting the whole production past the censors as her gravitas and reputation as an actress were enough to mitigate against the potential offensiveness of having an unmarried couple together in a bedroom.

5

The British New Wave on Stage and Screen

What sort of cinema have we got in Britain? First of all it is neces-sary to point out that it is an English cinema (and Southern English at that), metropolitan in attitude and entirely middle-class. This combination gives it, to be fair, a few quite amiable qualities: a tol-erance, a kind of benignity, a lack of pomposity, an easy-going good nature. But a resolution never to be discovered taking things too seriously can soon become a vice rather than a virtue, particularly when the ship is in danger of going down. To counterbalance the rather tepid humanism of our cinema, it must also be said that it is snobbish, anti-intelligent, emotionally inhibited, wilfully blind to the conditions and problems of the present, dedicated to an out-of-date, exhausted national ideal.

(Anderson 1957: 14)

In 1957, when Anderson made these remarks, Britain was on the cusp of a social revolution, triggered by the first generation to benefit from universal healthcare and selective secondary education coming of age.[1] In both theatre and cinema, by the late 1950s, a desire to transcend what was considered to be restrictive bound-aries in content and aesthetics in both art forms was evident. The result was what has been termed the British New Wave, which started in the theatre but was taken up by directors who crossed between stage and film such as Anderson and Tony Richardson. As the latter put it, British cinema and theatre were 'part of the same movement. The same writers want to make films [...] the way it is going there is quite a lot of cross-fertilization' (Richardson cited in Geraghty 2013: 125). Yet by 1962 an editorial in *Sight and Sound* lamented that the promise of a

breakthrough had not been effected and identified the reliance on adaptations as a major problem:

> Almost everything that is good or serious or adventurous in our cinema originates in a novel or a play and although there is nothing wrong with adaptations as such [...] there is something wrong with an industry which thinks so consistently in terms of adaptation.
>
> (Anon. 1962: 55)

Critiques of British cinema for being too dependent on 'literary' sources persisted and are reflected in selected scholarship on the New Wave films. For instance, B.F. Taylor in his comprehensive study of the British New Wave quotes Elsaesser as claiming that the films produced were lesser than the French New Wave because they were not 'experimental' in form (Taylor 2013: 29). This chapter, on the other hand, understands the stage-to-screen adaptation in more productive terms, arguing that the hybridity of these films had a specifically national dimension, in the way they integrated both theatrical and cinematic elements. Indeed, as David Forrest argues, the theatrical antecedents of the British New Wave films actually distinguished them from other national cinematic movements of the time:

> The New Wave aspired to retain and reform the indigenous cultural elements which define the British cinema (a realist aesthetic and theatrical style) confirming the art cinema textual product of the New Wave as uniquely British.
>
> (Forrest 2013: 78)

There is therefore much to be gained from thinking about these films as stage adaptations, and this challenges histories of the period that can neglect their adaptive status. The period in question has been looked at in detail by theatre scholars and by film scholars but has generated debates specific to these disciplines rather than cross-disciplinary investigations (Higson 1996; Hill 1986; Rebellato 2002). Studies have also tended not to distinguish between the literary and the dramatic sources of the New Wave (notable exceptions being Lacey 2002 and Nicholson 2013). This has meant that aspects of the performance text, such as use of space, acting, design and sound, have been neglected. Furthermore, 'theatre' is treated as a homogenous entity, when in fact there were many different types of theatre in the period under consideration, from the writer-led outputs of the Royal Court to the non-hierarchical performance practices that marked Joan Littlewood's Theatre Workshop. I will approach this period in a similar way to the previous chapter, in terms of investigating performance cultures that were affected by porous boundaries

between theatre and cinema where practices moved between these areas of cultural production.

This chapter will therefore investigate questions of performance in three film adaptations: two from plays that originated from the Royal Court, *The Entertainer* (1960) and *The Kitchen* (1961), and one that originated from Theatre Workshop, *A Taste of Honey* (1961). I argue that particular aesthetic challenges to the status quo were asserted that crossed both stage and screen mediums and offered new representational practices and acting styles across both forms. Richardson, a director who worked in both theatre and cinema, argued in 1959 that practitioners needed to be challenging established norms across all cultural forms:

> It is absolutely vital to get into British films the same sort of impact and sense
> of life that what you can loosely call the Angry Young Man cult has had in the
> theatre and literary worlds. It is a desperate need.
> (Richardson cited in Tibbetts 1999: 64)

In comparison to the French New Wave directors, who sought to distance themselves from the adaptation, the British New Wave actively sought to draw upon the energy generated by developments in other media.[2] Again, in a similar fashion to the early sound adaptations, this was determined by a specific industrial context. Film adaptations of stage plays were trying to work commercially within a restricted local market, using established properties to draw upon the theatrical movement's articulation of revolution versus stasis. By adapting these plays, the producers sought to identify new, younger (a growing and thus more profitable demographic) audience for the films and began to challenge the imposition of censorship rules that regulated both the theatre and cinema of the time.[3] Therefore as Robert Shail argues, 'literary' sources gave a base 'from which to build inroads into the more conservative film industry' (2012: 42).

There was also a growing awareness in the 1950s of issues of 'access' and 'public value' that derived from the establishment of the Arts Council in 1946 and their investment of public money into theatrical institutions and ventures. As Greenhalgh points out:

> Filmed or televised stage productions offered the opportunity simultaneously to
> memorialize celebrated performances, and to enable audiences beyond the time
> and place of the original theatrical staging some kind of access to the experience.
> (2018: 22)

The engagement of a large, youthful, more culturally and regionally diverse audience, and a sense that the democratization of culture was not just necessary but

politically expedient, therefore necessitated changes to performance cultures that crossed stage and screen.

The parameters of what is called the 'New Wave' in the theatre are usually demarcated by the first production of *Look Back in Anger* at the Royal Court in 1956, though this narrative of radicalism challenging conformity has been questioned by scholars such as Rebellato (2002) and Shellard (2000). The British New Wave movement on film is thought to start a little later with *Room at the Top* (1959) and consisting of just nine films, though again the notion of a canon has been called into question by scholars such as Taylor (2013) and Hutchings (2002).[4] It is possible to see the play (as opposed to novel) adaptations as a grouping in themselves because of how the film adaptations sought to absorb or depart from the aesthetics and practices embedded in the theatre productions. For instance, as Lacey (1996) points out, when poetic realism gained more currency as a style in films it then made its way back into the theatre as a new visual aesthetic via designers such as Jocelyn Herbert who then bought those ideas into cinema, in her designs for films in the late 1960s such as *Isadora* (1968) and *if...* (1968). Acting styles also crossed between the two mediums, with many actors emerging from the theatre to challenge the look and sound of film in Britain in the late 1950s and early 1960s by broadening the range and types of characters and accents. This was partly due to changes in the funding of actors' training, which introduced grants for the poorest students and therefore enfranchised a much broader social mix of regional and working-class acting talent. For instance, Penelope Houston wrote approvingly of the 'freshness' that actors such as Alan Bates and Joan Plowright brought to the film adaptation of *The Entertainer*.

> They share the same qualities of likeableness and seriousness, energy and a kind of unstressed and unshowy honesty. This kind of purposeful acting is something encouragingly new on the British screen and the cinema cannot be allowed to imagine it can continue to do without it.
>
> (Houston 1960: 2)

Directors and writers also moved between stage and screen at the time. Tony Richardson at the same time as directing *Look Back in Anger* at the Royal Court was part of the Free Cinema movement that preceded the New Wave. The roots of this movement were in the film journal, *Sequence*, co-founded by the stage-and-film director Lindsay Anderson in 1947. The journal railed against films 'without vitality', therefore demonstrating shared concerns to those who dismissed the prevailing theatrical culture in the 1950s. Out of this emerged the Free Cinema Group in 1956 who collectively arranged to present a programme

of films at the National Film Theatre in February 1956. Their first manifesto famously asserted that

> As film makers we believe that
> No film can be too personal
> The image speaks. Sound amplifies and comments. Size is irrelevant
> Perfection is not an aim
> An attitude means a style. A style means an attitude
>
> (Anderson cited in Izod et al. 2018: 52)

Whilst Anderson claimed the Free Cinema movement had petered out by 1959, the group forged a number of personal and professional relationships that crossed between stage and screen. Richardson was clear that he thought it was of no help to have directing experience in the theatre when it came to films. Yet his idea was that Woodfall, the company he set up to produce films with producer Harry Saltzman and the playwright John Osborne, would be a 'parallel organisation to the English Stage Company – a Trojan horse that would break down the citadel walls of the British film industry – and provide opportunities for fresh, innovative work by new writers, actors and directors' (Murphy 2014: 381).

Both film adaptations examined in this first section derived from plays first put on at the Royal Court by the English Stage Company, one of a number of institutions that became famously associated with challenging theatrical orthodoxies. From 1956 to 1965, the Court was under the artistic directorship of George Devine, who acted as a sort of mentor to many of the New Wave directors, designers and actors. Devine promoted a system that emphasized creative production as emerging from a close relationship between writer, director and designer. Thus particular staging practices emerged during the rehearsal period which might take a written text in a completely different direction in performance. The adaptations had to negotiate translating the dramaturgical space of these theatrical performances into the film medium, often drawing on principles established by the Free Cinema movement, which took filming out of the studio and into the street, yet still dealing with characters in a fiction played by actors rather than using 'real people' as many of the Free Cinema documentaries had done. As Taylor rightly identifies, the implications of utilizing the documentary realist tradition of the Free Cinema movement as the aesthetic mode of representation in a range of adaptations have come to dominate scholarly discussion of the British New Wave films, in the sense that 'allegedly, these new British films were unable successfully to contain their use of locations within their narratives' (Taylor 2013: 15). Thus we have critics such as V.F. Perkins (1962) talking about the films in terms of 'landscape mongering', Higson (1996) in terms of 'narrative excess' and finally Hill

(1986) in terms of 'surplus and noticeability', all of which seem to invalidate the films as the documents of lived experience that these critics are claiming they were intended to be. Whilst not denying these interpretations of the films, reframing the debate in terms of how these films adapt the dramaturgical spaces of the original theatrical source material might offer a different understanding of how and why these landscapes were used. So whereas the possibilities of the theatre auditorium are put to work to provide metaphors for the action in the plays (the cramped and claustrophobic single-room setting of the flat in *Look Back in Anger*, the music hall in *The Entertainer*), the films could be seen as using their settings to 'perform' the same metaphoric function, albeit with obviously different effects.

The Entertainer

The genesis of the play appears to have derived from a meeting between writer John Osborne and actor Lawrence Olivier in 1958. In his autobiography (1991: 135), Osborne recalls that Olivier approached him to write something suitable to star in, although Osborne claims that he had already had the idea to write something about the dying out of music hall as a form. Olivier, on the other hand (1982: 212), recalled that he had hated *Look Back in Anger* on first viewing but that a subsequent visit with Arthur Miller persuaded him of its merits as a play. Despite the New Wave playwrights' so-called use of 'kitchen sink' realism, it's clear that *The Entertainer* was a significant departure from any form of naturalism. The structure of the play is nonlinear with Archie's music hall turns punctuating the action on stage and dislocated in time and space from the rest of the play. Osborne gave indications on the sparseness of the décor in the play text – 'furniture and props are as basic as they would be for a short sketch' (1993: 1) – and this was replicated in the simple set depicting the cramped quarters of the family, designed by Alan Tagg for the play's first performance at the Royal Court. In Osborne's text, the initial description of the setting also describes a very specific location that is designed to point to a particular social milieu rather than as directions for anything that is achievable within a theatre space.

> The action takes place in a large coastal resort [...] this is a part of the town the holiday makers never see – or if they do, they decide to turn back to the Pleasure Gardens [...] they don't even have to pass it on the way from the central station, for this is a town on its own [...] It is not residential. It is hardly industrial. It is full of dirty blank spaces, high black walls, a gas holder, a tall chimney.
>
> (Osborne 1993: 1)

It therefore operates more as metaphor for Archie's situation – the reality behind the garish façade. Despite this description being more realizable on film, the actual opening of the film shows the tourist part of Morecambe, with the parade, sea front and pier teeming with visitors. Nigel Kneale, who co-adapted the film version with Osborne, claimed that Morecambe had seen the film as an opportunity to promote the seaside town and so had gone to considerable expense in doing the town up before filming started, somewhat negating the symbolic purpose of Osborne's original setting (Murray 2017: 69). This points to a difference between the function of place on stage and on film. As the conventions of the theatre mark off the playing space from everyday life, it follows that setting can more easily work as a metaphor. This is often a notable feature of Osborne's plays – the characters are often trapped within the three walls of the playing area in the same way as they are trapped by life – whether this is Jimmy Porter in a provincial flat, railing against the establishment in *Look Back in Anger* or the dysfunctional family trapped in their cramped, third-rate digs in *The Entertainer*. The use of a real, recognizable environment on film means that different interests are involved in the representation and the metaphoric function of the setting can be undermined, despite the director's best intentions, as is clear from an article before the film was released.

> We intend, says director Richardson, to make the atmosphere of an English seaside resort an extra comment on Osborne's characters and situations.
> (Richardson 1959: 9)

The linking of place with thematic concerns becomes clearer in certain scenes later in the film, particularly when Jean and Archie share a bottle of champagne and some chips whilst sitting on a bit of a deserted scrub ground overlooking a rather dilapidated amusement park, with a rollercoaster prominently visible in the centre of the frame between the two characters. If it were ever in doubt, the rollercoaster recalls the vicissitudes of Archie's life as an entertainer, with scrubland signifying the decay behind the bright façade of the seafront. Taylor therefore argues that 'Richardson's use of the wasteland allowed connections to be made between the characters and the films' spaces' (2013: 52).

Although then, superficially, the play seems a departure from *Look Back in Anger*, in many ways it displays the same preoccupations. Whilst the music hall scenes set it apart from the earlier Osborne play, most of the action in *The Entertainer* takes place in a small, cluttered domestic dwelling, in which another group of people (in this case a dysfunctional family) air their disappointments with each other and the world beyond the living room. It's a play about waiting and reacting and this sense of treading water is bought to a head at the end of the second act, with news of

Billy's death at Suez, which precipitates the final decline shown in the third act. The weariness is articulated most cogently by Archie's daughter Jean who laments that

> Everyone's tired all right. Everybody's tired, everybody's standing about, loitering without any intent whatsoever, waiting to be picked up by whatever they may allow to happen to us next.
>
> (Osborne 1993: 75)

Despite this outburst, overall in the play, Jean is very much a reactive character, whose function, returning from London, seems designed to force each of the characters into a point of reckoning. Her relationship with Archie seems to be one of simmering resentment, which boils over in the final act, when she accuses him of 'apathy' and 'not bothering' (Osborne 1993: 76).

Reviews were generally positive, however, with most of the attention going to Olivier for his performance as Archie Rice. Harold Hobson in the *Sunday Times* remarked that '[i]ts theatrical effect is enormous' and singled out Olivier for particular praise: 'you will not see more magnificent acting than this anywhere in the world' (Hobson quoted in Shellard 2000: 84). For many, Olivier's performance came to acquire a symbolic value; that of the abandonment of old forms of theatre and embrace of the new. Olivier's career was in limbo before the play; acclaimed for his Shakespearean work but still representing the theatrical establishment that the New Wave claimed to be rebelling against. However, Lacey points out that there were consequences to the play being dominated by Olivier's performance, in that, whilst the music hall sections were a key metaphor for the collapse of Britain as a world power, they also served 'as a context for the playing out of the primary emotional despair' (2002: 105). Oliver's barnstorming performance therefore accentuated this emotional identification with Archie, an effect that complicated the play's attitude to conservatism and change, as it appeared to thus lament British loss of imperialist power rather than critique it (Rebellato 2002: 42).

Preserving Olivier's performance on celluloid for audiences in the United Kingdom and beyond was therefore the primary reason for Woodfall's decision to adapt the play in 1960. On the other hand, Nigel Kneale claims that James Cagney was in the running for the lead role at one time and Kneale himself objected strongly to Olivier playing Archie on film, because he thought he would be too theatrical for the film medium. Indeed in his biography, Kneale recalled that Olivier objected to the first draft of his screenplay as he felt that he had cut all his best lines (Murray 2017: 76).

The film not only depicts scenes and locations that are only mentioned in the play, but more crucially involves a different protagonist. Whilst Jean, in the play, is one

of a chorus of characters who circulate around Archie, in the film she is given much greater prominence. Such a move seems designed to appeal to a more youthful audience, but was also introduced in order to balance out the over-dominance of Archie, in terms of character and Olivier's performance, and to give a more identifiable and sympathetic protagonist; one more in tune with the demands of classical film narrative, whose experience structures the film and gives a point of identification for a younger audience.

The difference is notable right from the very start as we are shown images of a seaside town, full of people walking down the streets, with trams in the background, from the point of view of someone walking about it, as if we are seeing these pictures from a particular perspective. In the montage of shots, this viewpoint is revealed to be Jean (Joan Plowright), and the camera settles on a close up of her face, as she is seen to be looking and thinking, before cutting to a playbill announcing the appearance of 'Archie Rice – star of radio and television'. Jean then turns to listen to a passer-by comment on whether they have ever heard Archie on the radio. Thus a key theme of the film, the infiltration of mass culture on traditional working-class culture, is introduced, but crucially and unlike the play through the perspective of Jean. Introducing Jean at this point also revives what was becoming a key New Wave film trope, that of the environment seen from the perspective of the returning outsider, the one who leaves, but never feels quite at home in either place.

This scene is followed by an extended flashback sequence (not in the play) that shows Jean's existence in London and sets up the context for her visit back up north. We see her at work in her art studio, supervising a class of young people and then as she dismisses the class, in order to meet her fiancé, a shot in the mirror of her studio shows both Jean and the young people, now dancing, implicitly showing both her connection with but distance from this group of people.

The subsequent conversation between Jean and her fiancé, Graham, sets out Jean's dilemma: whether to stay with her job, working with under-privileged young people, or go off with Graham to South Africa. As Lacey notes, a female character's decision is still predicated on her relationship to marriage and motherhood, but it is notable that their clearly articulated position at the beginning of the film, to a certain extent, changes the perspective towards its key themes (2002: 185). This is borne out by the rest of the film in which she carries on being the perspective through which the action is seen and we are made aware of her watchful presence right through to the end, when she stays with Archie for his final performance. This introduces a different resonance to the adaptation in which we are watching Archie's decline through her eyes; the view of the younger generation on the one that preceded it. Therefore it is less of a lament for the loss of Britain's imperial power but an indictment of an old, turgid

Britain (the one railed against by Anderson in the opening of this chapter), one that sends its youth to fight in a useless war, and has nothing to offer a vibrant new generation. This is reinforced by Plowright's luminous performance, with Richardson concentrating the camera frame on her watchful eyes, seeing and understanding the demise of her father as somehow necessary for the renewal offered by the next generation.

It is perhaps for this reason that the film seems more subdued than the play, as the playwright Arnold Wesker identified in a review on the film's release, with a plea for the film to be understood on its own terms.

> The Entertainer is a film about a third rate society and a third rate comedian who is touched by the political scene he prefers to ignore; and in so far as Archie Rice can boast of no moral standards, it is about the decay of the British personality. Its theme could have been handled flippantly – imagine the Boulting Brothers; it could have been handled viciously – imagine Kazan; instead it is handled with a sadness that is loving.
>
> (Wesker 1960: 2)

Wesker here is defending the film adaptation, with an appeal to how different it was in tone from previous British or American films, as reviews were not universally positive. Many were marked by consideration of how well or ineffectively the film adapted the play, showing that these films were often seen within a perspective of their relationship to the stage. For instance Penelope Houston in *Sight and Sound*:

> The Morecambe locations are conspicuously well used and the combination of an emotional and an ironic comment in a scene such as the memorial service parade is something purely of the cinema. Yet the writers – Osborne himself – have not faced the main difficulty. The claustrophobic tautness is not just a stage technique but the means by which the play clinches its emotional grip. Let it relax and we are left with a series of isolated impressions rather than a dramatic entity.
>
> (Houston 1960: 2)

Houston's review therefore seems to articulate the uncertain status of the film in its combination of what are understood to be theatrical and cinematic elements. Changes in setting, the opening out of the characters in terms of motivations and the balance between them all add up to a particular textual identity that reveals the mixing of theatrical and cinematic dramaturgies.[5] A similar effect, though achieved through different means, can be understood in relation to the second case study, *The Kitchen*.

The Kitchen

Arnold Wesker's *The Kitchen* was first performed at the Royal Court in 1959 with John Dexter directing and Jocelyn Herbert as designer. It was adapted as a film in 1961 by Sidney Cole and directed by James Hill. Although it shares other New Wave films' theatrical antecedents, it hasn't been co-opted into the canon of the British New Wave. This is perhaps because there was no Woodfall contribution, either in production or direction, and because on the whole it replicates the interior setting of the play, eschewing the comprehensive 'opening out' demonstrated by other play adaptations. But it seems more likely that Wesker's original play, which moves away from the domestic sphere and observes a collective at work, with the setting clearly functioning symbolically as a comment on wider society, was resistant to the New Wave film trope of the disaffected protagonist, reacting to or railing against the changes in post-war British society. Wesker's play was also clearly more experimental in form than the Osborne/Richardson collaborations. Stephen Lacey has described how, in rehearsal, the staging of the play moved away from naturalism towards a more Brechtian presentation (1996: 241). It was also more explicitly political: *The Kitchen* showed how workers are alienated by their labour and exploited by the workings of capitalism, using this as an allegory for wider society.

In the play text, Wesker describes how each of the characters relate to each other in the hierarchy that structures the kitchen environment, and by telling us which food they are preparing, he gives a sense of how their individual contribution is necessary for the whole system to function. This focus on the collective is noted by Wesker in the introduction when he states:

> Each person has his own particular job. We glance in upon him, highlighting as it were the individual. But though we may watch just one or a group of people, the rest of the kitchen staff does not. They work on.
>
> (2012: 9)

The first production of the play was a one-off performance on Sunday night in September 1959 as part of the Royal Court's experimental season. It then opened at the Belgrade in Coventry in June 1961, before opening at the Court itself on 28 June 1961. A key and often overlooked element of the production was its radically new approach to design and use of sound. Its designer Jocelyn Herbert was part of a group at the Royal Court (among them directors Lindsay Anderson and *The Kitchen*'s director John Dexter) who, influenced by Brecht and directions in European theatre, were moving away from the constraints of naturalistic design and pushing towards a more abstract presentation of the setting.

Herbert has written how the motivating impulse for her design was initially the 'movement' that she thought was the most important aspect of the play, so that her set had to allow for the section where the speed and the rhythm of the meal service builds to an almost unbearable frenzy. Thus the placing of the stoves was key and 'other elements just had to take their positions around them' (Courtney 1993: 37). For the first Sunday performance, they used trestle tables for the stoves and put black material on them. She wanted to show a contrast with the sweets and salad tables so a last-minute addition was covering them with white sheets. The importance of sound to the production was clear as she recalls that the serving points made from orange boxes were covered in tin so they made the right clashing noises during the frenzied service. Sound was also highlighted by the growing hiss of the ovens as they are turned on at the beginning of the performance and was coordinated with the lights getting brighter one by one. Key to the whole production was the revelation of the building of the theatre itself. Herbert remembers how they

> Used the bare stage for the first time with the back wall and all the pipes showing. It was a real breakthrough and I think it was also the first time we put the lighting rig above the set and allowed everything to seen.
>
> (Herbert cited in Courtney 1993: 38)

Overall John Dexter recalls how '*The Kitchen* pointed me in the direction – not of minimalism that's the wrong word – but of provoking the audience to think for themselves and to use their imagination' (Dexter cited in Courtney 1993: 38).

The film, as is common with most of the adaptations of plays, came a couple of years after the performance at the Royal Court. It was produced by the cinematographers' trade union ACTT and financed almost entirely by the National Film Finance Corporation. This public subsidy arguably endowed it with the ability to be more experimental. It also gave Wesker complete control of the script and the final say in any changes, though the adaptation is officially attributed to Sidney Cole. In terms of the push towards the more anti-naturalistic presentation developed by Herbert and Dexter, the film shows a more 'realistic' setting in the shape of an identifiably working kitchen. We see the workers preparing, eating and serving 'real food'. In fact a montage about 25 minutes into the film clearly communicates who is responsible for which task in the kitchen and shows close ups of fish being gutted and vegetables being chopped in preparation for the service. On the other hand, by keeping the majority of the action in the kitchen and resisting the temptation to follow the characters outside for the most part (there are a couple of sequences where Peter follows Monique out into the night at the beginning and

then we see the lovers drift round London streets during the break in service), the film echoes the play's demarcation of the kitchen as a symbolic, dramatic space where all the action is played out. An interview on set with writer and producer reports that

> They both agreed that an essential ingredient of the play, the feeling of claustrophobia and isolation which wears down the characters would be lost if the action was spread out beyond the confines of the kitchen itself.
>
> (Taylor 1961: 5)

Therefore, unlike *The Entertainer,* maintaining the temporal and spatial aspects of the world articulated in the theatrical production offered opportunities for the spectator to 'engage with each image's inherent multiplicity of meanings' rather than have their perspective on the action fixed by the camera (Bazin quoted in Diamond et al. 2006: 83).

The film adaptation, again unlike *The Entertainer*, also resisted creating a clearly defined protagonist and maintained the emphasis on the collective, as in the play. Although the affair between Monique and Peter is given more prominence in the film, it still resists the classical film, single protagonist-driven narrative, to encompass all the inhabitants of the kitchen. Specifically cinematic techniques such as the close up are used, but in a different way to the cinematic realism utilized in the rest of the film and thus could be understood as mimicking the anti-naturalistic presentation of the play. The film begins with a sequence which is only described in the play; the fight between Peter and Gaston, the Cypriot cook. There are no titles before this sequence and the first shot of the film is of an extreme close up of a man's face, held in momentarily static, painful physical exertion before it reveals the context for the action, the fight between two men. The fight itself then is played out within the dramatic space, without the shot, reverse shots by which cinematic space is usually constructed. The sound is also key here as there is very little dialogue and the non-diegetic music is percussive and abstract in its scoring of the images, echoing the expressionistic use of sound in the original performance. There is no attempt to obey the rules of Classical Hollywood Narrative, using long shots to establish where the characters are or moving from a broader to more specific location. The opening of *The Kitchen* thus positions its audience in a similar way to that of the theatre audience, as an observer of the action, rather than suturing them into the narrative.

At the end there is also a device used which deploys the potentialities of the medium for theatrical effect. In the play, the written stage directions describe how the owner of the Kitchen, Marengo, is left facing his staff

Who stand around, almost accusingly, looking at him. And he asks again, 'What is there more? What is there more?' We have seen that there must be something more and so the lights must slowly fade.

(Wesker 2012: 49)

The slow fade of the lights here is designed to give the audience space to think about the implications of what has just been witnessed. In the film, after Peter has taken an axe to the gas pipes and the ovens close down, we are left with the characters surrounding him and Marengo delivers his final speech, both to Peter and to the workers at large, asking rhetorically, as in the play, 'What is there more?' The frame used here is a wide one so that we get a clear sense of linking the characters and their behaviour to their environment. There is no sense that the film ends on Peter as the key protagonist. Slowly, the figures fade out one by one from the kitchen setting and then Marengo, as the only figure left, is finally faded out too, leaving the bare, empty space of the kitchen as the final image before the film ends. This is a literal representation of Peter's speech during the play's quiet 'interlude' where the characters become philosophical about their situation. As the new Irish recruit Kevin lays down, exhausted by the madness of the service, Peter reflects on their situation:

Like this place, this house – this too, it'll always be here. That's a thought for you Irishman. This – this madhouse it's always here. When you go, when I go, when Dimitri goes – this kitchen stays. It'll go on when we die, think about that.

(Wesker 2012: 31)

The film's ending uses this cinematic technique to actually show this happening and therefore moves towards a more poetic expression of the characters' predicament, reinforcing the play's political message of how workers are alienated from their labour and environment.

New Wave films often adapted their sources to accentuate the aspects that would appeal to younger audiences and *The Kitchen* is similar to others in this respect. There is the obligatory 'young people dancing to modern music' section (surely as ubiquitous as Higson's 'that shot of our town from the hill'? [1996]), as one of the characters, Dimitri, brings in his radio and tunes it to a pop music station and the characters bop around before they are sent back to work by their boss. As in *Look Back in Anger*, the film's soundtrack leans heavily towards modern jazz. A sequence in the middle of the film conveys the chaos of service, through rapid cutting and close ups, and is underpinned by its score that seems like an improvised jazz set, with soaring saxophone solos and high-pitched trumpets. Sound is clearly as important here as it is in the play, with a clear sense of structuring the narrative

from the use of percussion to score the opening sequence, through the build-up of jazz in the first section, followed by the quiet interlude, in which the diegetic strumming of the guitar emphasizes the reflective mood.

It's also perhaps worth noting that the film does not draw upon star performers, unlike *The Entertainer* and *Look Back in Anger*, with many of the actors (e.g. James Bolam) making the transition from the stage production to the film. This points to the emphasis on the collective and mitigates against the possibility of a 'star' performance undermining a sense of the ensemble.

Reviews for the film were mixed, although, like *The Entertainer*, many were notable in basing their evaluations, whether positive or negative, on an understanding of the film's status *as* an adaptation. Jonathan Miller in the *New Statesman* complained that 'the pattern of the drama is hidden under a heap of competent but boring cinematic trivia' (1961: 12) whilst the anonymous reviewer in *The Guardian* argued that 'the job of adaptation has been done skilfully and with a very proper emphasis on the text rather than on cinematic decoration' (Anon. 1961). In a similar fashion to *The Entertainer*, there was a sense that the film was striving for something different from other films of the time.

> If it fails, as I think it does, it is because it asks to be judged on a level to which most British films never aspire [...] for once the screen adaptation preserves the radical tone of the original [...] but these qualities are mainly expressed through dialogue.
>
> (Sulik 1961)

This view was echoed by a more considered evaluation by David Robinson:

> In theory, *The Kitchen* is exactly the sort of British film we have been looking for for years. The play has not been adulterated; it is boldly presented with its full original text in its single claustrophobic setting of a big restaurant kitchen. [...] So what is wrong? Something pretty vital has been mislaid from stage to screen. [...] I think that the difference is that while the play succeeded in being at once documentary and intensely dramatic, the film hesitates somewhere between. *The Kitchen* is probably one of the most honest sincere and thoughtful British films since the war and so its failure is all the sadder.
>
> (Robinson 1961: 5)

The film of *The Kitchen* provides an interesting counterbalance to its contemporaries. It adopts a more stylized realism than in other films associated with the New Wave, such as *Saturday Night and Sunday Morning* (Reisz, 1960) – its self-conscious theatricality almost deconstructing the realist aspirations of the New

Wave. This ultimately made it doomed not to succeed commercially or be co-opted into the canon of the British New Wave. Indeed it was screened outside of the West End at the International Film Theatre in Notting Hill in what was described in one review as 'a cinema devoted to continental and minority films' (Sulik 1961). This then demands a question about how it can be understood as an 'indigenous' cultural product, particularly when its place of exhibition puts it alongside films from a European art-house sensibility. On one level this is a problem with defining the limits of the national within particular parameters that will always be exceeded (Hjort and Mackenzie 2000: 5). However, as David Forrest has astutely observed, 'New Wave films were consistently marked by a balance of European stylistic subversion with a firm commitment to national cinematic and cultural tropes' (2013: 77). These cultural 'tropes' then – as mentioned – involved a utilization of representational means outside classical filmmaking strategies, and in this case engendered by the adaptation process from stage to screen. Therefore the mixture of cinematic and theatrical codes, even potentially the breaking down of the distinctions between them, can be understood as a distinctive cultural poetics.

A Taste of Honey

Finally, this chapter will examine one of the most celebrated of the New Wave films, *A Taste of Honey* (1961). It offers intriguing possibilities for comparison because of its very different original performance context, Joan Littlewood's Theatre Workshop; an aspect often neglected when plays are treated as literary texts. Shelagh Delaney's *A Taste of Honey* was directed by Tony Richardson and was the first Woodfall film made after Harry Saltzman left the company in 1960 to be replaced by Oscar Lewenstein. Robert Shail claims that *A Taste of Honey* was the film where Richardson escaped from the restraints imposed upon him in the shooting of *Look Back in Anger* and *The Entertainer* and was able to imbue the project with the principles developed by the Free Cinema movement (2012: 34). Emblematic of this was his change of cinematographer, from the seasoned studio professional Oswald Morris, who shot Richardson's previous films, to the more experimental Walter Lassally, who had been a key figure in Free Cinema. Yet little has been written about the connections between the original production and the film adaptation.

Nadine Holdsworth has researched extensively into Littlewood's theatre practice and argues that she situated her work as part of an 'illegitimate theatre genealogy' that privileged the live event of performance over the written word.

> She took their texts and invested them with an exuberant theatricality that
> relied on and heightened the very qualities of performance – its liveness,

unpredictability and moment of exchange between the performance space and spectator.

(Holdsworth 2011: 166)

This set these productions apart from what Holdsworth terms the 'text bound out-puts' of the Royal Court (2011: 165). With these specific modes of developing and playing the performance embedded in the play, how were these elements adapted to the screen? To investigate this, this section will examine some of the critical responses to the film as it is significant that many of them signalled out the unique-ness of the film as coming not from Free Cinema principles but from the particular lack of formal structure embedded in the play. Central to the success of the play *and* the film were new types of actors bringing fresh ways of acting characters. For the play, Littlewood recruited actors whose working-class backgrounds matched the characters they were playing. For the film, Richardson and Delaney launched a nationwide hunt for an unknown 'ugly girl' to play the central role of Jo and the success of that 'ugly girl', Rita Tushingham, in the role launched a totemic career for her in the 1960s. Scholars such as Sarah Street have understood these New Wave actors as developing a style that could be defined in opposition to the 'theatrical', in terms of 'naturalness' and 'spontaneity' (1997b: 121). Yet many of these actors crossed between stage *and* screen, developing a career in new plays at the theatre and in films. Rita Tushingham is no exception here as after her suc-cess in *A Taste of Honey*, she appeared in Wesker's play *The Kitchen*, discussed above and then toured for a year in the Ann Jellicoe play, *The Knack* (subsequently made into a film with Tushingham in 1965). Therefore the remaining section of this chapter will argue that revolutions in playing styles crossed between stage and screen, though the difference in star discourses between theatre and film (with the latter drawing on the idea of the star as text, constructed through elements beyond the film itself such as advertising, magazines and biography) ensured that Tushingham's film appearance as Jo reverberated beyond the film itself to model a new type of youthful femininity appropriate for the decade.

Unlike *The Kitchen*, *A Taste of Honey* as both play and film has not suffered from lack of critical attention. With the latter, its 'iconographical repertoire of space' (Lovell 1996: 92), through the depiction of a northern industrial town-scape, namely the streets and canals of Manchester and Salford, has resulted in much critical attention being paid to its representation of landscape. The film has thus been the focus of extensive analysis by Higson and Hill, both arguing in dif-ferent ways how Richardson's poetic realism, in drawing attention to the formal composition of the shots, makes certain sequences in the film narratively redun-dant. Both argue that the consequences of this approach to the material inscribe the middle-class viewer as spectator, looking on at the working-class locations as

spectacle, rather than the simple background environment of the action (Higson 1996; Hill 1986). Lovell concurs, claiming that 'the concept of poetic realism allowed the New Wave directors to stress the personal vision of the observer/ filmmaker as well as the authenticity of what was observed' (1996: 83). This, she argues, leads to the film distorting the radical material of the play particularly in terms of losing its female-centric perspective. Familiar New Wave tropes such as oppositions between mass culture and traditional culture are shoehorned into the film by Richardson, leaving it with a kind of 'double vision' (1996: 85). Recent perspectives on *A Taste of Honey* as a film have come mainly out of a desire to rehabilitate Richardson as a key British filmmaker (Shail 2012) and/or re-assess his creative agency in the production of the film (Murphy 2014). Only Taylor, however, in his re-assessment of the New Wave as a whole, argues against Hill and Higson in terms of the function of the location sequences in *A Taste of Honey*. He contends that *A Taste of Honey* deftly integrates its locations with its themes and analyses the moves made between interior and exterior spaces. He thus dismisses the idea that these outside spaces are narratively redundant by tracking how they represent opportunity and escape and contrast with the constriction and encroachment of the (largely domestic) interior spaces (Taylor 2013).

This opposition is of course embedded in the play through its one location and interior spaces, which work to contain both Jo and her mother Helen, within the domestic sphere. Escape and dreams of alternative ways of living are then expressed in the dialogue and through the performances of the actors as the characters who have

> Little trouble expressing real and painful feelings, and perhaps this is because they are all in one sense or another socially marginal – single mother and part time whore, illegitimate teenage mother, gay white man, black sailor boy.
>
> (Wandor 2014: 42)

The first production of *A Taste of Honey* was by Joan Littlewood's Theatre Workshop at the Theatre Royal in May 1958 and then it later transferred to the West End and Broadway. There is surprisingly little about the production in Littlewood's autobiography but Nadine Holdsworth, in her analysis of Littlewood's work, offers a detailed examination of the processes by which Delaney's original script was worked upon in the rehearsal process (Holdsworth 2011: 179–87). There is also Delaney's original script in the Joan Littlewood archive at the British Library (MS 89164/8/75, accessible online via Nye 2017). Nye argues that the original script was much bleaker than the eventual published play, with recurring images of death and fear of abandonment. Some characters were also changed through Littlewood's intervention; for instance Peter in Delaney's original script was more

of a potential father figure for Jo and offers to house Jo when the baby is born, whereas in the play he is a brash, moneyed drunk (Nye 2017).

Delaney was a young, novice playwright from Salford, whose background was often invoked to authenticate the reality of the world depicted in the play. Her work was seen by some London critics as verbatim dispatches from the frontline of northern working-class life. For instance, Kenneth Tynan hailed Delaney for 'presenting real people [...] joking and flaring and scuffling' (quoted in Nye 2017). *A Taste of Honey* was tangibly different from other New Wave plays in terms of both content and form. For instance, its depiction of Jo's mother Helen was a world away from the typically northern 'Mam' of popular culture. Helen is heavy drinking, flighty, promiscuous and a demonstrably negligent mother. Her return to Jo at the end of the play is presented unsentimentally as being because she has been kicked out by Peter, rather than because she has realized that Jo needs her. Holdsworth also argues that Delaney offered a radically different view of working-class culture by undercutting notions of 'homogenous community identity through her radical representation of different ethnic backgrounds, sexualities and miscegenation' (2011: 187).

In this way *A Taste of Honey* shows a world without attempting to explain it and therefore (unlike Wesker) there is no attempt to show how characters' actions are a product of their environment and thus draw wider conclusions about society. Therefore it is not because of society's marginalization of men as carers that Geof gets kicked out but because Helen acts out of self-interest, seeing him as a threat to her. As Holdsworth concludes, 'rather than presenting an extended lament for a lost culture of extended families and close-knit communities, it maps a different experience of individuals who live wholly in the present moment as they collide to create alternative, often temporary family units' (2011: 194). This sensibility arguably does not extend to the film, which offers its viewers a more homogenous idea of working-class culture, through showcasing not just the unembellished environments of the time, but also the practices that take place within, such as the marching bands and children's games, with a somewhat sentimental eye.

One aspect that was very particular to *A Taste of Honey*, along with other Theatre Workshop productions, was how much of the play's particular aesthetic was created in the nightly performance. On the face of it, the stage directions are very sparse – the action all takes place in one bare, nondescript room, with only a naked light bulb to light the space. Therefore, the dialogue between characters is the key focus of interest and, in particular, the subtle graduations in the mother–daughter relationship as they progress through the events of the narrative. The actors were thus particularly important in this performance and Holdsworth talks about how Littlewood would encourage each actor to find 'a distinctive performance style for their character' (2011: 191). Avis Bunnage, who played Helen,

was cast for her experience in popular music hall, and was therefore encouraged by Littlewood to ad lib and interact with the audience. This aspect developed in rehearsals so that Helen began directing her comments about Jo directly to the audience. Littlewood also encouraged Bunnage to emphasize the humour of the writing to subvert the sense that the play was another northern miserablist memoir. In a radio interview with Studs Terkel in 1962, Frances Cuka, who played Jo, said that Delaney's dialogue captured the mordant wit and cynicism of northern people, in a way that was significantly different from previous representations of the north (WFMT Radio Network 1962: n.pag.).

Littlewood was clearly influenced not just by contemporaneous theatrical experimenters such as Brecht, but also by an identification with earlier popular theatrical forms where 'the stage acknowledges a process of dynamic intervention' (Holdsworth 2011: 97). This was underpinned in performance with the addition of a jazz band onstage (Johnnie Wallbank's Apex Trio), who improvised the opening score from night to night and played certain set numbers associated with particular moods or characters. One of the musicians stressed the importance of the music to each performance, in that it 'contributed a lot to the pace of the show. Instead of just having scene changes where people had to go off you could have a bit of music' (Joan Littlewood Archive MS 89164/5/29, British Library n.d.). Notes made by Joan Littlewood on the music itself list actual tunes that were used in the production, such as 'Everybody Loves My Baby' and 'Careless Love Blues', 'Dippermouth Blues' and 'Baby Doll'. Littlewood's note on the 'variation on the negro folk song "Black Boy"' indicates an adaptation of 'In the Pines', also known as 'Black Girl'; the variation refers to Littlewood's change in the lyrics from 'Black girl, black girl, don't you lie to me', to 'Black boy, black boy, don't you lie to me' (Joan Littlewood Archive MS 89164/5/29, British Library n.d.). It appeared that the free form score added to the impression of a messy slice of life, as both sound and visuals seemingly lacked an overall shape and direction. Murray Melvin who played Geof in the play described how the theatre space was used to break down the barriers between audience and performers:

> The effect was especially strong because the actors on stage interacted with the band, which was located in the audience. So the band brought the show into the audience, and then the actors and band openly communicated, thoroughly destroying the illusion of 'reality' as defined by the naturalistic theatre of the time.
>
> (cited in Holdsworth 2011: 190)

Holdsworth thus argues that Littlewood's performance practice was key to the aesthetic of A Taste of Honey as 'these additions functioned to destabilise the primacy

and authority of the social realist text in favour of the collaborative creative act and live communally encountered performance event' (2011: 19).

The play was a commercial success for Theatre Workshop and injected some much-needed finances into the enterprise. Cuka describes how production costs were so low that they couldn't afford a stage manager and the wardrobe mistress had to do the singing voices of children offstage. It received mixed reviews critically, although Kenneth Tynan hailed Delaney as an important new voice in the theatre: 'There are plenty of crudities in Miss Delaney's play; there is also more importantly the smell of living' (*Observer*, 1 June 1958; Ellis 2003).

The production transferred to the West End, Wyndham's Theatre on 10 February 1958 and ran for a year, winning Foyles Best New Play award. It opened in America at the Bitmore Theater in Los Angeles on 6 September 1960, with *Entertainer* alumna Joan Plowright playing Jo, Angela Lansbury her mother and Tony Richardson coming in as co-director. This production transferred to Broadway at the New York Lyceum and ran for 376 performances, netting Plowright a Tony for Best Actress in 1960. Richardson had by this time already begun working on the screenplay with Delaney, and the Broadway premiere was strategic in ensuring transatlantic distribution for the film, according to Olivier's autobiography (1982: 85).

Richardson's writing collaboration with Delaney seems to have been a more harmonious collaboration than previous writing partnerships (Murphy 2014). Central to the project was a desire to go out and shoot scenes as much as possible in the streets of Salford. As Richardson told Thomas Wiseman in 1961, in an interesting echo of Littlewood's aim with the live performance of the play, he wanted to create a 'rough texture [...] The trouble with working in a studio is that everything can be controlled [...] in an insidious way, this produces artificiality' (Wiseman 1961: n. pag.). In the same interview, he mentions how a Hollywood producer wanted Audrey Hepburn to play the girl and change the ending so Jo would have a miscarriage and be able to start life afresh, 'and so Mr Richardson declined the Hollywood offer' (Wiseman 1961: n.pag.) As noted in previous chapters, newspaper publicity for these adaptations often drew attention to what distinguished them from Hollywood films, such as star performances and happy endings. An article in the *Daily Herald* talks extensively about how even the interiors were shot on location (albeit in Chelsea!), with the production renting a derelict house in Elm Park Gardens off the Fulham Road. It describes how everything has to be crammed in so that 'the camera cannot [...] do anything else much except photograph the acting' (Nathan 1961: n.pag.)

The radical aspect of the play's form and how it translated to film was a central concern. For instance, David Robinson in the *Financial Times* claimed that

> The play made no attempt to form these characters and events into a neat theatrical form [...] The play was in a sense descriptive: here are some people, this is

what happens, take it or leave it [...]. This descriptive character and the quality of the observation adapt very well to the screen version.

<div align="right">(Robinson 1961: n.pag.)</div>

Boleslaw Sulik in the *Tribune* makes the connection between play and film clear, by situating them both in terms of a shared performance culture using different means to achieve the same ends.

> In *A Taste of Honey*, two cultural phenomena meet and merge; the revival of the British drama, a movement widely publicised, genuinely dynamic and fertile and 'free cinema' a group of documentary films made outside the system, a movement of largely symbolic significance, yet now bearing late fruit.
>
> <div align="right">(Sulik 1961: n.pag.)</div>

The aim of both movements was, he claimed, to 'defy the dead and sterile conventions of British theatre in one case, British cinema in the other and reveal the real face of Modern Britain'. Thus he argued the film could not be judged by the usual criteria, as it clearly 'does away altogether with conventional production values and with players of 'star quality' (Sulik 1961: n.pag.)

This makes it clear that *A Taste of Honey* as both play *and* film was meant to overturn the norms within each medium by upending the expectations associated with each of their forms. However, an extended analysis of the film by Albert Hunt in the *Universities and New Left Review* complains that the freshness and directness of Delaney's and Littlewood's vision is compromised by Richardson's direction.

> Shelagh Delaney's approach to the theatre is based on a concern for truth and a distrust of the phoney. Her plays are not explanations but presentations. [...] the plays are almost staged jazz [...]. What we are interested in is the subtly shifting relationships we see on stage.
>
> <div align="right">(Hunt 1961: 5)</div>

He then asks whether Richardson has found a method of translating this 'stage idiom' to the screen and concludes that, in many places (and foreshadowing later critiques by Higson and Hill), Richardson is too busy either drawing attention to the camera work or explaining relationships for the 'freshness' of the original play to be preserved. In a precursor of Hill's later critical analysis of the style of the film, Hunt argues that the streets in Richardson's film seem to be

Filled with picturesquely dirty children playing singing games [...] the children are not included because they are interesting and alive. They are atmospheric props, part of the pseudo poetic blur. This search for the 'poetic' completely destroys the real poetry of Shelagh Delaney's play. [...] Delaney's refusal to dramatize is nowhere more evident than at the end of the play. Helen comes back, Geof goes and that is all. There is acceptance. By placing the scene against the contrived background of bonfire night Richardson falls back on a conventional 'dramatic' effect.

(Hunt 1961: n.pag.)

Hunt's analysis is relevant here as is his use of theatrical language to describe the effects of the *film* rather than the stage play. He argues that Richardson is using the setting in the film in a conventional, dramatic way, as a metaphor (for presumably 'hope' in an otherwise bleak scenario for Jo and her unborn baby). The irony is that, despite the recourse to shooting in the street, the city's landscapes were used in a performative way by Richardson, rendering it more 'theatrical' than Delaney's original play. In this then, it is clear that the film of Delaney's play was shaped by Richardson's aesthetic decisions in the same way that the play in production was shaped by the distinctive performance practices of Littlewood's Theatre Workshop.

What was not in doubt in terms of the critical response was the success of Rita Tushingham as Jo, although rather than 'doing away with players of star quality' as Sulik claimed, it was more that Tushingham was a different kind of star. She had been chosen from over 2000 hopefuls by Richardson and John Osborne and was still a teenager when she made her film debut, winning the BAFTA for Most Promising Newcomer in 1961 for her role in the film.[6] Promoted by Richardson as a 'natural talent' and as the antithesis of the traditional movie actress, her youth was central to her star persona. As Melanie Williams argues, her age, looks and provenance from outside London (she came from Liverpool and had worked as a trainee assistant stage manager at the Playhouse before her big break) 'epitomised British cinema's innovative developments during the 1960s and became closely associated with a new kind of film-making (which demanded a new kind of look)' (2017: 90).

Therefore whilst the different theatre practices of Littlewood's Theatre Workshop demanded different kind of performances, that crossed the fourth wall and drew upon popular cultural forms, the engagement with audiences offered by film needed a different kind of star. Richardson's public pronouncements about the distinctiveness of *A Taste of Honey* were epitomized by Tushingham's stardom, one that deviated from the standard, in terms not just of looks but also of class

('her father is a Liverpool grocer') bestowing an extratextual persona that empha-sized 'ordinariness' and 'authenticity' (Williams 2017: 96). As the press release for *A Taste of Honey* pointed out, 'she has a face as improbable in films as her name' (Anon. 1960). Indeed, refusing to change her name to something more glamorous, in the way that someone like Diana Dors had, became a 'statement of realist intent' (Williams 2017: 96). Her nickname 'Tush' was mentioned fre-quently in popular newspaper interviews (e.g. with Patricia Lewis, *Daily Express*, 7 September 1961). Tony Richardson drew parallels between her down-to-earth attitude and his approach to filming *A Taste of Honey* – 'This is 1960 and we are filming a play about life and loneliness and reality' (Evans 1960: 12) – thus utilizing the extratextual channels available to him to reinforce the film's claims to realism through an identification with the anti-star persona that Tushingham offered.

Yet also emphasized in the press coverage of Tushingham was her commitment to her craft – *Time* magazine describes her as 'an actress not a slum kitten picked up for verisimilitude' (Anon. 1962b) and a long feature on her debut in the film puts her stardom into context by mentioning that she is currently earning '£13 12s 6d a week', living in 'a small service flat', whilst playing a waitress in Wesker's *The Kitchen* (Lewis 1961: 7). Tushingham was one of the few female northern actors who became film stars alongside Woodfall discoveries such as Albert Finney and Tom Courtenay, and her subsequent career in the 1960s developed her waifish and artless persona in roles such as *Girl with the Green Eyes* (1964) and Lara's daughter in *Dr Zhivago* (1965).

If we acknowledge that the aesthetic relationship between theatre and cinema is not fixed but historically and culturally contingent we can see how film's links to theatre in the United Kingdom were utilized at different times and with different effects to construct a distinctive cultural identity for its output. This re-imagines the relationship between theatre and cinema, as one of facilitating a 'cross media poetics' rather than undermining the essential identity of each individual dramatic form. Recovery of the history of adaptations between stage and screen then, as Gledhill argues, brings into view 'the particular significance of this relationship for British culture, [highlighting] the nature of the media as cultural spaces open to each other's products and practices' (Gledhill 2003: 178). Whilst Lacey (2002) is right to argue that a rejection of theatricality and embrace of 'realism' was one of the features that characterized the New Wave adaptation, there was also an attempt within both theatre and film to move away from realism and naturalism. Therefore, the film of *The Entertainer* attempted to use its real-life settings in ways that functioned symbolically, in the same way as the theatre play, but avoided being dominated by Olivier's performance by making Jean the key protagonist. Whereas film adaptations, such as *The Kitchen*, repurposed the theatricality that was deemed to have had such a deadening influence on the development of British

cinema, and deployed it as a dynamic tool with which to expose the discontents of cinematic realism. The film of *A Taste of Honey* was embedded with both the Establishment-challenging aesthetic sensibilities of its original incarnation and the representational strategies of its New Wave director, Tony Richardson. Its departure from the norm called for a new kind of star in Rita Tushingham who would go on to challenge female star orthodoxies in the 1960s with her unconventional looks and screen presence, changing the sound and look of British cinema in the process.

In the next chapter, I invert the framework to examine stage adaptations of British film classics that have been produced since 2000 and examine their significance in terms of the construction of 'national' identity.

NOTES

1. Part of this chapter was previously published in Lowe, V. (2020), 'Reframing performance: The British New Wave on stage and screen', in M. Stewart and R. Munro (eds), *Intercultural Screen Adaptation: British and Global Case Studies*, Edinburgh: Edinburgh University Press.

2. Although many French New Wave films are actually based on literary texts (although not many on plays, which rather demonstrates the centrality of the theatre–film relationship for British culture). Truffaut and Godard sought little-known texts and then adapted them so that their respective individual film styles were foregrounded. French New Wave directors also pioneered a new kind of adaptation in the 'cine-novel'. Many thanks to Darren Waldron for pointing this out to me.

3. For a more detailed discussion of how censorship affected the transition of stage plays to the screen, see Aldgate (1995).

4. According to Zarhy-Levo (2010: 232) those films are: *Room at the Top* (1959), *Look Back in Anger* (1959), *The Entertainer* (1960), *Saturday Night and Sunday Morning* (1961), *A Taste of Honey* (1961), *A Kind of Loving* (1962), *The Loneliness of the Long Distance Runner* (1962), *This Sporting Life* (1963) and *Billy Liar* (1963).

5. Aldgate describes and analyses the censors' reports for stage and screen versions of *The Entertainer*. In the end, the screen version, like Osborne's *Look Back in Anger*, received an X certificate (1995: 82–86).

6. Aldgate has a chapter on the censorship reports on the play and screenplay of *A Taste of Honey* and one of the key recommendations of the censors report on the latter is that the actress playing Jo shouldn't be young (Aldgate 1995).

6

Staging 'British Cinema' Post 2000

I am sure that is one of the reasons why I want to do adaptations –
I want to work with that emotional memory.

(Emma Rice in Radosavljevic 2010: 93)

This chapter will reverse the trajectory of the previous two chapters by examining the adaptation of 'British' films to the stage. This is a shift which needs to be understood not just as an inversion of the stage-to-screen adaptation but as symptomatic of the fluid and inter-directional relationship enjoyed by theatre and cinema in British cultural practice. However, as Chapter 2 argued, when films are taken as sources, they operate in different ways to plays for 'it is clear that for any film to stage adaptation, the source film serves as a repository of past performances, visual imagery, memorable lines and as an archival document from the cultural moment in which it was produced' (Pellegrini 2014: 161). Screen-to-stage productions therefore offer rich possibilities for scholars looking to challenge the text-based literary paradigm that drives work on adaptation. Analyses of screen-to-stage productions reframe films as performances, both within the frame, in terms of the performances of actors, stars and the relationship between images and sounds but also outside the frame, in terms of collective or singular acts of viewing the film, all of which can be referenced in the adaptation. In the adaptations of specifically British films looked at in this chapter, I contend that in all of them the negotiation of collective cultural memory of cinema and cinema-going in these works is a key factor that both reflects and shapes an idea of what is specifically 'British' cinema. As we have seen, cinema can also be understood as an event in which a spectator participates in an affective and embodied experience. Annette Kuhn in her work on cinema and cultural memory of the 1930s argues that, '[i]t is apparent from the memories of cinema-goers of these years that the pleasure of looking at the cinema screen is but

142

a small part of an all-encompassing, somatic, sensuous and affective involvement in the cinema experience' (2002: 147). So, whereas some of the works discussed within this chapter engage with particular images, performances or genre from their 'source' film, others will address what is clearly an unstable and fluid entity, the embodied memories of these films and their particular viewing contexts.

All of the source material examined in this chapter are 'classics' or 'cult classics' from pre-1980s British film history, although obviously the term 'classic' is a contentious one. A classic film can be one that through repetition becomes cherished by audiences, or is associated with a particular director or actor. It is also, in the post-cinematic age, a commercial term denoting films available for viewing on specific channels or platforms, such as TCM (Turner Classic Movies) and it is no coincidence that the plethora of stage adaptations of specifically British films has flourished in a time when these films are circulated on multiple platforms. The categorization of cinema through nation is also contentious and critics have debated how far British cinema can be understood as a national cinema. Andrew Higson in his pointedly titled book *Film England* still claims that the idea of the national when discussing cinema should be retained because

> Cinema is one of the means by which national communities are maintained, the people of a nation are reminded of their ties with each other and with their nation's history and traditions and people are invited to recognise themselves as national subjects, distinct from people of other nations.
>
> (Higson 2010: 1)

Similarly, theatre scholarship has recognized how theatre as a public forum facilitates and is facilitated by ideas of nationhood, particularly when broader debates about Scottish and Welsh independence and the British referendum on leaving the EU has led to a sustained public handwringing about 'how we might seek to define "British" national identity – as something insular and independent, or characterised by a more collective set of multiple identities' (Rees 2017: 10).

Does the popularity of the adaptation of British films then reflect the ongoing negotiations of national identity in a globalized and post-Brexit world? Are these adaptations, often looking back to an idealized past, then the theatrical equivalent of Jameson's 'nostalgia film'? For Jameson, the nostalgic mode to evade the complications of history has the power to help audiences escape 'the enormity of a situation in which we seem increasingly incapable of fashioning representations of our own current experience' (1991: 68). The fact that these adaptations have almost entirely white (and mostly male) casts reflects a fairly narrow definition of the canon of British cinema and suggests that they might represent a more worrying turn towards a narrow and exclusive definition of British

cultural identity. Or can we find in these adaptations a more positive celebration of cultural identities that emphasizes shared humour and indeed a celebration of the kind of ensemble character acting that often positively distinguishes British from Hollywood films. What is also notable about the adaptations examined in this chapter is that often they demonstrate theatre celebrating itself through film. Whereas we have seen film in the early sound period attempting to define itself in relation to the theatre, it appears that at the beginning of the twenty-first century, theatre is attempting to discover its identity through film. Indeed these adaptations indicate a confidence in the theatre as a distinctive, live cultural form that, rather than losing out to cinema in today's multimedia environment, can cheerfully co-opt its products and repurpose them for legions of audiences both old and new.

The chapter will look firstly at the adaptation of the Ealing comedy, *The Ladykillers* produced in 2011 and the same year as the films were digitally remastered and re-released on DVD to mark their 60th birthday (and the 80th birthday of the Basil Dean established Ealing Studios). Kenneth Tynan claimed that even by the mid-1950s the Ealing comedies had taken on the mantle of representing the nation:

> Ealing has become the regimental mascot of the British cinema, devoted to interpreting a national way of life and taking as its general theme, the extraordinary and resilient British, coping with a series of perfectly alarming situations.
>
> (1955: 4)

Whilst replicating the characters and most of the dialogue of the film, I will argue that it uses stage design to inventively recreate the *mise en scène* of the film and adapts its black humour to the more traditional theatrical genre of farce. I will then examine one of the first stage adaptations of a British film, *The 39 Steps* (1996–present) and discuss the ways in which the visuals and sound of the original Hitchcock film are referenced in the adaptation. What is notable about *The 39 Steps* is how it utilizes performance to stage a relationship to the source text – one that is far from slavishly faithful. Indeed, it is the very impossibility of live performance replicating the source film that is the foundation of its dramaturgy. This naturally has implications for notions of fidelity in terms of what these adaptations are 'performing' when they imaginatively attempt to reproduce an image or sequence of images from a film on stage, through the interaction of space, acting, sound and design.

The next two case studies involve discussion of one classic British film and one 'cult' film, Kneehigh's 2007 adaptation of David Lean's 1945 *Brief Encounter* and Improbable's *Theatre of Blood*, staged at the National Theatre in 2005, from the 1973 film starring Vincent Price. It's notable that both the companies involved in the adaptations have pointedly talked about their memories of these films rather than

the films themselves as being the starting point of the adaptive process and therefore I will be examining the mediation of cultural memory that takes place in different ways in these adaptations. This has a particular pertinence to stage adaptations of films as film as a recorded medium has a wider circulation; films are repeatable, can be encountered in different ways at different historical moments, from traditional cinema exhibition to late night television showings and fan postings on YouTube. Thus the double process involved in interpreting stage adaptations of pre-existing recorded material echoes the nostalgic's desire to transcend time and return to a fantasy past.

> Nostalgia is a sentiment of loss and displacement, but it is also a romance with one's own fantasy. Nostalgic love can only survive in a long distance relationship.
>
> (Boym 2001: xiii)

I have deliberately used the term 'British cinema' rather than English cinema, although as others have eloquently argued, the term 'British' has often been used to describe cultural production that is more imagined than based in the equal representation of the countries that make up Britain (Higson 2000). But it is precisely British cinema as cultural imaginary that all these productions are, literally and figuratively, staging; the idea of national cinema as a form of address (Dix 2016: 291). Thus these productions, as a discursive practice in a public forum, serve to construct their subjects as 'national', with the proviso that, as Vitali argues, the latter are

> understood as the always unstable discursive effects of a fundamentally conflictual civil society whose constitutive relations are over determined by, but not reducible to, the relations of production as anchored by the institutions of the state.
>
> (Vitali and Willemen 2006: 7)

Therefore part of the reason for looking at adaptations of British films in particular is to ask what they have to say about the culture that has spawned them. Obviously the first decade of the twenty-first century has been dominated with discussions around how identity formations can be linked with the idea of the national. Theatre historians have made productive inquiries into the relationships between theatre and nation, yet there has been little attention paid to how these screen-to-stage shows draw upon the idea of British cinema as a dynamic cultural force, shaping identities. As Jen Harvie argues, 'national identities are neither biologically nor territorially given; rather they are creatively produced or staged' (2005: 2) and the term 'staged' here is central to this group of adaptations because of the different ways that the films themselves are referred to, either in terms of

images on the screen as in *Brief Encounter* or, as in *The 39 Steps*, with the meta references of the constant impossibility of recreating the film's key scenes on stage. Therefore theatre 'contribute[s] to the creation of the nation through the cultural discourses it ignites, the representations it offers and the stories it chooses to tell' (Holdsworth 2010: 79–80) and the fact that these adaptations of British films keep recurring in the new millennium should alert us to how they are engaging discursively with notions of national identity. However it is not just notions of national identity but their identities as media that is at stake. As we have seen in the previous chapters, the relationship between theatre and cinema is affected by social and industrial change. In the era of post digitalization, 'cinema mutates into post-national, pan-national, and transnational forms: the proliferation of formats moving across the nation-state's increasingly porous boundaries' (Boose and Burt 2003: 5–6). In a post-cinematic era, could the proliferation of these stage adaptations be a way of reclaiming these films to within specifically national borders, asserting their national identity?

This is not to negate the economic reasons why these adaptations have come into being. Familiarity with audiences is often the starting point for critics writing about these productions, in terms of how they are simply recycling familiar narratives for commercial gains. Aleks Sierz has written somewhat despairingly about how new writing in the British theatre is being severely impeded by the recourse to stage adaptations of films. He argues that 'people are looking for a brand. It's been hard to sell straight plays recently' (Sierz n.d.). Although producer Gareth Pugh in the same article argues that the financial incentives might be overemphasized as with new plays, investors see a greater return than with those where the rights are held by film studios.

There seems to be a pattern emerging, which certainly testifies to the commercial potential of many of these productions starting out in regional theatres but ending up in the West End after being tested on local audiences. For instance, *The Ladykillers* first premiered at the Liverpool Playhouse in 2011 before transferring to the Gielgud theatre later that year. Similarly, *Chariots of Fire* at Hampstead in May 2012, before moving again to the Gielgud in June. There is also a tendency for these productions to draw upon the politics of place, by locating these initial performances in places where the original films were set or had some connection with the film. For instance, *The Full Monty* had its world premiere at the Lyceum Theatre in Sheffield in February 2013 before transferring to London. The original film famously started with documentary footage of Sheffield in its heyday as a centre of steel production in the United Kingdom, followed by images of its industrial decline in the 1980s; the background for the film's narrative of ex-steelworkers reinventing themselves as strippers. Therefore the spatial strategies of the theatre

event engage with the spatial and historical dynamics of film consumption. The appeal of these productions is both local and national, with some productions utilizing particular staging practices in their theatres – e.g. *Brassed Off* at Oldham Theatre in September 2016 had various local brass bands playing on particular performances – or theatres drawing on their connections with the original film to add interest for audiences, as in March 2017, when *The Ladykillers* played at the Questors Theatre in Ealing, just round the corner from Ealing Studios, where the original *Ladykillers* was filmed.

These stage–screen adaptations also engage with the actors' performances on screen. Of the British films selected for stage adaptation, it's notable that many of them are ensemble films featuring groups of characters, rather than star vehicles. Even when the original films are dominated by one or two characters, it appears that the stage adaptations enlarge the role of the secondary characters, to reflect on the main story, as with *Brief Encounter* or *Chariots of Fire*. Actors who appear in the stage adaptations are often not very well known, so that their performances can relate more easily to the characterizations in the original films. The exception to this can be seen in *The Ladykillers*, although arguably the cast were known for comedy/character roles in film and television rather than star vehicles; for instance, Peter Capaldi, playing the Alec Guinness role of the Professor, was at the time known for his role as foul-mouthed spin doctor Malcolm Tucker in *The Thick of It* (2005–12). This distinguishes them from the more star-orientated stage adaptations of Hollywood films such as *Legally Blonde* (2001/2007) and *The Graduate* (1967/2000) and feeds into an idealization of the past as being more orientated towards a collective or a community, again significant in a time when the cohesiveness of the nation is at stake.

In this respect it is significant that many of the films adapted are distinguishable by genre, in that that they are 'much loved' comedies, helpfully limited to one location and often music and sound are used to offer an extended sonic experience of the film to audiences. Again this could be seen simply in terms of the commercial aspirations of these productions. The playwright Simon Stephens observed that in the latter half of the 2000s, all the most successful plays aimed fundamentally to 'to entertain, to uplift, to inspire, to tickle. Nowadays, only fun sells' (cited in Sierz n.d.). Yet comedy of course is crucial to the construction of cultural identity. As Andy Medhurst argued in relation to English cultural identities, 'English comedy is widely acclaimed by English audiences and contributes significantly to how English culture has imagined its Englishness' (2007: 1). This is even more emphasized when a comedy film is recreated in a live theatre context, where the sound of laughing within the same time and space can construct a restorative if temporary sense of communal identity.

The Ladykillers

This is particularly true of the adaptation of the 1955 Ealing Studios classic, *The Ladykillers* by Graham Linehan in 2011, which is marked by a buoyantly theatrical take on the original film. Whereas *The 39 Steps* reduces its cast, *The Ladykillers* pretty much replicates both the main and the subsidiary characters of the film, from the genteel Mrs Wilberforce to the kindly neighbourhood policeman.

The original film was directed by Alexander Mackendrick before he left for Hollywood and its defiantly black humour has been understood as the director's acerbic farewell note to Britain before he left it for good (Barr 1998). However, Aldgate argues that it can be seen as both a critique and a celebration of 1950s Britain; the former in its celebration of the little old lady who stands up to the criminals and wins out in the end; the latter in the fact that the little old lady seems to represent old style, imperial values and tradition, from the dominating picture on the wall of her naval captain husband to her frequent making of tea (Aldgate and Richards 1998: 159). Indeed Charles Barr goes so far as to argue that the film can be read as a metaphor for the squashing of post-war Labour ideals by the Conservative party with their narrow victory in 1951. This situation was replicated in 2010, the year before this production, with the ending of fourteen years of Labour government and the establishment of the Coalition government with a new Conservative prime minister, David Cameron.

> The gang are the post-war Labour Government; taking over 'the House', they gratify the Conservative incumbent by their civilized behaviour (that nice music) and decide to use at least the façade of respectability for their radical programme of redistributing wealth (humouring Mrs Wilberforce and using her as a front). Their success is undermined by two factors interacting: their own internecine quarrels, and the startling, paralysing charisma of the 'natural' governing class, which effortlessly takes over from them again in time to exploit their gains.
>
> (Barr 1998: 46)

The film is particularly distinguishable by its stellar range of performances from some of Britain's finest character actors of the time. Katie Johnson, as the old lady, Louisa Wilberforce, won a BAFTA for best actress for her performance, which works as a straight person to the rest of the cast who play the gang. Alec Guinness, as its leader Professor Marcus, exemplifies the film's unique mixture of the sinister and comic. His eyes rimmed in black, his perpetual sweeping up of his straggly grey hair and the insanely buck teeth are brought to bear in a characterization that gets more demented as the film goes on. In one of the key scenes, when the gang

are forced by Mrs Wilberforce to entertain her genteel lady guests, he is seen sitting hunched over the pianola with his back to the camera, peering at the scrolling perforations controlling the music. He glances back to the robustly singing ladies in their starched Edwardian dresses and hats and, in a gesture of abject capitulation, starts joining in weakly with their singing. The rest of the gang are equally well drawn out, from Cecil Parker as the nervous major, to Peter Sellers in his first major role as the jumpy Cockney wide boy. The film is full of little performance details; for instance the way Herbert Lom as the Romanian gangster Louis unwittingly carries his violin case like he's carrying a machine gun.

Melanie Williams has argued that character acting as a tradition is central to British cinema (and of course comes from cinema's historical links with the theatre). She also identifies it as aligned with ideas about national character:

> In addition to serving as a valuable means of product differentiation from Hollywood's emphasis on stellar glamour, the character actor's centrality to British cinema also tallies with certain concepts of British identity. A nation characterized as the paradise of individuality, eccentricity, heresy, anomalies suggests itself as the ideal haven for idiosyncratic and offbeat character performers.
>
> (2011: 97)

The theatre adaptation similarly drew upon a range of British character actors for the roles (such as the aforementioned Peter Capaldi as Professor Marcus and James Fleet as the Major) and in this way preserves the ensemble interplay between characters that was so essential to the success of the film. However, it is clear that performance is rendered in a different way in the stage adaptation of the film. For instance, much of the comic effect of Guinness' performance is due to Mackendrick's use of the close up, to emphasize his fraudulence. As he is revealed on the doorstep of Mrs Wilberforce's house, after a looming gothic shadow cast across the threshold announces his presence, Mackendrick shows us the difference between his obsequious posture, benign smile and then in close up – shrewdly calculating eyes. Capaldi, in an interview to publicize the play, talks about the difference between screen and stage performance and how the performer needs to think about different ways of portraying character:

> All the emotion has to be done without, of course, close-up shots [...] The contrasting emotions, the duplicity, it's all pure stagecraft, up to us to get it right and to Sean [Foley] to make sure the audience gets the right view every second.
>
> (Ferguson 2011: n.pag.)

Linehan claims in fact that his adaptation expands the characters of the gang so that there is not so much emphasis on the Marcus character (Ferguson 2011). Thus the Cockney wide boy is also a pill-popping cleaning fanatic and the Major has a penchant for dressing up in women's clothing. Linehan is known for character-driven comedy as his previous writing credits on *Father Ted* (1995–98) and *The IT Crowd* (2006–13) attest. It is difficult of course to communicate, in a written medium, how much the success of both the film and the play is due to the tiny nuances of the performances. As Andy Medhurst argues, 'comedy is never only textual – it is performed, enacted, an event, a transaction, lived out in a shared moment between producers and consumers' (2007: 5).

The stage play premiered at the Liverpool Playhouse and then went on to the Gielgud theatre in London (followed by a four-month limited run with a new cast at the Vaudeville in 2013). The original production was a critical and commercial success, breaking West End box office records by taking £400,000 in a week. Many critics remarked on how the adaptation recreated itself as slapstick farce, by putting in many running sight gags:

> Chairs and tables spin across the stage every time a train passes, the robbery is re-created by miniaturised cars colliding on a vertical wall, and, when the thieves fall out, a trick-knife is embedded in the boxer's bonce, and the pill-popper is apparently run through with a non-musical stave.
>
> (Billington 2011: n.pag.)

Peter Bradshaw also compared it favourably to the Coen Brothers film remake in 2004, because he argues the writing, characterization and stagecraft are utilized skilfully to make the stage production equally as funny as the original (Bradshaw 2011: n.pag.). Billington claimed that the play does not capture the 'metaphorical resonance' of the film but Bradshaw argues that it sits alongside the film rather than being derived from it:

> Another part of the success of this stage play is that it doesn't feel the need to create some kind of spurious interpretative progress, to move the original on to some new era or setting or idea. On the contrary: part of what makes it so inspired is that it looks as if it might have existed before the film, that it could be a classic, well-made stage play which was developed into the classic movie.
>
> (Bradshaw 2011)

Bradshaw's observation demonstrates this inter-directional relationship between theatre and cinema in British culture that transcends critical frameworks that stress origin and copy. The play's treatment of the film's setting is also noteworthy

because of the way the set replicates aspects of the film's *mise en scène*. The film makes much of the contrast between the bustling local area of Kings Cross, where the film is set, and the oddly shaped Edwardian house, where Mrs Wilberforce lives. Wonky through subsidence after world war bombs have shaken its foundations, it is set apart from the rest of the houses, at the end of a cul-de-sac, looking out over Kings Cross Station, communicating the sense that British society was stuck between social change and torpidity (Aldgate and Richards 1998). The *mise en scène* of the film emphasizes the place in all its angular, outdated glory. Frames pick out the stifling décor and the gang always seem to be slightly bending down in the hallway. In the scene after the ladies have come to tea, some of the gangsters are washing up the tea things in the tiny kitchen. The framing here underlines the moral compromises being discussed by Professor Marcus as he tries to deter Mrs Wilberforce from phoning the police. The angles are all crooked until we cut to a shot alone of Mrs Wilberforce after she declares that she is not for corrupting.

This is picked up on in the stage production where the house itself is spectacularly crooked and angular. It revolves around frequently to reveal the interior and the back of the house and even manages to conceal a railway tunnel where Professor Marcus meets his end. At points in the play, when a train rumbles behind the house, all the furniture starts to rattle and shudder and the lights flash on and off and there is an unbearable screech of a train engine.

> Train effects – whole house shakes – crockery – lights flicker on and off then darkness ... for length of time it takes to pass it is BEDLAM.
>
> (Linehan 2011: 54)

Therefore the set communicates a sense of disorder constantly threatening the genteel orderliness of Mrs Wilberforce's domestic environment. This is further reinforced with the introduction of a news broadcast at the beginning of the play relaying events in Suez, clearly locating the play in 1956, the year after the film was made. Suez has been described as a key event in British history that highlighted the country's declining status as a world power and brought an end to 'deference'. This suggests that Linehan was drawing the audience's attention to the adaptation as social document, drawing parallels between the Britain of 2010 and the country in transition in 1956.

The 39 Steps

The film is, of course, one of the 'classics' of British cinema, directed by Alfred Hitchcock, Britain's most famous film director. Adapted from John Buchan's novel

and starring Robert Donat and Madeleine Carroll, it regularly makes the top ten lists of *Best British films* (in the 1999 BFI list of the 100 greatest British films of the twentieth century it came fourth). The play was first produced on stage by North Country Theatre in April 1996 at the Georgian Theatre, Richmond, North Yorkshire. This version, by Simon Corbel and Nobby Dimon, was then adapted by Patrick Barlow, most well-known for setting up the National Theatre of Brent. It was first performed at the West Yorkshire Playhouse in 2005, and then subsequently a new production directed by Maria Aitken opened in London and the West End in 2006. This ran for eight years until 2015 and has spawned numerous touring productions since then. By 2008 it had made £9 million and had been performed in 21 different countries.

Whilst promotional materials for the play invoke not just Hitchcock but also Buchan, the actual production references the film of *The 39 Steps* specifically and other Hitchcock films more generally. This facilitates one of the key characteristics of the production (and a source of much of the humour): a constant meta-commentary on the difference between film and theatre as forms of dramatic expression. Elizabeth Klaver has written that 'if dramatic art wishes to realise its identity it must construct that identity in the light of some other' (2000: 6) and paradoxically the identity of *The 39 Steps* as a piece of theatre is realized through it implicitly defining itself in relation to film. This can be understood more broadly as pitting the 'authenticity' of theatre against the 'deceptiveness' of film.

The play follows the plot of the film extremely closely, apart from a prologue, where Hannay introduces himself to the audience and a final scene where the happy couple are enjoying their first Christmas together. The action proceeds from the music hall to Hannay's flat, to Scotland and back to the music hall scene. Every character in the film is represented on stage between the cast of four actors, thus entertainingly stretching credulity to its limits. For instance the scene between the bogus detectives and the owners of the inn has the actors managing to play four characters simultaneously with a quick change onstage behind a heavy coat. The dialogue remains almost exactly the same in this scene as well with Mrs McGarrigle chiding her husband at the end of the scene, 'Ye wouldn'nae give away a dear young couple, would ye?' (Barlow and Buchan 2009: 52). There are also key references to the look and the sound of the film. In the production at the Lowry Theatre Manchester, 2016, the actor playing Hannay was clearly modelled on the actor Robert Donat. Indeed one of the key running jokes of the play is repeated mention of Hannay's 'very attractive pencil moustache', which is referred to by the characters and by a very R.P. (Received Pronunciation) radio announcer who updates the audience on the progress of the chase. The actress playing Pamela in the production copies Madeline Carroll's blonde hair style and her costume throughout, a black mid-calf-length dress with a white distinctive

collar, is replicated in the stage production. The play even goes so far as to recreate famous shots and sequences from the film, most notably the notorious sound edit in the film, where the cleaning woman opens the door to Hannay's flat after he has escaped dressed as a milkman. She then turns to the camera and opens her mouth to scream but instead the soundtrack plays the screech of a train whistle and the next shot shows a train emerging from a tunnel at high speed. In the play, the cleaner pulls the dust sheet of a very horizontally dead Annabella and then turns to the audience to scream 'a blood curdling silent Munch like scream' which 'segues into [a] deafening train whistle' (Barlow and Buchan 2009: 14). This heightens the sense of self-reflexivity – the play is conscious of its status as an adaptation and makes that consciousness clear to the audience.

Also in terms of sound, actors play their characters with the same accents and voices displayed in the film. One particularly noticeable scene is the music hall scene that opens the film. In this scene, before we are introduced to Donat as Hannay in the audience, we see, onstage, the master of ceremonies introduce Mr Memory to the audience. Both actors use the same sort of slightly compressed, genteel Cockney, lower class English pronunciation to communicate their characters. In the theatre production, the play script indicates that both these characters are given the 'toothbrush moustache' that is sported by Mr Memory in the film and the words in the script indicate the same type of Cockney pronunciation: more facts in 'is brain' and the continuous 'Thankoo's' of Mr Memory (Barlow and Buchan 2009: 2).

Mr Memory's theme tune, which holds the key to the mystery, remains the same but there are further musical references, not just to *The 39 Steps*, but to other famous Hitchcock scores. The theme from *Vertigo* (1958) plays out over the scene in the bedroom between Pamela and Hannay where she removes her stockings and during the chase, a shower curtain is used to signal a waterfall, but with the music from *Psycho* (1960) it becomes *that* shower curtain, replete with the shadow of someone being stabbed on it. The music that accompanies the action of Pamela and Hannay returning to London is the Bernard Hermann music from *Psycho* that underscores the scene when Marian is driving towards the Bates Motel in the rain. Earlier on in the play (and of course not in the film), there is a sequence where a sheet goes up and we hear the sputtering buzz, buzz of the engine of a bi-plane. We then see a shadow projection of the planes swooping down and terrorizing a fleeing Hannay. If the reference is lost on anyone then a voice-over alludes to the film as the two pilots talk about 'north/northwest' as the direction that Hannay is heading in. To the aficionado, this might even reference the debate as to how much Hitchcock's later film re-invents scenarios from *The 39 Steps* (Glancy 2003: 102).

Even some of key differences in the adaptation seem to be designed to comically bring out things that the film was unable to be explicit about because of

film censorship in the 1930s; such as the Nazi allegiance of Professor Jordan and the '39 Steps' group of spies (Glancy 2003: 36). In the film, Mr Memory is just about to reveal the national identity of the spies on stage when he is shot and collapses and the fact that the secrets are going to Germany is never made explicit. Professor Jordan, although he reveals himself to be the mastermind of the gang, never divulges his origins and remains the archetypal English gentleman. To a certain extent, the restraint serves one reading of the film, which is that Hitchcock wanted to suggest that even the most outwardly respectable of establishment figures was not to be trusted. Some commentators have gone so far as to suggest that Hitchcock wanted the alliance between the British establishment and Nazi Germany to be clearly implied by the characters of Professor Jordan and his wife (Glancy 2003: 39). The play is not quite as restrained. During the scene between Hannay and the Professor, the stage directions indicate that 'we notice a German accent subtly emerging from the Professor's cultured British tones' and the Professor becomes ever more demented, ranting about the 'master race' (Barlow and Buchan 2009: 40). Furthermore, we see the shadows projected of people dancing (to indicate the party going on) turn to goose stepping by the end of the scene.

Most of the show's reviews picked up on the connections to the film, with Ben Brantley writing how

> This show delights in groaning references to all things Hitchcock, with name-checking puns, verbal and visual, to his movies and general style [...]. We are also reminded of [...] how fine the line is in Hitchcock between suspense and comedy, between high anxiety and low farce. In crossing that line, *39 Steps* is as much a celebration of a moviemaker's wit as it is a parody pastiche.
>
> (Brantley 2015: n.pag.)

Brantley's description of the piece as parody/pastiche is significant here as it seems very much in tune with the 'dominant' cultural paradigms of the early twenty-first century in which this form of hyperconscious intertextuality produces an ironic or postmodern take on the film (Jameson 1991). The qualification in Brantley's review is telling because it suggests that the piece works to also acknowledge the audience's familiarity with Hitchcock as auteur and celebrate this knowledge. The play's micro-references to the film seem designed to appeal to a very knowing audience, not just an older audience who might remember the film from the cinema or television but also the YouTube generation, who constantly have access to these films and images at their fingertips and can appreciate the ingenuity with which the live action on stage relates to the film. The play's success both in the United Kingdom and abroad would indicate that this is not just a local but a global

phenomenon, drawing on Hitchcock as one of the best known film directors of the twentieth century.

Hitchcock occupies an interesting position in relation to British cinema and the idea of the auteur director. Hitchcock was one of the studio directors initially reclaimed by *Cahiers du Cinéma* critics in the late 1950s as one whose films clearly displayed a trademark style, discernible across the body of his work (Truffaut et al. 1985). As we saw in Chapter 4, the narrative of Hitchcock's acclaim as an auteur initially consigned his English films to little more than the work of an apprentice before he was given the circumstances in Hollywood for his talent to be given free rein. With more attention being given to his British-made films, *The 39 Steps* came to be seen as a key film in the development of Hitchcock's style, with its economic storytelling, use of montage and concern for the unjustly accused. Therefore, the references to Hitchcockian style, and one of the most visible (and audible) personas of all twentieth-century film directors, are used in the play to broaden its appeal beyond *The 39 Steps* film and the play is faithful to a notion of Hitchcock as auteur, more than it is actually faithful to the film itself.

Indeed it exploits the humour to be gained from the impossibility of recreating a film world on stage. As Barlow explains in the foreword to the play:

> [O]ne of the thrilling things about writing this was the challenge of putting an entire movie on stage, complete with film noir murders, shooting train chases, plane crashes, trilbied heavies in fast cars, villains with little fingers missing, not to mention the most classic moments in the history of cinema.
>
> (Barlow and Buchan 2009: n.pag.)

Therefore, rather than being understood in purely intertextual terms, the play also operates intermedially to invoke theatre and film as distinctive and different methods of representation. Intermediality as a term is usually used to refer to a process within a broader historical framework, where the boundaries between media blur (Mueller in Shail 2010: 4). Yet in this case, there is a sense in which staging the film shows media competing with each other. There are numerous instances of this in action, from the toy train pulled across the stage to indicate the train journey from London to Edinburgh to the recreation of the Forth Bridge scene. In the film, montage (Hitchcock's stock in trade) is used to create a thrilling sequence showing Hannay escaping from the police. After stock footage of the steam train traversing the bridge we cut to Hannay, trying to evade capture by bursting into Pamela's carriage and kissing her. After he has been betrayed by Pamela, he swings out of the carriage door and climbs along the moving train to re-enter the carriage further down as it crosses the bridge. Then pursued by the police, he comes to a dead end after reaching a carriage full of barking dogs. After one of the policemen has pulled the emergency

brake, the train heaves to a stop on the bridge and the camera pulls out to reveal Hannay hiding behind an iron pillar. When the train leaves, the camera again pulls back to reveal Hannay's hiding place vacated as he has plunged into the river below.

In the stage production, a chase is indicated between Hannay and the policemen going in and out of the carriages. The outside of the carriage is conveyed by the performers swaying their bodies as if against a strong wind. A bridge is then recreated on stage using two builder's ladders and a plank, with Hannay hanging off the middle of the plank and two policemen crawling to him from either side until he finally lets go, the stage goes to blackness and there is the sound of a whistle and a tiny splash. In a similar way to the adaptation of *Jurassic Park* discussed in Chapter 2, the means of representation here are designed to demonstrate the ingenuity (and some might argue the superiority) of theatrical means of expression. This effect has also been observed in the depiction of film onstage. In a discussion of Marie Jones' *Stones in His Pockets* (1996), Roberts argues that

> Paradoxically the play disarmingly insists that performance that openly admits its falsity is less false than a realistic film. The play and performers intimate that one kind of performance can be considered more genuine than another. Theatre's performance is transparent, in contrast to the opaque and misleading representation in film.
>
> (Roberts 2001: 119)

This extends to the fact that the stage play only uses four actors to play the film's wide array of characters, thus implicitly valorizing live performance in its showcasing of actorly skill. The actors are involved in highly physical labour in their lightning switches between characters, which are visible for the audience to see and appreciate. This is particularly evident in the end to the inn scene, where Heavy One and Heavy Two, who have come to track down Hannay and Pamela, are interrupted first by Mr McGarrigle and then just as the latter is about to give the game away, the second Heavy switches round to become Mrs McGarrigle who stops her husband in mid-sentence. The script even acknowledges this in the climax to the play where Hannay and Pamela watch Mr Memory at the London Palladium, whilst the Professor looks onto the stage from a box at the side. With the arrival of Chief Inspector Albright, it's almost impossible to have the actor in sight as the Professor. However a footnote in the script suggests:

> In an ideal world, Clown 2 should appear as the professor in the box each time he is mentioned. [...] This will depend entirely on your design, amount of wing space and the actor's level of Olympian fitness. Quite a lot of this show depends on your actors' levels of Olympian fitness.
>
> (Barlow and Buchan 2009: 71)

Thus the different spatial strategies of theatre and film are referenced. In the film, the scene is constructed through its montage with impressive Hitchcockian economy by switching between Mr Memory, Hannay and Pamela in the audience, and Mr Memory in the Upper circle box. The impossibility of replicating this with only four actors in the continuous theatrical space becomes part of the appeal of the scene. This is then live performance stretched to its limits as audiences get to witness the actor's physical labour in seeming to be in two places at the same time.

Brief Encounter

If *The 39 Steps* and *The Ladykillers* follow the plot of the films fairly closely, whilst transforming cinematic into theatrical conventions, another adaptation of a classic British film takes a different strategy. Kneehigh Theatre's adaptation of *Brief Encounter*, first performed in 2007, is taken from the David Lean film of the same name, made in 1945, which was in itself adapted from the stage play *Still Life* by Noel Coward (1936). The film starred Celia Johnson, Trevor Howard and a variety of steam trains and told the story of a doomed romance between Laura and Alec, who meet by chance at a train station, both married to others and begin a tentative but ultimately unconsummated affair.

The film has become one of the most iconic romantic British films of all time, notable for David Lean's direction, camera work and *mise en scène* and the performances of its actors, particularly Celia Johnson as Laura. Although a relative critical success at the time, its status as a classic British film has fluctuated since the war; during the 1960s, it seemed to represent all that was most staid about British cinema, but recently its status as a British classic film has been re-evaluated. It was number two in the 1999 British Film Institute top 100 British films and its 70th anniversary in 2015 was marked by a restored and re-released version, with film critic John Patterson remarking that 'There's little new to be said about a movie that's lived seven decades in the English folkloric bloodstream' (Patterson 2015: n.pag.). It is a film that has therefore passed into a kind of collective cultural consciousness, used as the basis for several popular cultural re-fashionings, from adverts to a Victoria Wood parody. A reading based on Noel Coward's publicly repressed homosexuality was the basis of Richard Kwietniowski's short film *Flames of Passion* (1989) and recently parts of it were referenced in Todd Haynes' *Carol* (2015).

The character of Laura is central to the workings of the film as she is very much the teller of the tale. The romance unfolds through her interior monologue and the audience are given her subjective attitude to the event as recounted in the flashbacks. Richard Dyer has identified how important Johnson's performance

was to the success of the film, claiming that this is partly why the film has reson-
ance and has endured:

> the inflections she gives to the script, especially the way common sense and
> yearning, amusement and despair, eddy across her face, voice and body,
> come to suggest an inwardness with this situation, a sort of running com-
> mentary on it.
>
> (2015: 33)

This is an effect often achieved by Lean's use of the close up against the voice-
over as the audience are told of Laura's feelings as the affair progresses, pro-
viding an interiority that only the audience has access to. This was picked up by
C.A. Lejeune in her review of the film in 1946, singling out Johnson's voice as a
key part of her performance repertoire. She describes it as having 'a peculiar sort
of intimate appeal to the spectator, whispering directly and persuasively to the
individual rather than speaking to an audience as a crowd' (Lejeune, quoted in
Dyer 2015: 31). For instance, in the final scene, we see the lovers' goodbye inter-
rupted by Laura's friend Dolly Messiter, the camera zooms in on Johnson's face,
obscuring her surroundings with black and fading down the background noise
so that the only sound heard is her voice. Whilst her face looks forlornly out, the
voice-over tells us how she felt 'dazed and bewildered' until a train whistle brings
her back to the scene and, under the constraining presence of the third person, the
lovers say a perfunctory goodbye for ever. Through this key cinematic device of
close up against voice-over and Johnson's heart-wringing performance, the audi-
ence is made aware of the film's over-riding theme of the regulation of public and
social behaviour at the expense of individual desire.

So with this strategy being so central to the film, how does this very medium-
specific device work on stage? Before turning to the Kneehigh production, it
might be pertinent in this respect to look at an earlier adaptation of the film by
Andrew Taylor at the Lyric Theatre in London in 2000. This expanded the ori-
ginal Coward play to two acts but followed the plot of the film fairly faithfully.
It was slated by the critics with Mark Shenton in *What's on Stage* writing that
the version 'added precisely nothing, and indeed may have detracted, from the
cinematic experience'. He describes how the adapters tried to replicate Laura's
voice-overs by playing her monologues on a tape during scene changes but this he
argued left the actress playing her 'no opportunity to signify more than a strained
earnestness elsewhere'. He also writes that without the benefit of close ups to give
us access into the conflicted soul of Laura, she comes across as 'mostly blank'
(Shenton 2000). The implication here is that a straight theatrical rendering of
the cinematic devices used to present Laura's experience falls rather flat, because

the emotional experience that the film conveys is transferred to the mechanical rather than the human.

With this in mind, Kneehigh's version took very specific liberties with the film, in order to keep this central, emotional experience intact. The production was first performed at Birmingham Repertory theatre and the West Yorkshire Playhouse (now Leeds Playhouse) in 2007 and then transferred to the Haymarket cinema in London's West End in February 2008. Its critical and commercial success led to a nationwide tour and off-Broadway run. The adaptation went back to the original inspiration for the film, Noel Coward's play *Still Life*, and set the production in the time of the play, the late 1930s. It expanded the parts of the cafe manager Myrtle and her assistant Beryl and gives their developing relationships with the railway guard Stanley and delivery boy Albert more prominence. Laura's husband Fred is also given more weight than in the film. The director (and co-founder of Kneehigh) Emma Rice has talked about how she didn't want the adaptation to be about star performances because she felt that the play needed to be performed by a theatrical ensemble (Radosavljevic 2010). Thus the focus of the play was not entirely on the stars, an aspect again often determined by cinematic convention.

What was most striking about the play in terms of staging British cinema was that it invoked the embodied experience of going to cinema in the inter-war and post-war period. The staging of the play in the Haymarket cinema was significant as it was the same cinema where the original film was premiered in 1945. Thus the location of the production was performative in itself, in the sense of gesturing to one of the 'original' reception contexts of the film, and this was emphasized by having the audience welcomed in before the actual play began, by actors dressed as old-fashioned cinema ushers and by a band playing in the auditorium. The beginning of the piece references both theatre and cinema-going as the play begins as a scratchy old film on a screen, with the theatre audience cast as a 1940s cinema audience before moving into live action. This can be understood as an embodied nostalgia, implicitly contrasting this particular communal and affective experience of the cinema with the place it now occupies within today's new media ecology.

> As the word itself suggests, 'remembering' is better seen as an active engagement with the past, as performative, rather than reproductive. It is as much a matter of acting out a relationship to the past from a particular point in the present, as it is a matter of preserving and retrieving earlier stories.
>
> (Erll and Rigney 2009: 2)

As presumably most of the audience for Kneehigh's *Brief Encounter* wouldn't have been old enough to attend the cinema during this time, the production does

of course also construct memory through a performative enactment of the circumstances of 1940s cinema-going.

This production also referenced the film directly through the use of a slatted screen on the stage. Despite the availability of digital technology to put screens on stage and directly reference the films they are adapted from, Kneehigh's *Brief Encounter* is one of the few screen adaptations to use actual projection in its adaptive strategy. Images on the screen are not taken directly from the film, but are pre-recorded black-and-white sequences that often emphasize the distance between characters. For instance Laura watches her husband Fred on screen, reading in his armchair. Because the screen is slatted it means that characters can move from the stage to the screen space. This 'crossing the celluloid divide' (Giesekam 2007: 109) draws attention to the role of the medium in the construction of both these art works and denotes Bolter and Grusin's notion of hypermediacy, where 'the artist strives to make the viewer acknowledge the medium as a medium and indeed delight in that acknowledgment' (2000: 334). The distinction thus between cinematic and theatrical space is used as a metaphor in the sense that the separation of screen and stage, of filmed and live action, is used to represent the impossibility of the relationship between the would-be lovers.

Similarly the medium is invoked by how the theatre production references the close ups used in the film, by recreating them on the screen but within the stage space. Visually the close ups clearly reference the film in the similarity of the actress and to a certain extent even the expressions of Johnson's Laura. The similarity of make-up and costume, the type of framing by the camera, the lighting and the use of black and white in an otherwise colourful stage emphasize this. All these factors, along with the size of the screen and its scale in relation to the rest of the stage, indicate that Johnson's Laura is being referenced if not replicated. This then casts the actors in the play as 'hyper-historians', linking 'the historical past with the "fictional" performed here and now of the theatrical event', enabling audiences to recognize that the actor is repeating with a difference something about the past (Rokem 2000: 13). For Rokem, this is a kind of witnessing that both creates an account of the past and represents it, where the actor's body is the site of the articulation of hyper-history.

It is notable then that there is no voice-over from Laura herself (there is from Alec and Fred over some of the filmed sequences). Rather than use an interior monologue to capture the split between inner torment and outward restraint for Laura, the theatre production uses the screen to show images that evoked the tumultuous feelings engendered by Laura's encounter with Alec. These take the form of acknowledging the popular cinematic cliché of waves crashing against the rocks (used in more censorious times) and often are set against Laura playing the

film's famous Rachmaninov theme live on the piano to link her both with the music and with the images on screen. Indeed the play ends with a close up of Laura's face superimposed on a projection showing her swimming in the ocean, conveying a more optimistic sense of having found herself through the events portrayed unlike the film's more ambiguous ending in which Laura's dreary husband Fred famously thanks her 'for coming back to me'.

The use of the Rachmaninov, a key facet of the cinematic experience of *Brief Encounter*, opens up discussion of the way the production treats the sounds of the film. This is not just in the Rachmaninov music, as possibly another key aural memory from the film is the extraordinary Received Pronunciation voices of Celia Johnson and Trevor Howard, that have been much parodied and become a kind of shorthand for a particular type of repressed, muscle-paralysing vocal pattern of Englishness in terms of period and class. In the play, the accents of the characters in the film are also replicated but not parodied by the actors and these class-bound voices are set against the lower class/comic characters (a trope of British film that goes beyond *Brief Encounter*). In terms of the music the Rachmaninov is referred to in many different ways; not only is it played on the piano but it is sung acapella by members of the cast at different times and thus again becomes a performative staging of this key aspect of the film. However, the play also adds a lot more music that is not present in the film. There are songs throughout, which are sometimes done as character monologues and sometimes are performed in front of the main theatre curtain as a music hall turn, all written by Noel Coward but many with new musical arrangements. Some of Coward's poetry about the pain of love was also set to music. This is in line with Kneehigh's particular way of working where the drama develops organically with the music rather than the action being scored at a later date. However it also serves another function. Richard Dyer has written that film's recourse to music in what he terms this 'quite extraordinarily verbal film' serves to articulate the limitations of everyday speech to express emotion and there is some evidence to suggest that the added songs in the stage version function at the same level (2015: 37). As Claudia Georgi argues:

> the cumulative effect of the songs is complex [...] audiences are drawn into an historical approximation of a period when popular songs expressed the kind of emotions that ordinary people found difficult to voice in everyday life.
>
> (2012: 75)

So this central feature, the opposition between the private and the public, is articulated in the film by the music alongside the *mise en scène* and performance, whereas in Kneehigh's production, it is also referenced through the added use of period music. This also of course re-enforces nostalgia for the period in which the film

was made, supported by all the staging strategies of the production that references not just the film but the very act of going to the cinema, something that is perhaps most keenly felt as a loss in contemporary culture with multiplexes and multiple platforms for viewing digital content.

This has implications for how the adaptation then also seeks to draw on the cultural memory of the film, rather than just the film itself. When talking about the development of the show, Emma Rice explicitly stated that the inspiration came from her memories of watching the film as a child. In an interview published in 2009, she talks about how important her emotional recall was in the development of the show and that the film provides her with a memory bank of material because it provides

> the stories I grew up with: the black-and-white films I watched when I was ill, the naughty, comfy treat when it's raining [...] When I decide to do a story, I do not tend to go and read or watch it, I tend to work on what my cultural memory of it is, because that is my truth [...] my foundation will be my memory.
>
> (Emma Rice in Radosavljevic 2010: 93)

This was something picked up on by reviewers who commented on how the piece was framed as a tribute to the film, a fan letter to it, rather than a simple rendering of the plot.

> The Kneehigh 'Brief Encounter' may be the most exquisite set of fan's notes ever to take form on a stage. Through musical numbers, film projections and vaudeville jollity it spells out not only what the show's doomed lovers are experiencing but also what we, who have known them for years, experience whenever we watch them on screen.
>
> (Brantley 2009)

This raises interesting questions from adaptation studies regarding source and adaptation, as here what is referenced is not a fixed text but a performance, if not a memory of a performance; its sounds and images, the feelings triggered by the memory of watching the film. As an adaptive practice what is being both addressed and constructed is, as John Ellis puts it, 'a generally circulated cultural memory' (1982:3). This goes beyond the story to encompass the performance elements shared between stage and screen and thus has implications in the production of nostalgia. Svetlana Boym has written about how nostalgia is a rebellion against the modern idea of time, 'the nostalgic desires to obliterate history and turn it into private or collective mythology, to revisit time like space, refusing to surrender to the irreversibility of time that plagues the human condition'. Theatre as a public space thus can provide the stage for re-enactments of these 'collective' mythologies. Boym also

argues that 'nostalgia tantalises us with its fundamental ambivalence. It's about the repetition of the unrepeatable, materialisation of the immaterial' (2001: 14). By drawing on the affective experience of the film and transforming it into material culture, I contend that the stage production does gesture towards materializing the immaterial, thus allowing the audience to publicly experience the film's historicity affectively 'as an atmosphere, a space for reflection on the passage of time' (Boym 2001: 14).

Theatre of Blood

This relationship of the stage adaptation to the film is central to understanding my final case study *Theatre of Blood* (1973/2004), although here the adaptation invokes nostalgia for a lost style of acting rather than a viewing experience. Unlike the other films discussed in this chapter, it might best be described as a cult rather than a classic British film because of its strange mixture of high camp, horror and irreverent treatment of Shakespeare and its appropriation by specific groups of fans. In the 1980s it was shown in a downtown cinema in Los Angeles 24 hours a day to an audience who knew the whole dialogue by heart and chanted along, although many viewers might have encountered the film, like I did, rather glee-fully in the solitary comfort of a suburban living room late on a Friday night in the 1980s. The film was made in 1973 by Douglas Hickox and starred Vincent Price, Diana Rigg and a further range of British finest character actors from twenty years after *The Ladykillers*, such as Coral Browne, Harry Andrews and Robert Morley. The play on the other hand was conceived and produced by Improbable Theatre for the National Theatre in London in 2005, with Jim Broadbent in the Price role and, in a self-reflexive twist, Rigg's daughter Rachael Stirling playing the same part as her mother.

The film's central character Edward Lionheart is an old style actor whose stage performances in a range of Shakespearean roles have been lampooned by the critics so, after faking his own death, he decides to take revenge on them by subjecting them to a range of gruesome deaths taken from Shakespeare plays. One of the film's most notorious scenes enacts the unsuspecting Tamora's eating of her children in *Titus Andronicus*. The character is changed to flamboyant critic Meredith Merridew, played by a larger than life Robert Morley, whose beloved fluffy poodles are baked in a pie for his delectation. In this way the film is itself an adaptation and enfranchises the viewer in proportion to their foreknowledge of events and lines from the Bard. As *Empire* magazine commented in 2002 on the DVD release, 'you may need to brush up your Shakespeare to get the punch lines' (Anon. 2002: 158).

When the film was made at the beginning of the 1970s, British cinema was very much in the doldrums after the withdrawal of American studios from funding British films. Conversely, theatre was seen to be in the ascendancy as 1973 saw the long-awaited establishment and building of the National Theatre on the South Bank. This was a point not lost on the writers of the 2004 production who set the play in the year the film was made, 1973, and throughout it weave in references to the building of the National Theatre on the South Bank, arguing that this event precipitated the co-opting of theatre to the establishment in the United Kingdom, representing a suffocation of independent spirit invoked by the shamelessly theatrical and flamboyant performance style of Edward Lionheart.

Several changes were made in the theatre adaptation. Two of the murders were dropped; those that in the film took place in locations outside the old theatre that Lionheart takes over for his devilish deeds. The police investigation that runs throughout the film is also removed. Everything is staged inside a dilapidated old-fashioned proscenium arch theatre, which contrasts with the more modern frame of the Olivier Theatre. With this *mise en abyme*, Improbable make explicit their underlying theme of radicalism vs. conformity and by association casting themselves, Improbable Theatre Company, as the mischievous and independent antithesis of their host institution.

Both film and stage adaptations offer opportunities for a barnstorming central performance and yet there are key differences between Price and Broadbent in the central role. Marvin Carlson has talked about the ghosting of performances by actors in the theatre and this applies to cross media embodiments.

> [W]hen a new actor undertakes an established role, this almost always involves a negotiation on the part of both audience and actor between two ghostly backgrounds, that of the previous incarnation or incarnations of the role and that of the previous work of this new actor.
>
> (Carlson 2003: 96–97)

In the film Vincent Price's star persona and self-parodying style were a key shaping influence (Lowe 2010: 103). The film's scriptwriter Anthony Greville Bell says that the interest of Vincent Price in the movie was instrumental in it going ahead because of the perfect fit between Lionheart and Price's situation: 'Vincent was the obvious choice because he was a frustrated Shakespearean actor anyway' (quoted in Lowe 2010: 48). Therefore in the film, Price fans have seen, in Lionheart's situation, an allegory of establishment failure to see Price as a great actor because he appeared in the doubly culturally degraded genre of horror film.

The film plays upon this extratextual persona of Price throughout. There is a scene in the middle of the film, where Lionheart appears suddenly at a meeting

of the Critic's Circle in an airy riverside apartment, to claim the award that has been given to another actor. Initially, Price as Dracula is alluded to here, as we see him enter framed in the doorway in full evening dress and red velvet-lined cloak. But as he strides around the balcony to the apartment, contemplating death after his humiliation, rather than sending up the delivery, Price delivers the 'to be or not to be' speech from *Hamlet* with heartfelt and subdued emotion. The film foregrounds his performance as we hear Price in voice-over delivering the first few famous lines, while we see him walk outside mournfully onto the balcony. The performance is also framed by the use of explicitly theatrical devices in this scene such as the curtains actually being pulled back by the critics inside the apartment to encase the lone figure of Price on the balcony like a proscenium arch. Therefore, 'we can see that Price's actual performance negotiates the transactions between stage and screen, constructing a charged medial space where theatrical conventions and modes of expression are respected and privileged' (Lowe 2010: 49). This gives an extra complexity to the performance and whilst there are plenty of examples of Price's trademark self-parodying campy style these are contrasted by moments in the film that are played straight, where Price actually sets out his stall to be considered as a 'great Shakespearean actor lost'.

In terms of the theatre adaptation, Broadbent does not have this extratextual resonance to his performance and its notable that (and in contrast to *Brief Encounter* that explicitly references Celia Johnson's performance) the theatre production does not try to invoke Price's performance but instead draws much more upon Broadbent's own filmic persona as flamboyant man of the theatre drawn from such appearances as *Moulin Rouge* (2001) and *Topsy Turvy* (1998). Broadbent also references for comic effect a more culturally established range of iconic Shakespearean performances on film, most notably Olivier's *Richard III* clearly parodying the swinging bob-cut hair, the stooping sideways gait and the clipped, nasal delivery.

Again the makers of the theatre version stress that their impetus for the production was the residue of feeling that remained in their memories from their original encounter with the film. Director Lee Simpson and designer Rae Smith write in the education pack that accompanies the production:

> The *Theatre of Blood* film is quite badly behaved and I think that attracted us to it: we wanted to maintain its bad behaviour (Simpson 2004: 12).
> The memory of the film gave me a distinct excitement: about the gothic horror, extreme violence, the camp joy of revenge and the murdering of critics. (Smith 2004: 15).
>
> (National Theatre Education Workpack 2004)

Yet nostalgia functions quite differently in *Theatre of Blood*. The sense of transgression that Simpson identifies is channelled in the Improbable adaptation, not through direct reference to the film but through the way that the theatre piece pokes fun at its place of performance (and by extension its audience) as a moribund locus of state sanctioned conformity. In staging this production in the National Theatre, Improbable seem to be almost baiting the audience at the National Theatre, setting themselves against the National in terms of cultural institutions. In a rather tagged on scene at the end, that wasn't in the film, Lionheart's final speech with newspaper critic Devlin is about how the latter is going to be appointed literary manager at the new NT, which Lionheart calls 'diplomatic service with artistic knobs on', which caused a ripple of uneasy laughter the evening that I saw the production. Nostalgia for the actual film, in terms of the affective experience of it, seemed much more downplayed in Improbable's stage production. Perhaps this is because *Theatre of Blood* as a cult film has a less secure place in the British cultural psyche and, by virtue of its subcultural capital, a more niche audience appeal. If the production did seem nostalgic it was then for a popular, theatrical theatre, before the 'Oxbridge intellectuals and critics', who Lionheart despises got their hands on it. As Lionheart claims at the end of the play, 'In the good old days theatre depended on the promise of blood or titillation; But then someone decided that going to the theatre was good for us. Instead of the delicious illicit tang of the betting shop or brothel it had the sanctimonious cultural cachet of a collective confessional!' (Simpson and McDermott 2005: 96). This view is echoed by Improbable's Phelim McDermott:

> There's something about that older style of acting that is not naturalistic and audiences long to see that in the theatre; they long to see people really do what theatre does best which is to be as theatrical as possible. [That style] is what has become known as bad acting, but in turning our backs on that style of performance I think we've lost something.
>
> (National Theatre Education Workpack 2004)

Again this demonstrates the permeable borders between theatre and cinema in British cultural practice; namely a theatre piece celebrating a film's theatrical acting style that was in itself an adaptation of various bits of Shakespearean plays. As I have argued previously, 'the film plays upon the tensions between what it deems to be the medium-specific spaces of theatre and film historically produced by British culture' (Lowe 2010: 99). In adapting the film for the stage, arguably the cinematic elements of the original film are diminished and the piece becomes a theatrical celebration of the theatrical, through pantomime acting styles set within proscenium arch spatial dynamics.

Examining the adaptation of British films to the stage brings up many of the issues debated in the rest of this book, such as the treatment of actors' performance, sound and design and how *mise en scène* is translated into stage praxis. However, as Aragay has argued, framing 'adaptations as cultural practice' necessitates examining them as 'acts of discourse partaking of a particular era's cultural and aesthetic needs and pressures' (2005: 19). In sympathy with the aims of this second section as a whole, I contend that at the beginning of the twenty-first century it is the stage adaptations of specifically British films, rather than the reverse, which can be seen to mobilize issues around nation and nationhood and the crisis of medium. Edward Said asserts that 'nations themselves are narrations. The power to narrate, or to block other narrations from forming and emerging, is very important to culture' (1978: xiii). This proposes that cultural narratives, such as those produced through both film and theatre, contribute to a sense of national identity. So the preponderance of stage adaptations of classic British films can be understood as being significant in the context of broader debates on the state of the nation. On this level the number of adaptations of classic British films from the past then might appear to be regressive – the co-opting of a very particular, white, middle-class and male culture to stand as a national culture: a retreat into 'Little Englishness' in which 'Englishness' is then re-asserted to stand for Britishness. However, whilst not disputing this reading, I would argue that the very act of staging these films opens up a space for dialogue and debate, a kind of staging and interrogation of the state of the nation. Often popular British theatre does not receive much critical attention but the scale and scope of these adaptations of specifically British films demand more scholarly investigation. Staging 'Britishness' through this evocation of its cinematic cultural products (often from those deemed to be golden ages of British cinema but also through 'alternative' classics such as Derek Jarman's *Jubilee,* staged at the Royal Exchange, Manchester in September 2017) can thus be understood as a response to contextual debates around national identity formations. In an increasingly mediatized culture, theatre's staging of these films can then be seen as an intervention in a similar way that Robert Shaughnessy has argued characterizes the presence of the 'theatrical' in film adaptations of Shakespeare, 'the relationship between theatre and cinema mediates the contending claims of the past and modernity, the old world and the new' (Shaughnessy 2006: 69).

Conclusion

This book started with Susan Sontag's article 'Film and theatre' which proposed that a 'new idea' was needed to resolve the question of whether 'cinema [is] the successor, the rival or the revivifier of theatre' ([1966] 1994: 33). What this book has proposed is not a new idea but a new way of looking at adaptation between film and theatre; two areas of cultural production that have now had over 100 years of a relationship. It takes as its starting point elements that they have in common rather than stating their differences as a way of asserting their individual identities, whilst taking on board how this relationship is affected by changes in technology, cultural and industrial contexts and audience expectations.

One of the fundamental questions that has been raised is what distinguishes adaptations between stage and screen from other types of adaptation and what are the advantages of seeing them as a discrete area of investigation. This book has argued for them to be understood as distinctive because of the way they share aspects of performance – not just in the acting out, look and sound of the drama but also in terms of an event in which an audience gather at a specified time and place and experience something collectively. This understanding has then been extended to take in how exchanges between stage and screen have worked within specific historical and cultural environments in order to move towards, as Charles Musser has put it, 'an integrated history of stage and screen', but one that moves beyond the pre-1930s discussed in Musser's work (2004).

Part of the motivation behind this book then has been to put aside prejudices towards adaptations between these media, and move beyond seeing them as negatively influencing each other, i.e. in terms of 'canned' theatre on screen or the tired recycling of old films for the theatre, thinking instead of them as exciting hybrids that are often enjoyable for audiences to encounter. Indeed one aspect that has emerged during the book is that these are often very successful works that audiences want to see again and again. Simone Murray's work in adaptation studies is crucial here because she argues that adaptations in particular need to be understood in relation to the commercial imperatives of their respective industries (Murray 2012).

I have also argued that studies on individual adaptations or indeed respective media histories have assumed critical or mono disciplinary viewpoints that need to be challenged when dealing with stage–screen adaptations. Theatrical influences can enhance a film just as much as filmic modes of expression can be thoughtfully staged in the theatre. I have argued that critical views on stage–screen adaptations often need to be set within their own particular historical contexts. What might not seem for instance particularly cinematic according to one set of criteria about what defines a film, when these works are understood *as* adaptations, can be seen as different ways of relating to the source material – either in terms of trying to replicate and articulate a particular performance within a different medium or perhaps preserve it for prosperity. Such strategies have often been looked on as antithetical to the screen but this assumes that a film has essential elements that make it a film. One of the purposes of looking at adaptations between stage and screen diachronically has been to contextualize these adaptations so that we can historicize critical reactions to them and examine them for how far they express prevailing cultural norms – that are subject to historical difference and development. So for instance when looking at the early sound adaptations one can understand them as existing in a period of intense change for both cinema and theatre with the introduction of synchronized sound – one that created a contested terrain for how they should relate to each other with practitioners taking different approaches reflecting the values they privileged in adapting these works between media. In a different way, we can see how both theatre *and* film were implicated in the British New Wave – because of the way that they both could be used to act out and perform the social changes triggered by post-war changes in society. This potentially made them more aligned as modes of creative expression, with aesthetic experimentation moving between these media, albeit differentiated by industrial context and audience reach. Similarly the chapter on stage adaptations of British films examines them as products of another reconfiguration of the relationship between theatre and cinema when their status AS media has been thrown into crisis by broader changes in the landscape of cultural production. This has resulted in theatre staging the products of cinema and interrogating their medium specificity, which often (but not always) means using screens on stage and intermedial effects that blur the boundaries between the two and the viewing positions associated with them – for instance, when a close up is used on a screen of an action that is simultaneously taking place on stage.

The latter point shows that many of these developments are responding also to changing technology (without being necessarily determined by them) and by changing perceptions of that technology in understanding the parameters of stage and screen – for instance the seemingly simple opposition of liveness vs. recording is complicated by a multi-platform digital environment with its sophisticated

recording, mixing and transmitting capacities that have fundamentally altered audiences' perception of what is live and what is not and its imbrication of spatial and temporal proximity to the event.

I have tried where possible to understand these changes from the practitioners' point of view – be it Basil Dean in the early 1930s enthusiastically trying to create a writer's cinema from the works of established playwrights or Emma Rice in the 2000s using her encounters with or memories of specific films as triggers for her artistic practice in adapting them to the stage. This has meant broadening the materials consulted to include archive materials, anecdote and hearsay. This doesn't make them necessarily representative (particularly when dealing with historical material as white men's papers are more likely to be held in archives than ethnic minority practitioners or women) and there is probably less sustained engagement with archive materials than I would have liked, but it has been important to include these materials where I could. This is obviously because I have been trying to understand practitioners' understandings of their own creative environments in order to dig behind particular established or institutional representations of the relationship between stage and screen and partly because practitioner accounts of their work usually transcend ad hoc disciplinary boundaries. This doesn't make for an easier job in more broadly categorizing these stage–screen adaptations as individuals will have different experiences and assumptions that they bring to bear on their practice. But I feel this is what gives a better sense of the range of responses to the challenges of adapting material between stage and screen – one that often gives more of a sense of the vibrancy that these works contain. For adaptations can 'do' many things – they can interpret a past through a present moment and they can be a way of understanding a present moment through reference to a representation of the past. Alongside words being translated into space and action they can also offer translations of embodied moments of action – an actor's way of understanding a character can be transformed by another actor's way of understanding a character. They can sometimes offer a visual transcription of the source material but can also do things by being subtly different. These gaps are where the interest lies because when film and theatre speak to each other, each form is destabilized 'making immediate and graspable' the sense in which each form 'is not fixed, final and authoritative but malleable, contingent and contestable' (Babbage 2017: 214).

This book then has offered different ways of looking at adaptation between stage and screen such as consideration of spatial arrangements e.g. when adapting a theatrical performance for the screen, how consideration of its working out on stage might be translated into screen terms and how design elements might be utilized differently in the film. Thinking about these works specifically *as* adaptations (whether or not they are experienced that way by audiences) helps us to see how these films might be affected by the different effects of medium, such as when a

film records the actual material place that functions as an imaginary/metaphorical place within the theatre, from *Gone Too Far*'s use of Peckham to *The Entertainer*'s use of Morecambe.

Therefore, consideration of performance elements has been put at the heart of analysis of interactions between stage and screen. This has been expanded to think through the event of the performance and how the audience's relationship with the material is affected. Changes in technology have also been implicated here as the growth of mobile technologies has affected the way that audiences think about themselves as audiences and thus affected the way they encounter the adaptation. This is an environment that is developing quickly. We have seen a remarkable growth in the live broadcast of plays to cinemas worldwide and as indicated, experiments in making cinema more of a live event like the theatre have also started to make their mark on the cultural landscape. Similarly, the live performance event has been adapted by ever more sophisticated technology such as virtual reality and augmented reality environments, which will undoubtedly lead to further re-considerations of this subject in the not too distant future.[1] Returning to Sontag then, asking whether cinema is the successor/rival/revivifier of theatre is no longer a relevant question when what we understand as cinema and theatre themselves are subject to such monumental changes.

NOTE

1. This was written before the COVID-19 pandemic which has obviously massively impacted both theatre and film sectors in the UK in ways that are only now being fully understood. What has been notable, however, is the ever more inventive use of digital tools to bring performances to audiences. Some companies have chosen to put their live broadcasts online or have live streamed work direct from empty auditoriums. Others have adapted performances to utilize whatever spaces were available for them at the time. But that will have to be the subject of another book...

References

Aebischer, P., Greenhalgh, S. and Osborne, L. (2018), *Shakespeare and the 'Live' Theatre Broadcast Experience*, London: Bloomsbury Publishing.

Aftab, K. (2017), '*Lost In London*: Was Woody Harrelson's live feature a success?', *Screen Daily*, 20 January, https://www.screendaily.com/news/lost-in-london-was-woody-harrelsons-live-feature-a-success/5113978.article. Accessed 28 August 2019.

Aldgate, A. (1995), *Censorship and the Permissive Society: British Cinema and Theatre, 1955–1965*, Oxford: Oxford University Press.

——— (1998), 'Loose ends, hidden gems and the moment of "melodramatic emotionality"', in J. Richards (ed.), *The Unknown Thirties: An Alternative History of the British Cinema 1929–39*, London: IB Tauris, pp. 219–37.

Aldgate, A. and Richards, J. (1998), *Best of British: Cinema and Society from 1930 to the Present*, London: Tauris Parke.

Anderson, L. (1957), 'Get out and push', *Encounter*, 9, pp. 14–22.

Annett, S. (2014), 'The nostalgic remediation of cinema in *Hugo* and *Paprika*', *Journal of Adaptation in Film & Performance*, 7, pp. 169–80.

Anon. (1930a), 'The film world: Four British talkies', *The Times*, 30 August, p. 8.

——— (1930b), 'Review', *The Bioscope*, 8 September, n.pag.

——— (1930c), 'Something new', *Daily Express*, 24 January, n.pag.

——— (1960), press release in press cuttings file, 'A Taste of Honey', FI Library.

——— (1962a), 'The front page', *Sight and Sound*, Spring, 31:2, p. 55.

——— (1962b), 'Review of *Taste of Honey*', *Time*, 8 June, n.pag.

——— (1966), 'Review of *Alfie*', *Monthly Film Bulletin*, April, n.pag.

——— (2002), 'DVD review of *Theatre of Blood*', *Empire*, 161, p. 158.

Aragay, M. (2005), *Books in Motion: Adaptation, Intertextuality, Authorship*, Amsterdam: Rodopi.

Archive.org (n.d.), 'Alfie Elkins and his little life', https://archive.org/details/AlfieElkinsAndHisLittleLife_201608. Accessed 28 August 2019.

Aristotle and Cooper, L. (1913), *Aristotle on the Art of Poetry: An Amplified Version with Supplementary Illustrations for Students of English*, Boston: Ginn.

Atkinson, S. A. (2017), '"You sure that's a film, man?": Audience anticipation, expectation and engagement in *Lost in London LIVE*', *Participation: Journal of Audience and Reception Studies*, 14:2, pp. 697–713.

Atkinson, S. and Kennedy, H.W. (2017), *Live Cinema: Cultures, Economies, Aesthetics*, New York: Bloomsbury Publishing USA.

Auslander, P. (2004), 'Postmodernism and performance', in S. Connor (ed.), *The Cambridge Companion to Postmodernism*, Cambridge: Cambridge University Press, pp. 97–115.

—— (2008), *Liveness: Performance in a Mediatized Culture*, Abingdon: Routledge.

—— (2012), 'Digital liveness: A historico-philosophical perspective', *PAJ: A Journal of Performance and Art*, 34, pp. 3–11.

Babbage, F. (2017), *Adaptation in Contemporary Theatre: Performing Literature*, London: Bloomsbury Publishing.

Barker, M. (2003), 'Crash, theatre audiences, and the idea of "liveness"', *Studies in Theatre & Performance*, 23:1, pp. 21–39.

—— (2012), *Live to Your Local Cinema: The Remarkable Rise of Livecasting*, New York: Springer.

Barlow, P. and Buchan, J. (2009), *The 39 Steps*, London: Samuel French.

Baron, C. and Carnicke, S. M. (2011), *Reframing Screen Performance*, Ann Arbor, MI: University of Michigan Press.

Baron, C. A., Carson, D. and Tomasulo, F. P. (2004), *More than a Method: Trends and Traditions in Contemporary Film Performance*, Detroit: Wayne State University Press.

Barr, C. (1998), *Ealing Studios*, Berkeley, CA: University of California Press.

—— (1999), *English Hitchcock*, Moffat: Cameron & Hollis.

—— (2011), '"The knock of disapproval": *Juno and the Paycock* and its Irish reception', in S. Gottlieb and R. Allen (eds), *Hitchcock Annual*, New York: Columbia University Press, pp. 63–94.

Bazin, A. (1967), *What Is Cinema? Volume I* (trans. H. Gray), Berkeley, CA: University of California Press.

—— (1971), *Theatre and Cinema: Part Two: What Is Cinema 2*, Berkeley, CA: University of California Press.

Beckett, S. (2009), *Play*, London: Faber & Faber, https://doi.org/10.5040/9780571293766.40000035. Accessed 20 September 2019.

Beja, M. (1979), *Film and Literature*, New York: Longmans.

Benjamin, W. ([1936] 1999), 'The work of art in the age of mechanical reproduction', in W. Benjamin and H. Arendt, *Illuminations*, London: Pimlico, pp. 211–45.

Bennett, S. (2018), 'Shakespeare's new marketplace: The places of event cinema', in P. Aebischer, S. Greenhalgh and L. Osborne (eds), *Shakespeare and the 'Live' Theatre Broadcast Experience*, London: Bloomsbury Publishing, pp. 41–58.

Bennett, S. and Massai, S. (2018), *Ivo Van Hove: From Shakespeare to David Bowie*, London: Bloomsbury Publishing.

BFI Screenonline (n.d.), 'Film and theatre: 1930s', BFI Screenonline, https://www.screenonline. org.uk/film/id/445010/index.html. Accessed 28 August 2019.

Billington, M. (2000), 'Oh dear, Mrs Robinson: *The Graduate*', *The Guardian*, 7 April, https:// www.theguardian.com/stage/2000/apr/07/theatre.artsfeatures. Accessed 28 August 2019.

—— (2007), '*All About My Mother* – review', *The Guardian*, 5 September, https://www. theguardian.com/stage/2007/sep/05/theatre1. Accessed 9 March 2020.

—— (2011), '*The Ladykillers* – review', *The Guardian*, 8 December, https://www.theguardian. com/stage/2011/dec/08/the-ladykillers-review-michael-billington. Accessed 20 September 2019.

Bloomsbury.com (n.d.), 'Screening the Royal Shakespeare Company', Bloomsbury Publishing, https://www.bloomsbury.com/uk/screening-the-royal-shakespeare-company-9781350006584/. Accessed 29 August 2019.

Boehm, M. (2003), 'Granting Disney's wish', *Los Angeles Times*, 5 January, https://www. latimes.com/archives/la-xpm-2003-jan-05-ca-boehm5-story.html. Accessed 9 March 2020.

Bolter, J. D. and Grusin, R. (2000), *Remediation: Understanding New Media*, Cambridge, MA: MIT Press.

Boose, L. E. and Burt, R. (2003), *Shakespeare, the Movie, II: Popularizing the Plays on Film, TV, Video, and DVD*, London and New York: Routledge.

Boozer, J. (2008), 'Introduction: The screenplay and authorship in adaptation', in J. Boozer (ed.), *Authorship in Film Adaptation*, Austin, TX: University of Texas Press, pp. 1–30.

Bordwell, D. (1979), 'The art cinema as a mode of film practice', *Film Criticism*, 4, pp. 56–64.

Boym, S. (2001), *The Future of Nostalgia,* New York: Basic Books.

Boyum, J. G. (1985), *Double Exposure: Fiction into Film*, New York: Plume.

Bradshaw, P. (2011), 'Why it's the theatre that's given us a *Ladykillers* to die for', *The Guardian*, 22 December, https://www.theguardian.com/film/filmblog/2011/dec/22/the-lady-killers-theatre-peter-bradshaw. Accessed 20 September 2019.

Brantley, B. (2008), 'A natural Cassavetes woman, theatricalized, magnified and multiplied', *New York Times*, 4 November, https://www.nytimes.com/2008/12/04/arts/04iht-04opening.18405877.html. Accessed 28 August 2019.

—— (2009), 'Revisiting those strangers at a train station', *New York Times*, 8 December, https://www.nytimes.com/2009/12/09/theater/reviews/09encounter.html. Accessed 22 June 2020.

—— (2015), 'Review: *39 Steps*, frenetic thriller spoof, rises again', *New York Times*, 13 April, https://www.nytimes.com/2015/04/14/theater/review-39-steps-frenetic-thriller-spoof-rises-again.html?_r=0. Accessed 28 August 2019.

Braudy, L. (2005), 'Acting: Stage vs. screen', in R. Knopf (ed.), *Theater and Film: A Comparative Anthology*, New Haven and London: Yale University Press, pp. 352–60.

British Library (n.d.), 'Notes made by Joan Littlewood about the music in *A Taste of Honey*', Collection Items, British Library, https://www.bl.uk/collection-items/notes-made-by-joan-littlewood-about-the-music-in-a-taste-of-honey. Accessed 28 August 2019.

Brown, G. (1986), '"Sister of the stage": British film and British theatre', *All Our Yesterdays*, 90, pp. 143–67.

Brown, T. (2012), *Breaking the Fourth Wall: Direct Address in the Cinema*, Edinburgh: Edinburgh University Press.

Bruhn, J., Gjelsvik, A. and Hanssen, E. F. (2013), *Adaptation Studies: New Challenges, New Directions*, London: Bloomsbury.

Brunel, A. (1949), *Nice Work: The Story of Thirty Years in British Film Production*, London: Forbes Robertson.

Buchanan, J. (2005), *Shakespeare on Film*, Harlow: Longman Pearson.

Burrows, J. (2003), *Legitimate Cinema: Theatre Stars in Silent British Films, 1908–1918*, Quebec: Presses Université Laval.

Butler, D. (2002), *Jazz Noir: Listening to Music from Phantom Lady to The Last Seduction*, Westport, CT: Greenwood Publishing Group.

Caine, M. (1993), *What's It All About?*, London: Random House.

Campbell, J. (2013), 'See-thru desire and the dream of gay marriage: Orton's *Entertaining Mr Sloane* on stage and screen', in R. B. Palmer and W. R. Bray (eds), *Modern British Drama on Screen*, Cambridge: Cambridge University Press, pp. 145–68.

Cardullo, B. (2012), *Stage and Screen: Adaptation Theory from 1916 to 2000*, London: Continuum.

Cardullo, B., Geduld, H., Gottesman, R. and Woods, L. (1998), *Playing to the Camera: Film Actors Discuss Their Craft*, London: Yale University Press.

Carlson, M. (2003), *The Haunted Stage: The Theatre as Memory Machine*, Ann Arbor, MI: University of Michigan Press.

Carroll, R. (2009), *Adaptation in Contemporary Culture: Textual Infidelities*, London: A&C Black.

Carson, B. (1998), 'Comedy, sexuality and "Swinging London" films', *Journal of Popular British Cinema*, 1, pp. 48–54.

Cartmell, D. (2012), *A Companion to Literature, Film, and Adaptation*, Chichester: Wiley-Blackwell.

Cartmell, D. and Whelehan, I. (2010), *Screen Adaptation Impure Cinema*, Basingstoke: Palgrave Macmillan.

Cassavetes, J. and Carney, R. (2001), *Cassavetes on Cassavetes*, London: Faber & Faber.

Chapple, F. and Kattenbelt, C. (2006), *Intermediality in Theatre and Performance*, Amsterdam: Rodopi.

Cochrane, B. and Bonner, F. (2014), 'Screening from the Met, the NT, or the House: What changes with the live relay', *Adaptation*, 7, pp. 121–33.

Collins, J. (2015), 'Report from the Edinburgh International Festival August 2015', *Theatre and Performance Design*, 1, pp. 256–67.

Corrigan, T. (2011), *Film and Literature: An Introduction and Reader*, London: Routledge.

Courtney, E. C. (1993), *Jocelyn Herbert: A Theatre Workbook*, London: Art Books International.

Coveney, M. (2011), 'John Neville obituary', *The Guardian*, 21 November, https://www.theguardian.com/stage/2011/nov/21/john-neville. Accessed 9 March 2020.

Crossman, R. H. S. (1962), 'A chance for appraisal', *The Guardian*, 30 November, p. 22.

Cuckoo in the Nest (1933), press book, London: BFI.

Darlington, W. A. (1963), 'Egotist who gets almost endearing', *Daily Telegraph*, 21 June, p. 16.

Davies, A. (1990), *Filming Shakespeare's Plays: The Adaptations of Laurence Olivier, Orson Welles, Peter Brook and Akira Kurosawa*, Cambridge: Cambridge University Press.

Davis, P. (1990), 'Literary history: Retelling *A Christmas Carol*: Text and culture-text', *American Scholar*, 59, pp. 109–15.

Davison, A. (2009), *Alex North's* A Streetcar Named Desire: *A Film Score Guide*, Lanham, MD: Scarecrow Press.

—— (2011), 'Dramas with music: Tennessee Williams's *A Streetcar Named Desire* and the challenges of music for the postwar stage', *American Music*, 29, pp. 401–42.

Dean, B. (1927), 'The stage and the screen: Do you prefer the films?', BDA, 12/1/41, Manchester: John Ryland's Special Collections.

—— (1928a), BDA, 1/2/643, 19 July, Manchester: John Ryland's Special Collections.

—— (1928b), BDA, 1/2/686, 28 January, Manchester: John Ryland's Special Collections.

—— (1929a), BDA, 1/2/665, 2 May, Manchester: John Ryland's Special Collections.

—— (1929b), 'These talking pictures', BDA, 12/1/50, Manchester: John Ryland's Special Collections.

—— (1930a), 'Stage or screen?' BDA, 12/1/55, Manchester: John Ryland's Special Collections.

—— (1930b), BDA, 1/2/691, 7 April, Manchester: John Ryland's Special Collections.

—— (1931), 'Meet the British talking pictures', BDA, 2/1/60, Manchester: John Ryland's Special Collections.

—— (1938), 'The future of stage and screen', in C. Davy (ed.), *Footnotes to the Film*, London: Readers Union, n.pag.

—— (1973), *Mind's Eye: An Autobiography, 1927–1972*, London: Hutchinson.

Del Rio, E. (2008), *Deleuze and the Cinemas of Performance: Powers of Affection*, Edinburgh: Edinburgh University Press.

Desmond, J. M. and Hawkes, P. (2005), *Adaptation: Studying Film and Literature*, New York: McGraw-Hill.

Diamond, E., Ackerman, A. and Puchner, M. (2006), *Against Theatre: Creative Destructions on the Modernist Stage*, London: Palgrave.

Dicecco, N. (2017), 'The aura of againness: Performing adaptation', in T. Leitch (ed.), *The Oxford Handbook of Adaptation Studies*, Oxford: Oxford University Press, pp. 607–24.

Dickinson, M. and Street, S. (1985), *Cinema and State: The Film Industry and the Government 1927–84*, London: British Film Institute.

Dix, A. (2016), *Beginning Film Studies*, Oxford: Oxford University Press.

Donald, J., Friedberg, A. and Marcus, L. (eds) (1999), *Close Up, 1927–33: Cinema and Modernism*, Princeton, NJ: Princeton University Press.

Doran, G. (2014), 'How Shakespeare can work on screen', *The Stage*, 4 September, p. 11.

Du Maurier, D. (2010), *Gerald: A Portrait*, London: Hachette UK.

Dyer, R. (2015), *Brief Encounter*, London: Bloomsbury Publishing.

Ede, L. N. (2010), *British Film Design: A History*, London: Bloomsbury Publishing.

Edelstein, D. (2016), 'Denzel Washington's *Fences* gets stuck between stage and screen', *Vulture*, 23 December, https://www.vulture.com/2016/12/movie-review-fences.html. Accessed 17 September 2019.

Eldridge, D. (2013), *Festen*, London: A&C Black.

Ellis, J. (1982), 'The literary adaptation', *Screen*, 23:1, May/June, pp. 3–5.

Ellis, S. (2003), '*A Taste of Honey*, London, 1958', *The Guardian*, 10 September, https://www.theguardian.com/stage/2003/sep/10/theatre2. Accessed 28 August 2019.

Erll, A. and Rigney, A. (2009), 'Introduction: Cultural memory and its dynamics', in A. Erll and A. Rigney (eds), *Mediation, Remediation, and the Dynamics of Cultural Memory*, Berlin and New York: Walter de Gruyter, pp. 1–11.

Evans, P. (1960), 'Found: The ugly girl', *Daily Express*, 27 April, p. 12.

Ferguson, E. (2011), '*The Ladykillers* – reborn for the stage', *The Guardian*, 30 October, https://www.theguardian.com/culture/2011/oct/30/the-ladykillers-theatre-graham-linehan. Accessed 20 September 2019.

Flanagan, K. M. (2015), 'Displacements and diversions: *Oh! What a Lovely War* and the adaptation of trauma', *South Atlantic Review*, 80, pp. 96–102.

Forrest, D. (2013), *Social Realism: Art, Nationhood and Politics*, Newcastle-upon-Tyne: Cambridge Scholars Publishing.

Gale, M. B. (2008), *J.B. Priestley*, Abingdon: Routledge.

Gardner, L. (2008), 'Music deserves a bigger role in the theatre', *The Guardian*, 5 December, https://www.theguardian.com/stage/theatreblog/2008/dec/05/theatre-music-sound-design. Accessed 4 March 2020.

Gatten, B. (2009), 'The posthumous worlds of *Not I* and *Play*', *Texas Studies in Literature and Language*, 51, pp. 95–101.

Gaudreault, A. and Marion, P. (2015), *The End of Cinema? A Medium in Crisis in the Digital Age*, New York: Columbia University Press.

Georgi, C. (2012), 'Kneehigh Theatre's *Brief Encounter*: "Live on stage – not the film"', in L. Raw (ed.), *The Adaptation of History: Ways of Telling the Past*, Jefferson, NC: McFarland & Co Inc, pp. 66–78.

Geraghty, C. (2002), 'Crossing over: Performing as a lady and a dame', *Screen*, 43, pp. 41–56.

——— (2007), *Now a Major Motion Picture: Film Adaptations of Literature and Drama*, Lanham, MD: Rowman & Littlefield Publishers.

——— (2013), 'The shift from stage to screen: Space, performance, and language in *The Knack ... and How to Get It*', in R. B. Palmer and W. R. Bray (eds), *Modern British Drama on Screen*, Cambridge: Cambridge University Press, pp. 121–44.

——— (2019), 'Filming with words: British cinema, literature and adaptation', in J. Hill (ed.), *A Companion to British and Irish Cinema*, London: Blackwell Wiley, pp. 143–57.

Giesekam, G. (2007), *Staging the Screen: The Use of Film and Video in Theatre*, London: Macmillan International Higher Education.

Glancy, M. (2003), The 39 Steps: *The British Film Guide 3*, London: IB Tauris.

Gledhill, C. (1991), *Stardom: Industry of Desire*, London: Routledge.

——— (2003), *Reframing British Cinema 1918–1928: Between Restraint and Passion*, London: British Film Institute.

——— (2008), 'Play as experiment in 1920s British cinema', *Film History: An International Journal*, 20, pp. 14–34.

Gontarski, S. E. (2015), 'Samuel Beckett and the "idea" of theatre: Performance through Artaud and Deleuze', in D. V. Hulle (ed.), *The New Cambridge Companion to Samuel Beckett*, Cambridge: Cambridge University Press, pp. 126–41.

Goriely, S. (2018), 'Ivo van Hove's cinema onstage: Reconstructing the creative process', in D. Willinger (ed.), *Ivo von Hove Onstage*, https://doi.org/10.4324/9781351260084-3. Accessed 20 September 2019.

Green, S. N. (2011), *From Silver Screen to Spanish Stage: The Humorists of the Madrid Vanguardia and Hollywood Film*, Cardiff: University of Wales Press.

Greenhalgh, S. (2014), 'Guest editor's introduction', *Shakespeare Bulletin*, 32, pp. 255–61.

——— (2018), 'The remains of the stage: Revivifying Shakespearean theatre on screen 1964–2016,' in P. Aebischer, S. Greenhalgh and L. Osborne (eds), *Shakespeare and the 'Live' Theatre Broadcast Experience*, London: Bloomsbury Publishing, pp. 19–40.

Gritten, D. (2008), '"The technique of the talkie": Screenwriting manuals and the coming of sound to British cinema', *Journal of British Cinema and Television*, 5, pp. 262–79.

Grossman, J. (2015), *Literature, Film, and Their Hideous Progeny: Adaptation and ElasTEXTity*, New York: Springer.

Grossman, J. and Palmer, R. B. (2017), *Adaptation in Visual Culture: Images, Texts, and Their Multiple Worlds*, New York: Springer.

Gruzd, A., Wellman, B. and Takhteyev, Y. (2011), 'Imagining Twitter as an imagined community', *American Behavioral Scientist*, 55, pp. 1294–318, https://doi.org/10.1177/0002764211409378. Accessed 20 September 2019.

Hadley B. (2017), *Theatre, Social Media, and Meaning Making*, https://doi.org/10.1007/978-3-319-54882-1. Accessed 9 March 2020.

Harper, S. (1990), 'A note on Basil Dean, Sir Robert Vansittart and British historical films of the 1930s', *Historical Journal of Film, Radio and Television*, 10, pp. 81–87.

Harvey, D. (2007), *A Brief History of Neoliberalism*, New York: Oxford University Press.

Harvie, J. (2005), *Staging the UK*, Manchester: Manchester University Press.

Hatchuel, S. (2004), *Shakespeare, from Stage to Screen*, Cambridge: Cambridge University Press.

Herren, G. (2009), 'Different music: Karmitz and Beckett's film adaptation of *Comédie*', *Journal of Beckett Studies*, 18, pp. 10–31.

Higson, A. (1996), 'Space, place, spectacle: Landscape and townscape in the "kitchen sink" film', in A. Higson (ed.), *Dissolving Views: Key Writings on British Cinema*, London: Continuum, pp. 133–56.

—— (2000), 'The instability of the national', in J. Ashby and A. Higson (eds), *British Cinema, Past and Present*, Abingdon: Routledge, pp. 35–48.

—— (2010), *Film England: Culturally English Filmmaking Since the 1990s*, London: IB Tauris.

Hill, J. (1986), *Sex, Class, and Realism British Cinema, 1956–1963*, London: British Film Institute.

—— (2013), 'From the New Wave to 'Brit-grit': Continuity and difference in working-class realism', in J. Ashby and A. Higson (eds), *British Cinema, Past and Present*, Abingdon: Routledge, pp. 269–80.

Hiscock, J. (2004a), 'I'm doing what I dreamed of', *The Telegraph*, 21 February, https://www.telegraph.co.uk/culture/4730354/Im-doing-what-I-dreamed-of.html. Accessed 9 March 2020.

—— (2004b), '"I didn't want to step into Caine's shoes"', *The Telegraph*, 8 October, https://www.telegraph.co.uk/culture/film/3625092/I-didnt-want-to-step-into-Caines-shoes.html. Accessed 28 August 2019.

The Hitchcock Zone (n.d.a), '*Juno and the Paycock* (1930)', Alfred Hitchcock Wiki, https://the.hitchcock.zone/wiki/Juno_and_the_Paycock_(1930). Accessed 28 August 2019.

—— (n.d.b), 'Articles from Jouvert', Alfred Hitchcock Wiki, https://the.hitchcock.zone/wiki/Jouvert. Accessed 28 August 2019.

Hitchman, L. (2018), 'From page to stage to screen: The live theatre broadcast as a new medium', *Adaptation*, 11, pp. 171–85.

Hjort, M. and MacKenzie, S. (2000), *Cinema and Nation*, Hove: Psychology Press.

Holdsworth, N. (2010), *Theatre and Nation*, London: Macmillan International Higher Education.

—— (2011), *Joan Littlewood's Theatre*, Cambridge: Cambridge University Press.

Holland, C. (2003), 'Stanley Kowalski: From page to performance – Christopher Holland shows how the famous 1951 film version of *A Streetcar Named Desire* subtly altered the slant of Tennessee Williams's original stage play', *English Review*, 13, pp. 10–15.

Houston, P. (1960), 'Review of *The Entertainer*', *Sight and Sound*, 29, p. 4.

Hunt, A. (1961), 'Review of *Taste of Honey*', *Universities and Left Review*, 6 September, p. 5

Hunter, I. Q. and Porter, L. (2012), *British Comedy Cinema*, Abingdon: Routledge.

Hutcheon, L. (2006), *A Theory of Adaptation*, Abingdon: Routledge.

Hutchings, P. (2002), 'Beyond the New Wave: Realism in British cinema, 1959–1963', in *The British Cinema Book*, London: British Film Institute, pp. 304–12.

Ingham, M. (2016), *Stage-Play and Screen-Play: The Intermediality of Theatre and Cinema*, Abingdon: Routledge.

Into Film Clubs (2015), 'Destiny Ekaragha, Bola Agbaje and OC Ukeje on *Gone Too Far*', YouTube, 6 August, https://www.youtube.com/watch?v=VeICxGvxl8c. Accessed 28 August 2019.

Isaacs, B. (2014), *The Orientation of Future Cinema: Technology, Aesthetics, Spectacle*, London: Bloomsbury.

Ivan-zadeh, L. (2019), 'Scene: Helen Mirren's delighted to be a game-changer', *Metro*, 18 June, https://www.metro.news/scene-helen-mirrens-delighted-to-be-a-game-changer/1603467/. Accessed 29 August 2019.

Izod, J., Magee, K., Hannan, K. and Gourdin-Sangouard, I. (2018), *Lindsay Anderson*, Manchester: Manchester University Press.

Jackson, R. (2014), *Shakespeare and the English-Speaking Cinema*, Oxford: Oxford University Press.

Jacobs, J. (2000), *The Intimate Screen: Early British Television Drama*, Oxford: Oxford University Press.

Jameson, F. (1991), *Postmodernism: Or, The Cultural Logic of Late Capitalism*, London: Verso.

Jenkins, H. (2006), *Convergence Culture: Where Old and New Media Collide*, New York: New York University Press.

jonnyleemiller.co.uk (n.d.), 'Jonny Lee Miller in *Festen*', jonnyleemiller, https://www.jonnyleemiller.co.uk/festen.html. Accessed 29 August 2019.

Juno and the Paycock (1930), press book, London: BFI.

Kattenbelt, C. (2008), 'Intermediality in theatre and performance: Definitions, perceptions and medial relationships', *Cultura, lenguaje y representación: revista de estudios culturales de la Universitat Jaume*, I, 6, pp. 19–29.

Kendrick, L. and Roesner, D. (2012), *Theatre Noise: The Sound of Performance*, Newcastle-upon-Tyne: Cambridge Scholars Publishing.

Kidnie, M. J. (2005), 'Where is Hamlet? Text, performance, and adaptation', in B. Hodgdon and W. B. Worthen (eds), *A Companion to Shakespeare and Performance*, Oxford: Blackwell, pp. 101–20.

—— (2009), *Shakespeare and the Problem of Adaptation*, Abingdon: Routledge.

Kilbourn, R. J. A. and Faubert, P. (2014), 'Introduction: Film adaptation in the post-cinematic era', *Journal of Adaptation in Film & Performance*, 7:2, pp. 155–58.

King, G. (2000), *Spectacular Narratives: Hollywood in the Age of the Blockbuster*, London: IB Tauris.

King, H. (2004), 'Free indirect affect in Cassavetes' *Opening Night* and *Faces*', *Camera Obscura*, 19, pp. 104–39.

Klaver, E. (2000), *Performing Television: Contemporary Drama and the Media Culture*, Madison, WI: Popular Press.

Klevan, A. (2005), *Film Performance: From Achievement to Appreciation*, London: Wallflower.

Knopf, R. (ed.) (2005), *Theater and Film: A Comparative Anthology*, New Haven and London: Yale University Press.

Knowlson, E. and Knowlson, J. (2006), *Beckett Remembering, Remembering Beckett: Uncollected Interviews with Samuel Beckett and Memories of Those Who Knew Him*, London: Bloomsbury.

Kuhn, A. (2002), *An Everyday Magic: Cinema and Cultural Memory*, London: IB Tauris.

Lacey, S. (1996), 'Naturalism, poetic realism, spectacle: Wesker's *The Kitchen* in performance', *New Theatre Quarterly*, 12, pp. 237–48.

—— (2002), *British Realist Theatre: The New Wave in its Context 1956–1965*, Abingdon: Routledge.

Laera, M. (2014), *Theatre and Adaptation: Return, Rewrite, Repeat*, London: A&C Black.

Lawrenson, H. (1966), *US Esquire*, December, n.pag.

Leitch, T. (2003), 'Twelve fallacies in contemporary adaptation theory', *Criticism*, 45, pp. 149–71.

Leitch, T. M. and Poague, L. A. (2011), *A Companion to Alfred Hitchcock*, n.p.: Wiley Online Library.

Levin, R. (1986), 'Performance-critics vs close readers in the study of English Renaissance drama', *Modern Language Review*, 81, pp. 545–59.

Lewis, P. (1961), 'Wide eyed appeal – in Tush's violet gaze', *Daily Express*, 7 September, p. 10.

Linehan, G. (2011), *The Ladykillers*, London: Samuel French.

Lochner, J. (2006), 'The music of *A Streetcar Named Desire*', Words of Note: Writings on Film Music, the Arts and More Words, https://wordsofnote.wordpress.com/articles/streetcar-named-desire/. Accessed 20 September 2019.

Lovell, T. (1996), 'Landscapes and stories in 1960s British realism', in A. Higson (ed.), *Dissolving Views: Key Writings on British Cinema*, London: Continuum, pp. 157–77.

Low, R. (1997), *The History of the British Film 1929–1939: Films of Comment and Persuasion of the 1930s*, Hove: Psychology Press.

Lowe, V. (2004), '"The best speaking voices in the world": Robert Donat, stardom and the voice in British cinema', *Journal of British Cinema and Television*, 1, pp. 181–96.

—— (2009), 'Performing Hitchcock: Robert Donat, film acting and *The 39 Steps* (1935)', *Scope: An Online Journal of Film and Television Studies*, https://www.nottingham.ac.uk/scope/documents/2009/june-2009/lowe.pdf. Accessed 9 March 2020.

—— (2010), '"Stages of performance": Adaptation and intermediality in *Theatre of Blood* (1973)', *Adaptation*, 3:2, pp. 99–111.

—— (2011), 'Escape from the stage? From play to screenplay in British cinema's early sound period', *Journal of Screenwriting*, 2, pp. 215–28.

——— (forthcoming 2020), 'This genuine theatre condition: Basil Dean and the live theatre broadcast', in J. Wyver and A. Wrigley (eds), *Screenplays*, Manchester: Manchester University Press, n.pag.

Lunn, O. (2016), 'Where to begin with John Cassavetes', BFI website, 9 December, https://www.bfi.org.uk/news-opinion/news-bfi/features/where-begin-john-cassavetes. Accessed 28 August 2019.

MacArthur, M., Wilkinson, L. and Zaiontz, K. (2009), *Performing Adaptations: Essays and Conversations on the Theory and Practice of Adaptation*, Newcastle-upon-Tyne: Cambridge Scholars Publishing.

Macdonald, I. W. (2010), 'Screenwriting in Britain 1895–1929', in *Analysing the Screenplay*, Abingdon: Routledge, pp. 58–82.

Macnab, G. (2000), *Searching for Stars: Stardom and Screen Acting in British Cinema*, London: A&C Black.

Magaril, J. (2014), 'Ivo van Hove on directing *Scenes from a Marriage* and *Angels in America*', *Slant*, 17 October, https://www.slantmagazine.com/features/ivo-van-hove-on-directing-scenes-from-a-marriage-and-angels-in-america/. Accessed 24 June 2019.

Manvell, R. (1979), *Theater and Film: A Comparative Study of the Two Forms of Dramatic Art, and of the Problems of Adaptations of Stage Plays into Films*, Rutherford, NJ: Fairleigh Dickinson University Press.

Marion, F. and Sherwood, R. E. (1937), *How to Write and Sell Film Stories*, New York: Covici-Friede.

Marks, L. U. and Polan, D. (2000), *The Skin of the Film: Intercultural Cinema, Embodiment, and the Senses*, Durham, NC: Duke University Press.

McFarlane, B. (1996), *Novel to Film: An Introduction to the Theory of Adaptation*, Oxford and New York: Oxford University Press.

Medhurst, A. (2007), *A National Joke: Popular Comedy and English Cultural Identities*, Abingdon: Routledge.

Michael Balcon Collection (1934), MEB 1110/C31, London: BFI.

Miller, J. (1961), 'Kitchenette', *New Statesman*, 21 July, p. 12.

Morgan, J. (1994), 'Alfred Hitchcock's *Juno and the Paycock*', *Irish University Review*, 24:2, pp. 212–16.

Moviefone (2017), '"*Lost in London Live*" announcement trailer: Woody Harrelson', YouTube, 16 January, https://www.youtube.com/watch?v=3MCNDYlVzWoH. Accessed 28 August 2019.

Murphy, R. (1984), 'Coming of sound to the cinema in Britain', *Historical Journal of Film, Radio and Television*, 4, pp. 143–60.

——— (2012), 'English as she is spoke: The first British talkies', *Historical Journal of Film, Radio and Television*, 32, pp. 537–57, https://doi.org/10.1080/01439685.2012.727341. Accessed 20 September 2019.

—— (2014), 'New morning: Optimism and resilience in Tony Richardson's *A Taste of Honey* and *The Loneliness of the Long Distance Runner*', *Journal of British Cinema and Television*, 11, pp. 378–96.

Murray, A. (2017), *Into the Unknown: The Fantastic Life of Nigel Kneale (Revised & Updated)*, West Compton, CA: SCB Distributors.

Murray, S. (2012), *The Adaptation Industry: The Cultural Economy of Contemporary Literary Adaptation*, Abingdon: Routledge.

Musser, C. (2004), 'Towards a history of theatrical culture: Imagining an integrated history of stage and screen', in J. Fullerton (ed.), *Screen Culture: History and Textuality*, Eastleigh: John Libbey Publishing, pp. 3–20.

Napper, L. (2009), *British Cinema and Middlebrow Culture in the Interwar Years*, Exeter: University of Exeter Press.

—— (2012), '"No limit": British class and comedy of the 1930s', in I.Q. Hunter (ed.), *British Comedy Cinema*, Abingdon: Routledge, pp. 50–62.

—— (2013), '"That filth from which the glamour is not even yet departed": Adapting *Journey's End*', in R. B. Palmer and W. R. Bray (eds), *Modern British Drama on Screen*, Cambridge: Cambridge University Press, pp. 12–30.

Naremore, J. (1988), *Acting in the Cinema*, Berkeley, CA: University of California Press.

Nathan, D. (1961), 'The dingy drab doorway to fame', *Daily Herald*, 8 April, n.pag.

National Theatre (n.d.), 'The Studio', National Theatre website, https://www.nationaltheatre.org.uk/immersive/studio. Accessed 28 August 2019.

National Theatre Education Workpack (2004), *Theatre of Blood*, unpublished.

National Theatre Live (n.d.a), NT Live website, http://ntlive.nationaltheatre.org.uk/. Accessed 28 August 2019.

—— (n.d.b), '*Small Island*', NT Live website, http://ntlive.nationaltheatre.org.uk/productions/73263-small-island. Accessed 29 August 2019.

Naughton, B. (1963), *Alfie: A Play in Three Acts*, London: Samuel French Ltd.

NESTA (National Endowment for Science, Technology and the Arts) (n.d.), *NT Live – Digital Broadcast of Theatre: Learning From the Pilot Season*, https://media.nesta.org.uk/documents/nt_live.pdf. Accessed 28 August 2019.

Nicholas, R. (2018), 'Understanding "new" encounters with Shakespeare: Hybrid media and emerging audience behaviours', in P. Aebischer, S. Greenhalgh and L. Osborne (eds), *Shakespeare and the 'Live' Theatre Broadcast Experience*, London: Bloomsbury Publishing, pp. 77–94.

Nicholson, S. (2013) 'The British New Wave begins: Richardson's *Look Back in Anger*', in R. Palmer and W. Bray (eds), *Modern British Drama on Screen*, Cambridge: Cambridge University Press, pp. 103–20.

Nicklas, P. and Baumbach, S. (2018), 'Adaptation and perception', *Adaptation*, 11, pp. 103–10.

Nye, L. K. (2017), 'Looking at the original script for *A Taste of Honey*', British Library, https://www.bl.uk/20th-century-literature/articles/looking-at-the-original-script-for-a-taste-of-honey. Accessed 19 September 2019.

Olivier, L. (1982), *Confessions of an Actor*, London: Weidenfeld and Nicolson.

Onič, T. (2016), 'Music becomes emotions: The musical score in two productions of *A Streetcar Named Desire*', *ELOPE*, 1:13, pp. 59–68, https://doi.org/10.4312/elope.13.1.59-68. Accessed 20 September 2019.

Onyett, N. (2011), 'Good belle gone bad: *A Streetcar Named Desire* from stage to screen: Nicola Onyett looks at ways in which the iconic 1951 film version of Tennessee Williams' masterpiece may illuminate some of the text's themes and contexts', *English Review*, 21, pp. 30–35.

Orton, J. (2014), *Entertaining Mr Sloane*, London: Methuen Drama.

Osborne, J. (1991), *Almost a Gentleman: An Autobiography*, London: Faber & Faber.

—— (1993), *Look Back in Anger and Other Plays*, London: Faber & Faber.

Osipovich, D. (2006), 'What is a theatrical performance?', *Journal of Aesthetics and Art Criticism*, 64, pp. 461–70.

Palmer, R. B. and Boyd, D. (2011), *Hitchcock at the Source: The Auteur as Adapter*, New York: SUNY Press.

Palmer, R. B. and Bray, W. R. (eds) (2013), *Modern British Drama on Screen*, Cambridge: Cambridge University Press.

Parody, C. (2011), 'Adaptation essay prize winner: Franchising/adaptation', *Adaptation*, 4, pp. 210–18.

Patterson, J. (2008), 'If only Hitchcock had adapted more Noël Coward plays', *The Guardian*, 1 November, https://www.theguardian.com/film/2008/nov/01/alfred-hitchcock-noel-coward. Accessed 28 August 2019.

—— (2015), '*Brief Encounter*: Is it still relevant at 70?', *The Guardian*, 2 November, https://www.theguardian.com/film/2015/nov/02/david-lean-brief-encounter-70th-anniversary. Accessed 20 September 2019.

PCPA (n.d.), 'August Wilson's *Fences*', PCPA website, http://www.pcpa.org/Fences.html. Accessed 28 August 2019.

Pearce, G. (2007), 'Watch and learn, sunshine: Michael Caine', *Sunday Times*, 17 November, p. 21.

Pellegrini, D. (2014), 'Remediating Fassbinder', *Adaptation*, 7, pp. 154–68, https://doi.org/10.1093/adaptation/apu018. Accessed 20 September 2019.

Perkins, V. F. (1962), 'The British cinema', *Movie*, 1, pp. 2–7.

Phelan, P. (1993), 'The ontology of performance: Representation without reproduction', in *Unmarked: The Politics of Performance*, Abingdon: Routledge, pp. 146–66.

Porter, L. (2017), 'The talkies come to Britain: British silent cinema and the transition to sound, 1928–30', in I. Hunter, L. Porter and J. Smith (eds), *The Routledge Companion to British Cinema History*, Abingdon: Routledge, pp. 103–14.

Purcell, S. (2014), 'The impact of new forms of public performance', in C. Carson and P. Kirwan (eds), *Shakespeare and the Digital World: Redefining Scholarship and Practice*, Cambridge: Cambridge University Press, pp. 212–25.

Radosavljevic, D. (2010), 'Emma Rice in interview with Duska Radosavljevic', *Journal of Adaptation in Film and Performance*, 3:1, pp. 89–98.

Rancière, J. (2007), *The Future of the Image*, London and New York: Verso.

Ray, R. (2000), 'The field of "literature and film"', in J. Naremore (ed.), *Film Adaptation*, New Brunswick, NJ: Rutgers University Press, pp. 38–53.

Read, C. (2014), '"Live, or almost live…": The politics of performance and documentation', *International Journal of Performance Arts and Digital Media*, 10, pp. 67–76.

Rebellato, D. (2002), *1956 and All That: The Making of Modern British Drama*, Abingdon: Routledge.

Rees, C. (2017), *Adaptation and Nation: Theatrical Contexts for Contemporary English and Irish Drama*, London: Palgrave Macmillan.

Reilly, K. (2018), *Contemporary Approaches to Adaptation in Theatre*, New York: Springer.

Reinelt, J. (2007), 'Performing histories', in R. Boon (ed.), *The Cambridge Companion to David Hare*, Cambridge: Cambridge University Press, pp. 200–19.

Richards, J. (1984), *The Age of the Dream Palace: Cinema and Society in Britain 1930–1939*, London: Routledge and Kegan Paul.

—— (1997), *Films and British National Identity: From Dickens to Dad's Army*, Manchester: Manchester University Press.

—— (2016), *Cinema and Radio in Britain and America, 1920–60*, Manchester: Manchester University Press.

Richardson, T. (1959), 'The man behind an Angry-Young-Man', *Films and Filming*, February, p. 9.

Roberts, R. (2001), 'Gendered media rivalry: Television and film on the London stage', *Text and Performance Quarterly*, 21, pp. 114–27.

—— (2003), 'Gendered media rivalry: Irish drama and American film', *Australasian Drama Studies,* 43, pp. 108–27.

Robinson, D. (1961), 'This week's films', *Financial Times*, 15 September, n.pag.

Roesner, D. (2016), *Musicality in Theatre: Music as Model, Method and Metaphor in Theatre-Making*, Abingdon: Routledge.

Rokem, F. (2000), *Performing History: Theatrical Representations of the Past in Contemporary Theatre*, Studies in Theatre History and Culture, Iowa City: University of Iowa Press.

Rosenthal, D. (2004), 'Stage struck', *The Independent*, 14 March, https://www.independent. co.uk/arts-entertainment/theatre-dance/features/stage-struck-566397.html. Accessed 29 August 2019.

Rothman, W. (2012), *Hitchcock: The Murderous Gaze*, New York: SUNY Press.

RSC (Royal Shakespeare Company) (n.d.), 'RSC and Magic Leap offer unique fellowships to explore digital theatre innovation', https://www.rsc.org.uk/press/releases/royal-shakespeare-company-and-magic-leap-offer-unique-fellowships-to-explore-digital-theatre-innovation. Accessed 28 August 2019.

Ryall, T. (1996), *Alfred Hitchcock and the British Cinema*, London: Bloomsbury Publishing.

────── (2011), 'Gaumont Hitchcock', in T. M. Leitch and L. A. Poague (eds), *A Companion to Alfred Hitchcock*, Chichester: Wiley-Blackwell, pp. 270–88.

Ryan, M. L. (2014), 'Story/worlds/media', in M. L. Ryan and J. N. Thon (eds), *Storyworlds across Media*, Lincoln: University of Nebraska Press, pp. 25–49.

Said, E. (1978), *Orientalism*, London: Vintage Books.

Sanders, J. (2015), *Adaptation and Appropriation*, Abingdon: Routledge.

────── (2018), 'Synecdoche, adaptation, and the staged screenplay: Van Hove's obsession(s)', in S. Bennett and S. Massai (eds), *Ivo van Hove: From Shakespeare to David Bowie*, London: Methuen, pp. 170–77.

Sanderson, D. (2019), 'Filming Shakespeare on stage has a tragic flaw: Actors hate it', *The Times*, 14 January, https://www.thetimes.co.uk/article/filming-shakespeare-on-stage-has-a-tragic-flaw-actors-hate-it-5mts693tk. Accessed 28 August 2019.

Sandwell, I. (2012), 'NT Live: "It's about getting back to the core of what the theatrical experience is about"', *Screen Daily*, 18 October, https://www.screendaily.com/nt-live-its-about-getting-back-to-the-core-of-what-the-theatrical-experience-is-about/5047936.article. Accessed 28 August 2019.

Sauter, W. (2014), *The Theatrical Event: Dynamics of Performance and Perception,* Iowa City: Iowa State University Press.

Savran, D. (2003), *A Queer Sort of Materialism: Recontextualizing American Theater,* Ann Arbor, MI: University of Michigan Press.

────── (2005), 'The death of the avantgarde', *TDR/The Drama Review*, 49, pp. 10–42.

Schneider, R. (2001), 'Performance remains', *Performance Research*, 6:2, pp. 100–08.

Sedgwick, J. (2000), *Popular Filmgoing in 1930s Britain: A Choice of Pleasures*, Exeter: University of Exeter Press.

Seitz, M. Z. (2006), 'From the short stack: Ray Carney on John Cassavetes and The Method', *Slant*, 15 March, https://www.slantmagazine.com/blog/from-the-short-stack-ray-carney-on-john-cassavetes-and-the-method/. Accessed 28 August 2019.

Sellar, T. (2008), 'Theater director with a filmmaker's eye', *New York Times*, 25 November, https://www.nytimes.com/2008/11/30/theater/30Sell.html. Accessed 28 August 2019.

Shafer, S. (2003), *British Popular Films 1929–1939: The Cinema of Reassurance*, Abingdon: Routledge.

Shaffer, P. (1984), 'Making the screen speak', *Film Comment*, 20, p. 50.

Shail, A. (2010), 'Intermediality: Disciplinary flux or formalist retrenchment?' *Early Popular Visual Culture*, 8, pp. 3–15.

Shail, R. (2012), *Tony Richardson*, Oxford: Oxford University Press.

Sharrock, B. (2018), 'A view from the stage: Interviews with performers', in P. Aebischer, S. Greenhalgh and L. Osborne (eds), Shakes*peare and the 'Live' Theatre Broadcast Experience*, London: Bloomsbury Publishing, pp 95–102.

Shaughnessy, R. (2006), 'Stage, screen, and nation: Hamlet and the space of history', in D. Henderson (ed.), *A Concise Companion to Shakespeare on Screen*, Oxford: Blackwell Publishing, pp. 54–76.

Shellard, D. (2000), *British Theatre Since the War*, London: Yale University Press.

Shenton, M. (2000), 'Brief Encounter', *What's on Stage*, 12 September.

Shepherd, S. and Wallis, M. (2004), *Drama/Theatre/Performance,* Abingdon: Routledge.

Sherry, J (2016), 'Adaptation studies through screenplay studies: Theoretical mutuality and the adapted screenplay', *Journal of Screenwriting*, 7:2, pp. 11–28.

Shoard, C. (2016), '*Fences* review: Denzel Washington and Viola Davis set to convert Tonys to Oscars', *The Guardian*, 22 November, https://www.theguardian.com/film/2016/nov/22/fences-review-denzel-washington-viola-davis-august-wilson. Accessed 17 September 2019.

Shrimpton, J. and Hall, U. (1990), *Jean Shrimpton: An Autobiography*, London: Vintage.

Sierz, A. (n.d.), Aleks Sierz website, https://www.sierz.co.uk/. Accessed 20 September 2019.

Simpson, L. and McDermott, P. (2005), *Theatre of Blood*, London: Oberon Books Limited.

Smith, L. (1989), *Modern British Farce: A Selective Study of British Farce from Pinero to the Present Day*, London: Rowman & Littlefield.

Sobchack, V. (2004), *Carnal Thoughts: Embodiment and Moving Image Culture*, Berkeley, CA: University of California Press.

Sontag, S. ([1966] 1994), 'Film and theatre', in R. Knopf (ed.), *Theatre and Film: A Comparative Anthology*, London: Yale University Press, pp. 134–51.

Spottiswoode, R. (1965), *A Grammar of the Film*, Berkeley, CA: University of California Press.

Stamp, T. (1989), *Double Feature*, London: Bloomsbury.

Stollery, M. (2010), 'Transformation and enhancement: Film editors and theatrical adaptations in British cinema of the 1930s and 1940s', *Adaptation*, 3, pp. 1–20.

Stone, A. (2016), 'Not making a movie: The livecasting of Shakespeare stage productions by the Royal National Theatre and the Royal Shakespeare Company', *Shakespeare Bulletin*, 34, pp. 627–43.

Street, S. (1997a), 'British film and the national interest, 1927–1939', in *The British Cinema Book*, London: British Film Institute, pp. 28–34.

——— (1997b), *British National Cinema*, Abingdon: Routledge.

Sulcas, R. (2018), 'Why the sudden rash of movies onstage now?', *The Independent*, 20 February, https://www.independent.co.uk/arts-entertainment/theatre-dance/features/network-bryan-cranston-a8218316.html. Accessed 17 September 2019.

Sulik, B. (1961), 'Personal rebellion', *Tribune*, 22 September, n.pag.

Sullivan, E. (2017), '"The forms of things unknown": Shakespeare and the rise of the live broadcast', *Shakespeare Bulletin,* 35, pp. 627–62.

—— (2018), 'The audience is present: Aliveness, social media, and the theatre broadcast experience', in P. Aebischer, S. Greenhalgh and L. Osborne (eds), *Shakespeare and the 'Live' Theatre Broadcast Experience*, London: Bloomsbury Publishing, pp. 59–76.

Sunderland, J. (2014), 'Authorship in stage adaptations of "inherited tales": A survey approach', *Journal of Adaptation in Film & Performance*, 7, pp. 319–35.

Superbolt Theatre (n.d.), https://www.superbolttheatre.com/. Accessed 28 August 2019.

Sutton, D. R. (2000), *A Chorus of Raspberries: British Film Comedy 1929–1939*, Exeter: University of Exeter Press.

Svetlana, B. (2001), *The Future of Nostalgia*, New York: Basic Books.

Taylor, B. F. (2013), *The British New Wave: A Certain Tendency?*, Manchester: Manchester University Press.

Taylor, J. R. (1961), 'Two on the set', *Sight and Sound*, 30, p. 2.

Taylor, M. (2018), 'Prologue', in M. Taylor (ed.), *Theatre Music and Sound at the RSC: Macbeth to Matilda*, Palgrave Studies in British Musical Theatre, New York: Springer International Publishing, pp. 1–10, https://doi.org/10.1007/978-3-319-95222-2_1. Accessed 20 September 2019.

Taylor, P. (2016), '*Amadeus*, Olivier, National Theatre, London, review: Adam Gillen delivers the most moving portrayal of Mozart seen since Michael Sheen played the role 20 years ago', *The Independent*, 27 October, https://www.independent.co.uk/arts-entertainment/theatre-dance/reviews/amadeus-review-amadeus-peter-shaffer-michael-longhurst-lucian-msamati-a7383566.html. Accessed 17 September 2019.

Taymor, J. and Greene, A. (1997), *The Lion King: Pride Rock on Broadway*, New York: Hyperion.

TEDx Talks (2013), 'Infusing theatre into digital mediums: David Sabel at TEDxBroadway', YouTube, 1 March, https://www.youtube.com/watch?v=haShNYEKs1c. Accessed 28 August 2019.

Thielemans, J. (2010), 'Ivo van Hove's passionate quest for a necessary theatre: An interview', *Contemporary Theatre Review*, 20, pp. 455–60.

Thomson, C. C. (2014), *Thomas Vinterberg's* Festen *(The Celebration)*, Seattle: University of Washington Press.

Tibbetts, J. C. (2004), 'Faces and masks: Peter Shaffer's *Amadeus* from stage to screen', *Literature/Film Quarterly*, 32, p. 166.

Tibbetts, J. C. and Welsh, J. M. (2001), *The Encyclopedia of Stage Plays into Film*, New York: Facts on File.

Tibbetts, J. C and Welsh J. M. (eds) (1999), *The Cinema of Tony Richardson: Essays and Interviews*, New York: SUNY Press.

Toneelgroep Amsterdam (TGA) (n.d.), 'Husbands', TGA website, https://tga.nl/en/productions/husbands. Accessed 28 August 2019.

Travers, B. (1957), *Vale of Laughter: An Autobiography*, London: Geoffrey Bles.

Tripney, N. (2018), 'Romeo and Juliet', *The Stage*, https://www.thestage.co.uk/reviews/romeo-and-juliet-review-at-royal-shakespeare-theatre-stratford-upon-avon--fresh-and-engaging. Accessed 20 June 2020.

Trueman, M. (n.d.), 'Obsession: An interview with Ivo van Hove', National Theatre blog, https://www.nationaltheatre.org.uk/blog/obsession-interview-ivo-van-hove. Accessed 28 August 2019.

——— (2013), 'The surprise success of NT Live', *The Guardian*, 9 June, https://www.theguardian.com/stage/2013/jun/09/nt-live-success. Accessed 28 August 2019.

Truffaut, F., Hitchcock, A. and Scott, H. G. (1985), *Hitchcock*, New York: Simon and Schuster.

Tynan, K. (1955), 'Ealing: The studio in suburbia', *Films and Filming*, 55, pp. 22–24.

Vardac, A. N. (1950), 'From David Garrick to D. W. Griffith: The photographic ideal', *Educational Theatre Journal*, 2, pp. 39–47, https://doi.org/10.2307/3203775. Accessed 20 September 2019.

Venning, D. (2009), 'Opening night', *Theatre Journal*, 61, pp. 465–67.

Viera, M. (2004), 'Playing with performance: Directorial and acting style in John Cassavetes' *Opening Night*', in C. Baron, D. Carson and F. Tomasulo (eds), *More Than a Method: Trends and Traditions in Contemporary Film Performance*, Detroit: Wayne State University Press, pp. 153–72.

Vimeo (2008), '*Koppen* trailer', Vimeo, https://vimeo.com/777768. Accessed 29 August 2019.

Vitali, V. and Willemen, P. (2006), *Theorising National Cinema*, London: Palgrave Macmillan.

Walker, A. (2005), *Hollywood England: The British Film Industry in the Sixties*, London: Orion.

Walters, B. (2015), '*Jurassic Park*: Hollywood blockbusters retold at the Edinburgh fringe', *The Guardian*, 16 July, https://www.theguardian.com/stage/2015/jul/16/jurassic-park-among-the-blockbusters-stomp-over-edinburgh-festival. Accessed 9 March 2020.

Wandor, M. (2014), *Look Back in Gender (Routledge Revivals): Sexuality and the Family in Post-War British Drama*, Abingdon: Routledge.

Wardle, J. (2014), '"Outside broadcast": Looking backwards and forwards, live theatre in the cinema – NT Live and RSC Live', *Adaptation*, 7, pp. 134–53.

Way, G. (2017), 'Together, apart: Liveness, eventness, and streaming Shakespearean performance', *Shakespeare Bulletin*, 35, pp. 389–406.

Wesker, A. (1960), 'The Entertainer', *Tribune*, 19 August, p. 2.

——— (2012), *The Kitchen*, London: Oberon Books.

WFMT Radio Network (1962), 'Frances Cuka discusses the play *A Taste of Honey* and her career', WFMT Studs Terkel Radio Archive, https://studsterkel.wfmt.com/programs/frances-cuka-discusses-play-taste-honey-and-her-career. Accessed 24 April 2019.

Wheeler, D. (2010), 'All about Almodóvar? *Todo sobre mi madre* on the London Stage', *Bulletin of Hispanic Studies*, 87, pp. 821–42.

Wickstrom, M. (1999), 'Commodities, mimesis, and *The Lion King*: Retail theatre for the 1990s', *Theatre Journal*, 51, pp. 285–98.

Williams, M. (2011), 'Entering the paradise of anomalies: Studying female character acting in British cinema', *Screen*, 52, pp. 97–104.

——— (2017), *Female Stars of British Cinema: The Women in Question*, Edinburgh: Edinburgh University Press.

Williams, R. (1991), *Drama in Performance*, London: McGraw-Hill Education.

Williams, T. and Miller, A. (2009), *A Streetcar Named Desire*, London: Penguin Classics.

Willinger, D. (2018), *Ivo Van Hove Onstage*, Abingdon: Routledge.

Wiseman, T. (1961), 'Mr Richardson shoots it rough', *Evening Standard*, 7 April, n. pag.

Wolf, M. (2003), 'One cool Jude', *The Guardian*, 14 December, https://www.theguardian.com/film/2003/dec/14/features.review. Accessed 17 September 2019.

Wooden, I. (2011), '*Fences* (review)', *Theatre Journal*, 63, pp. 123–25, https://doi.org/10.1353/tj.2011.0000. Accessed 20 September 2019.

Woodward, C. (2017), 'Playwright, David Eldridge interview: "There's less procrastination when you're a dad"', Mr Carl Woodward, 6 October, https://www.mrcarlwoodward.com/interview/playwright-david-eldridge-interview-theres-less-procrastination-when-youre-a-dad/. Accessed 12 April 2018.

Wyver, J. (2014), '*Hamlet* performed by the Royal National Theatre (review)', *Shakespeare Bulletin*, 32, pp. 261–63, https://doi.org/10.1353/shb.2014.0016. Accessed 20 September 2019.

—— (2015), 'Screening the RSC stage: The 2014 Live from Stratford-upon-Avon cinema broadcasts', *Shakespeare*, 11, pp. 286–302.

—— (2019), *Screening the Royal Shakespeare Company: A Critical History*, London: Bloomsbury.

Yoshitaka, O. (2013), 'What is "the haptic"? Consideration of *Logique de la Sensation* and Deleuze's theory of sensation', *Aesthetics*, 17, pp. 13–24.

Zarhy-Levo, Y. (2010), 'Looking back at the British New Wave', *Journal of British Cinema and Television*, 7:2, pp. 232–47.

Zarrilli, Philip B. (2002), *Acting (Re)considered: A Theoretical and Practical Guide*, London: Routledge.

Zipfel, F. (2014), 'Fiction across media: Toward a transmedial concept of fictionality', in M. L. Ryan and J. N. Thon (eds), *Storyworlds across Media*, Lincoln: University of Nebraska Press, pp. 103–25.

Index

CPSIA information can be obtained
at www.ICGtesting.com
Printed in the USA
JSHW010836281222
35328JS00002B/3